Realistic
PET PORTRAITS in colored pencil

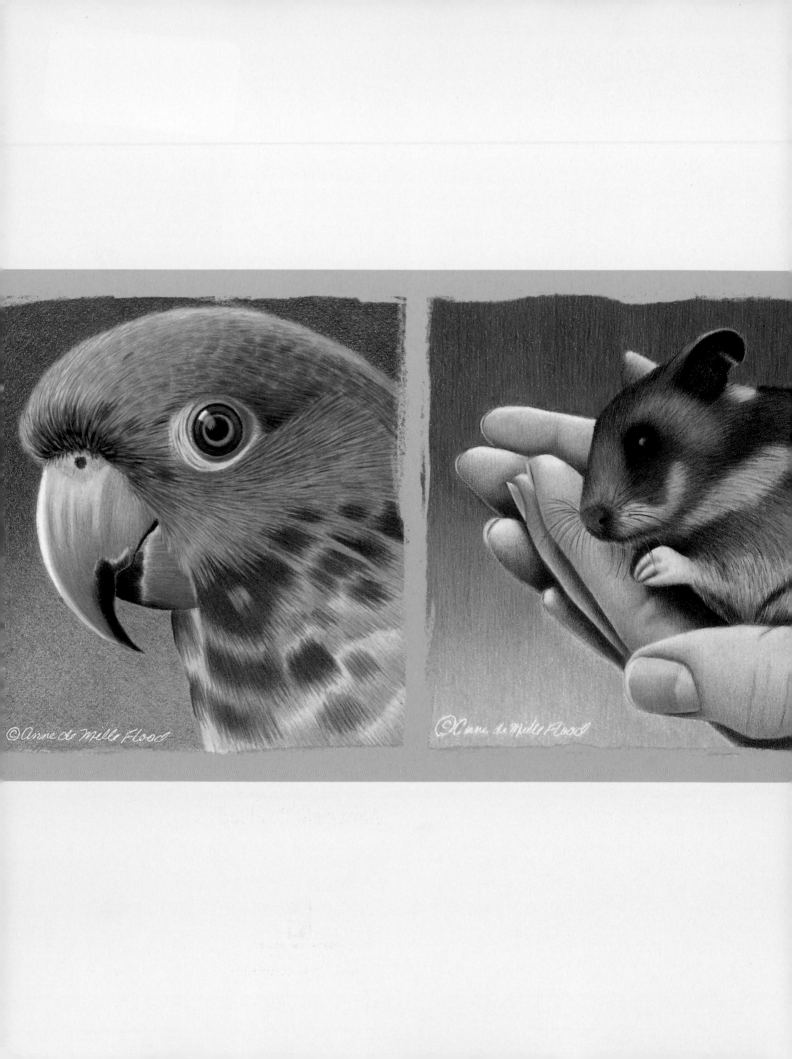

Realistic
PET PORTRAITS
in colored pencil

Anne deMille Flood

NORTH LIGHT BOOKS
CINCINNATI, OHIO
www.artistsnetwork.com

About the Author

Anne deMille Flood's lifelong fascination with drawing was sparked by the gift of a set of colored pencils in 1994. Since that time she has worked passionately with this versatile medium and has developed her love of colored pencil into a thriving pet portraiture business.

Anne resides in Washington state with her family and shares her knowledge of pet portraiture in workshops throughout the Pacific Northwest. This book is the culmination of years of experience combined with unique teaching skills and a truly deep love of the medium of colored pencil.

Her work has led down many paths, but one of her favorites is using her pet portrait skills to render wild animals. View more of Anne's work by visiting her web site at www.annedemilleflood.com.

Realistic Pet Portraits in Colored Pencil. Copyright © 2004 by Anne deMille Flood. Printed in Singapore. All rights reserved. No part of this book may be reproduced in any form or by any electronic or mechanical means including information storage and retrieval systems without permission in writing from the publisher, except by a reviewer who may quote brief passages in a review. Published by North Light Books, an imprint of F&W Publications, Inc., 4700 East Galbraith Road, Cincinnati, Ohio, 45236. (800) 289-0963. First Edition.

Other fine North Light Books are available from your local bookstore, art supply store or direct from the publisher.

08 07 06 05 04 5 4 3 2 1

Library of Congress Cataloging in Publication Data
Flood, Anne deMille-
　　Realistic pet portraits in colored pencil/Anne deMille Flood.
　　　　　p. cm
　　Includes index.
　　ISBN 1-58180-409-1 (pbk. : alk. paper)
　　1. Animals in art. 2. Colored pencil drawing—Technique. I. Title.

NC783.8.P48F58 2004
743.6—dc22 2003066213

Edited by Bethe Ferguson and Gina Rath
Cover Designed by Lisa Buchanan
Interior Designed by Karla Baker
Production coordinated by Mark Griffin

Metric Conversion Chart

To convert	to	multiply by
Inches	Centimeters	2.54
Centimeters	Inches	0.4
Feet	Centimeters	30.5
Centimeters	Feet	0.03
Yards	Meters	0.9
Meters	Yards	1.1
Sq. Inches	Sq. Centimeters	6.45
Sq. Centimeters	Sq. Inches	0.16
Sq. Feet	Sq. Meters	0.09
Sq. Meters	Sq. Feet	10.8
Sq. Yards	Sq. Meters	0.8
Sq. Meters	Sq. Yards	1.2
Pounds	Kilograms	0.45
Kilograms	Pounds	2.2
Ounces	Grams	28.4
Grams	Ounces	0.04

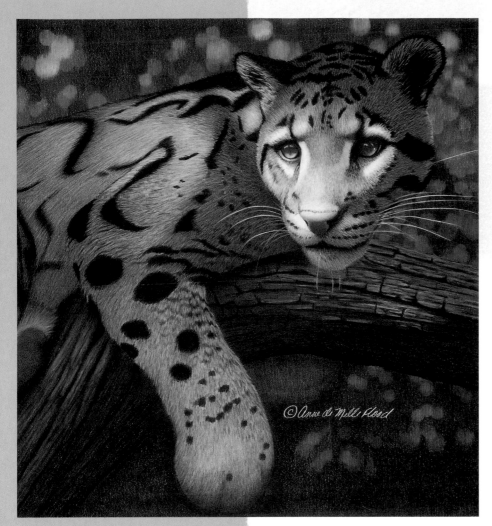
©Anne deMille Flood

Dedication

To my family, Matt, Jennifer and Erin.
My heartfelt thanks.

Clouded Leopard

I was delighted to be allowed to take some great close-up photos of this endangered species at the Point Defiance Zoo and Aquarium in Tacoma, Washington. I created this portrait of Raja from those shots. Now this image appears on greeting cards and prints that are sold in the gift shop and helps to raise funds for research. What a great way to put my art to good use!

To learn more about Clouded Leopards, visit their web site at www.cloudedleopard.org.

Raja
24"× 20" (61cm × 51cm)
Private Collection

Acknowledgments

Special thanks go to my dear family members and friends whose unconditional love and support sustained me throughout this process. To my patient and kind editors, Bethe Ferguson and Gina Rath who kept me on track, and to Rachel Wolf for choosing me. To Ann Kullberg, my first teacher—my inspiration, without whom this book would not have been possible. To all the students who helped me learn how to teach. To all the wonderful colored pencil artists who generously shared their knowledge and love of colored pencil art and to the Colored Pencil Society of America which gives us all a foundation for our artistic growth.

And finally to my mother, Myrna, and my late father, Eric, whose love of art lives on in me, and who would be so proud.

Anne deMille Flood

Table of Contents

chapter 1: ## General Instructions **10**
Learn the basics about color, point, pressure and shading.

chapter 2: ## Materials and Supplies **16**
Materials and supplies needed for creating your own pet portraits.

chapter 3: ## Basic Fur and Feather Techniques **24**
Lots of tips and techniques to help you effectively render fur and feathers. Learn fur color combinations and feather patterns.

chapter 4: ## Eyes **40**
The eyes of each type of animal are unique. Learn the different characteristics that will make your portrait believable and reflect your pet's personality.

chapter 5: ## Facial Features **52**
Helpful techniques and step-by-step demonstrations for rendering accurate facial features and seeing beyond the anatomy of the animal to the emotion.

chapter 6: ## Cats **66**
Cats have unique characteristics. With the information you have learned so far, you can easily follow the step-by-step instructions to create amazing cat portraits.

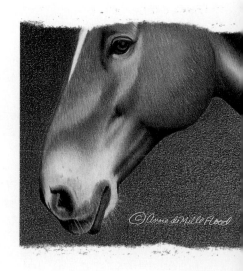

chapter 7: **Dogs** **80**
Step-by-step demonstrations for four popular dog breeds give you
a solid base for effectively capturing your dog's unique personality.

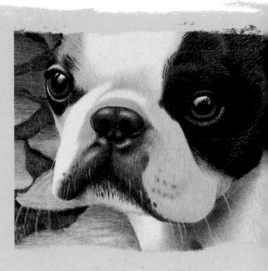

chapter 8: **Birds** **92**
Four step-by-step examples that will help you determine a strategy
when starting your own bird picture.

chapter 9: **Horses** **104**
Capture the dynamic beauty of your horse. Use these step-by-step demon-
strations to draw horses using many layers of color.

chapter 10: **Cuddly Friends** **116**
Create portraits of very small, cuddly animals so inviting that the viewer will
just want to reach out and touch them.

conclusion **125**

index **126**

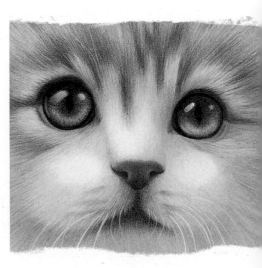

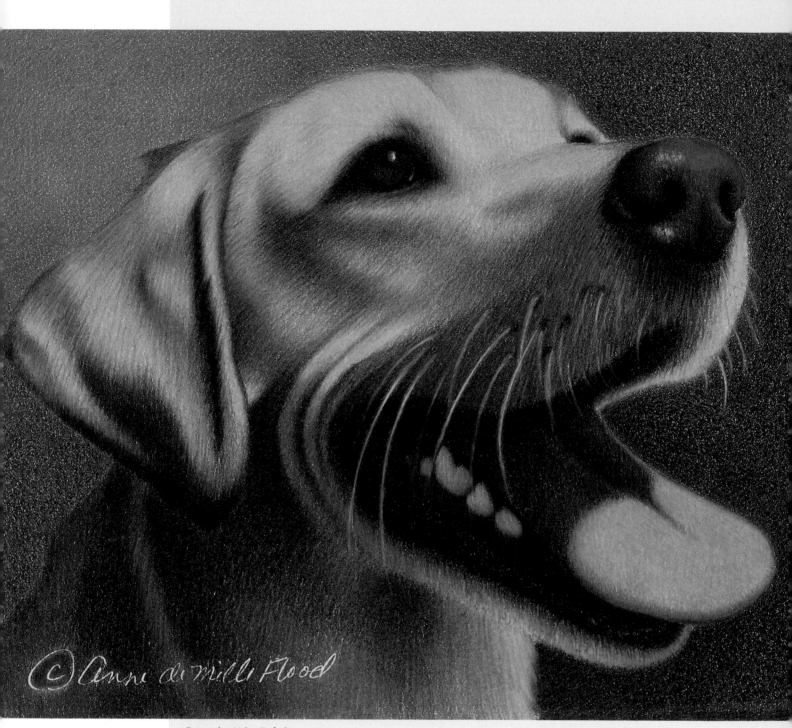

Expression Using Techniques

You cannot deny the expression of anticipation on the face of this Yellow Lab. He seems to be saying, "Is it time for my treat now?" or "If you throw me a ball, I'll be your friend for life!" Expression combined with all the techniques that you will learn for rendering eyes, fur, noses, teeth, tongues and even whiskers can add up to a remarkably realistic and enjoyable image.

I hope the information offered in this book will lead you to create your own wonderful colored pencil memories of a favorite pet. So, start at the beginning and don't be afraid to try something you probably never believed you could do.

Anticipation
7" × 9" (18cm × 23cm) • Collection of the Artist

If you are like millions of humans all over the world who are owned by a pet, I hope this book will open the door to your creativity and give you the tools to start on a wonderful new path of animal portraiture. When you look into the eyes of a being that gives back so much, it is a natural desire to capture that love forever. Photographs cannot compare to the richly layered effect you get by creating a portrait in colored pencil. A portrait that expresses the uniqueness of your pet's personality.

I can still remember so clearly the day in 1994 that I looked at my first colored pencil book and was absolutely wowed by the remarkable realism, intense colors and fabulous effects that could be achieved with colored pencil. I wished so much that I could create such beautiful artwork. Many workshops later and thanks to superb instruction from other artists, I launched my pet portrait business in 1996. My own pets, Max and Heather, were my inspiration and the first subjects of my colored pencil portraits. Those first few portraits led to requests by friends and family and finally commissions began rolling in. It seems like such a long way from those humble beginnings to where I am today. Every step seemed like a baby step, but every portrait was in fact a giant leap. What's amazing is that I am still learning!

What I hope to share with you in this book is the love of learning and the exhilaration of sitting down with your pencils and creating something that excites you. There are many valid and different methods of working in colored pencil, but I can only teach you about what works best for me. I hope you will take that knowledge and add your own creative insight and passion to the experience.

Before you begin applying the techniques presented in this book, please keep a few things in mind. First, I will start at the beginning with some very basic terms and techniques that I think are important. If you are new to colored pencil, you will find this information very helpful, and I encourage you to try the techniques and experiment with the pencils before you dive into your first portrait. All this information is building blocks to a satisfying result. If you are an experienced colored pencil artist, thank you for being open to new ideas, I hope this book will smooth the way for you.

I specifically created this book to be very straightforward and chose to work strictly in the medium of colored pencil. In fact, I even limited my choice of pencils to one brand and kept the accessory supplies to those that you can easily find just about anywhere. These are precisely the materials that I use in my everyday work!

Likewise, I kept focused strictly on my animal subjects and did not venture into the area of complicated backgrounds or settings. Instead, I concentrated solely on the information that you will need to render all aspects of your pet's individual characteristics.

Just as my discovery of colored pencil art has been a gift to me, I hope this book will be a gift to you—a jumping-off point that will spark your creativity and give you a good foundation. I hope it will also give you a new way to look at the world of animals and lead you to some wonderful results. Remember, the love you feel for your pet is the most valuable ingredient of all. I wish you good luck and many happy hours with your pencils.

General Instructions

Before you pick up your pencils and begin the journey of creating a wonderful portrait of your pet, there are some important terms and techniques that will help you on your way. The following few pages will explain and demonstrate the general instructions employed in this book. They will expand your colored pencil skills and enable you to complete a satisfying pet portrait. These are my tried-and-true techniques which, when applied, will help you achieve depth and realism and greatly enhance your colored pencil piece. Each step-by-step instruction will include the names, numbers and symbols of four basic categories to consider while working on each step. These categories are the pencil name, pencil point, amount of pressure to apply and the type of stroke to be used.

Additional terms such as wash, highlight, modeling, shading and burnishing will also be explained and demonstrated. These terms will be incorporated into many of the demonstrations throughout the book. Refer back to this chapter if you have any questions about how to use a technique while you are working. Let's get started!

Color

Throughout this book you will see pencil color names listed numerous times. The color name will always refer to Sanford Prismacolor brand of pencil. Although there are many suitable brands on the market, Prismacolor is widely available, relatively inexpensive and is my preferred type for this book. If you do not have Prismacolor pencils, any good art supply store should carry a comparable brand. Avoid purchasing student-grade pencils, as they do not have the layering and blending qualities of fine art pencils. With Prismacolor, the waxiness of the pigment enables you to achieve many layers of intense color. If you substitute another brand, look for pencils with color that feels smooth when applied to the paper and include a wide range of colors.

Point

The feeling of control that the artist has over color application is one of the most appealing aspects of working in colored pencil. When a smooth, even layer of color is desired, such as for the buildup of an eye color, the sharpness of the pencil point is crucial. The sharper the point, the more consistent and even the color buildup will be, and the more precise control you will have. The blunter the point, the more the pencil will skip over the tooth of the paper, creating a choppy and uneven layer of color. A needle-sharp point is necessary for delicate layering, and a gentle touch is necessary to keep the point from constantly snapping. Both sharp and dull points have their usefulness, as you will see in later chapters.

Pressure and Shading

When using colored pencils, the terms *pressure* and *shading* go hand in hand. Pressure refers to how hard you bear down when applying color; shading, using pressure to gradually move from light to dark values with a color. Many objects with curved or rounded surfaces will gradually darken as the edge moves away from the viewer. You can effectively portray this by adjusting pressure.

Point, Pressure
and Shading

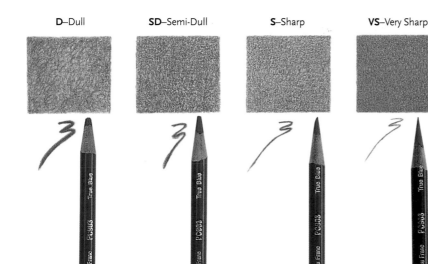

| D–Dull | SD–Semi-Dull | S–Sharp | VS–Very Sharp |

Tip Sharpen your pencil frequently to maintain a good point. Each time you pull the pencil out of the sharpener, wipe the sharpened end on a soft cloth. This will prevent pencil debris from dropping onto your work and becoming ground in.

What's the Point?

Throughout the book, you will see letters referring to the sharpness of point needed, as shown in the illustration above. All four of the boxes were applied with medium pressure using True Blue with differing sharpness of pencil. Utilize the sharpness of the point to achieve different effects in your work. For example, the box on the far left illustrates the rough color application you can achieve with a dull point. Create smooth, even layers by using a needle-sharp point, as shown in the box on the far right.

| 1–Very Light | 2–Light | 3–Medium | 4–Full Value |

How Hard to Press

Here you can see how a color changes according to how hard you press. To achieve a whisper of color, hold the pencil loosely, barely touching the paper (see the box on the far left). Medium pressure (the third box) is best described as pressing about as hard as you write your name. To achieve color as deep as the box on the far right, press as hard as you can—this application is called applying color full value. Throughout the book, look for numbers 1–4 in the accompanying charts to tell you how much pressure to use for each step.

Shading—From a Whisper to a Shout

Adjust your pressure to create soft shading and rich darks. Shading gives an object shape and form. Practice creating shapes by shading with a single color until you feel comfortable with the process. Shading can be used to create a tonal foundation on which you can build color.

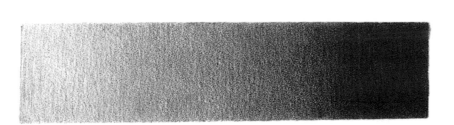

Stroke

In a colored pencil piece, stroke is just as important a factor as all the others we have discussed so far. This is because the type of stroke utilized combines with color, point and pressure to create a three-dimensional illusion on a flat piece of paper.

A stroke is best defined as the method you use to apply color and pertains to the direction and pattern of color application. The richness of the color buildup and the layering of the strokes bring depth and realism to your work. The following list of strokes are some that I have found to be effective in rendering animal characteristics, but they are not the last word when applying color to your piece. If you find a way to apply color that feels comfortable to you and gives you the desired effect, by all means use it!

Learn the Language

These strokes are the foundation for all the illustrations in this book. Practice them before you continue.

Tip
If you are having difficulty using a certain stroke, or it feels uncomfortable, try turning the paper as you work. This is especially useful if you are trying to get the stroke pattern to move in a specific direction. You will find it helpful to turn your reference photo to match your artwork.

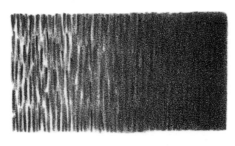

Vertical Line—VL
Vertical strokes placed side by side can be layered to achieve coverage. The length of stroke varies depending on the size of area that needs to be covered.

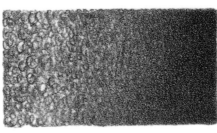

Circular—C
Move the pencil in an overlapping, circular pattern. The smaller and tighter the circles, the smoother the coverage.

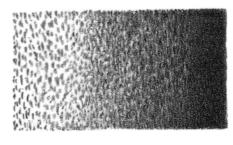

Stipple—ST
Dab the pencil point on the paper to create short, choppy strokes. The closer the stipples, the more coverage, but the pattern should be obvious. Avoid pounding the pencil, which creates impressed dimples.

Loose Scribble—LS
Open, loose, back-and-forth strokes, that can change direction. This stroke creates a fur-like appearance when layered. They can also overlap, making for more complete coverage.

Linear—L
Medium to long strokes that follow the shape of the object they are portraying.

Crosshatch—X
Diagonal strokes, crisscrossing each other. Layer them to achieve quick, even coverage for a background.

Coming to *Terms*

Now that you have explored some of the basic techniques that will help you along the way, let's discuss a few more terms followed by demonstrations.

Wash

A wash is an even layer of color applied to an area to create a basecoat. It will often have succeeding layers of color applied to it. Washes can be applied with a light touch or full value as shown below. They can be the foundation of a shape or just used to fill in an area that needs no more attention.

Burnishing

Burnishing is a technique in which several layers of darker-value colors are first heavily applied, then a lighter-value color is pressed onto this basecoat.

Create a solid base on which to add a lighter color by pressing hard enough to create a smooth, waxy surface without any paper surface showing through. Burnishing is an excellent technique for producing fine details or effects such as reflections, shine and moistness.

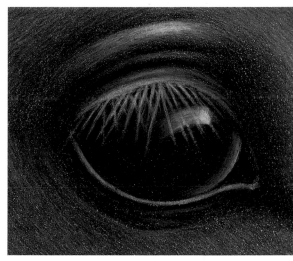

Burnish–B
See how reflections and eyelashes were created on this equine eye. I burnished lighter colors on top of several dark layers. I combined Black Grape, Indigo Blue and Black to create the foundation of the eyeball, then enhanced the shape and feature of the eye by applying White and Deco Blue on top.

(Even though burnishing is a technique, to simplify, it has been included with the *strokes* in the step-by-step graphs throughout the book.)

A Wash Can Be Delicate
I first applied Cream using a light touch and a circular stroke, followed by a wash of Deco Yellow and Chartreuse. This created a delicate foundation that might be used as the base for a luminous eye.

A Wash Can Be Bold
Here I used three full-value washes: I began all three blocks with Peacock Green, I then added a layer of Tuscan Red to the second and third blocks. Finally, I added a layer of Indigo Blue to the third block. This example is bold and dark and can be used as a background. It is easy to see how much a wash can differ. These examples demonstrate the smoothness and consistency of layering.

Layering

So far you have discovered techniques that allow you to build color through the use of pressure and stroke, and how to adjust texture using the sharpness of your pencil point. Now you will learn how layering achieves richness by adding multiple colors on top of one another. Layering is just as important for creating depth in your work as are other techniques. It differs somewhat from pressure and point because you must choose color combinations to help you achieve the results you are striving for.

There are many colors available in any colored pencil palette and the color-blending possibilities are endless. I always apply at least three layers of color to give depth to my work. Take the time to experiment with the different colors and you will discover many out-of-the-ordinary, attention-grabbing combinations, which may become your favorites.

When layering with colored pencils keep in mind that the colors are translucent, which means the underlying colors show through. The beauty of layering is in the wonderful mix of colors and how they combine when placed one on top of the other. The waxiness of the pencils also allows you to actually mix the colors with your pencil point, creating an impressionist-like effect.

Modeling

Modeling refers to the process of creating shapes by layering and shading. Layering and modeling combine to help create shape or model an object.

Highlight

Whenever the term *highlight* is used it will refer to an area of paper left free of color in order to give the effect that light is hitting that area directly. Highlights are crucial when creating the effect of light bathing the subject or touches of light striking it in certain spots. Highlights are very effective in making dramatic statements and giving excitement to your piece. You can maximize the highlight by always working on clean, pure white paper.

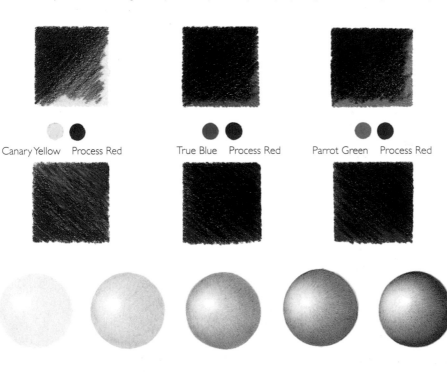

Canary Yellow Process Red True Blue Process Red Parrot Green Process Red

Translucent Layers Transform Colors

Colors change depending on how they are combined. The underlying wash shows through in all the samples at left, demonstrating how semi-transparent colors can be altered through layering. In this book, I will build color using only dry, wax-based pencils. Since the pigment is never liquefied, the layers remain translucent. I have never had a problem with overlayering, but if you are unhappy with a combination try adding another color—it will be transformed!

Layering, Modeling and Highlight Come Together

In this demonstration the shape of the sphere gradually appears as layering and modeling techniques are used. The highlight is left free of color throughout the process, eventually becoming the strongest point of the light source. The edges of the ball darken as they move into shadow. The first step is a wash of Cream, then each step adds a layer of color: Jasmine, Goldenrod, Terra Cotta and finally Tuscan Red and Dark Umber. Create the delicate buildup of color with the combination of a very sharp pencil point and a linear stroke.

Tip
Leave a border around your image so you can make notes, or keep some small swatches of your paper near your drawing table. This will allow you to note the color number, name and a sample of the combination you have discovered. Keep the swatches in a folder or transfer them to a chart so you can refer to them later. The more sophisticated and complex your colors become, the more rich and exciting your piece will be.

Putting it
All Together

On this page is a sample of the step-by-step chart that will guide you throughout this book. The gorgeous calico cat drawing demonstrates the importance of using proper color, point, pressure, stroke and highlighting in creating a captivating and lifelike image.

For each step-by-step demonstration in this book, the color, point, pressure and stroke used will be included (see chart below), along with the instructions describing what to accomplish in each step.

My hope is that once you have created drawings from the step-by-step demonstrations, you will use this information with your own photographs to create a unique drawing.

With so many different animals and fur colors, I want to include as much information as I can. Therefore, after the step-by-step demonstrations, you will find several samples of finished work with detailed charts of what I used for that particular drawing.

Step: Sample Step-by-Step Chart

	Point	Pressure	Stroke
Indigo Blue	SD	4	V
Wash in the background.			
Cream	VS	2	C
Use Cream and a circular stroke for the eye.			
Jasmine	S	3	L
Use Jasmine to wash in the nose.			
French Grey 10%	S	3	LS
Begin the fur with French Grey 10%.			

Point		Pressure		Stroke			
D–Dull	**SD**–Semi-Dull	**1**–Very Light	**2**–Light	**V**–Vertical Line	**C**–Circular	**X**–Crosshatch	**B**–Burnish
S–Sharp	**VS**–Very Sharp	**3**–Medium	**4**–Full Value	**ST**–Stipple	**L**–Linear	**LS**–Loose Scribble	

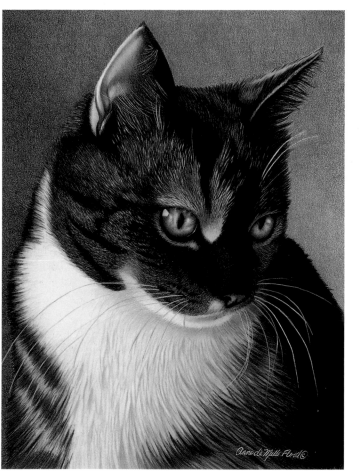

The Drama Is in the Details

The drama and liquid effect in the eyes of this attentive cat was acheived with finely applied layers, the blending of colors and the use of a needle-sharp pencil point. The highlights added even more depth and drama. Notice how the delicate modeling gives the eyes their round shape. The stroke pattern in the fur is clearly visible and makes it appear both believable and complex. The layers of color combine to make the fur appear multifaceted.

Watching and Waiting
17″ × 13″ (43cm × 33cm)
Collection of the Artist

Materials *and Supplies*

There are many factors that influence the final result in art. What motivates us first and foremost is inspiration; what enables us to persevere is the desire and determination to complete a master-piece. Every new picture is an exciting challenge and each experience will differ. Sometimes the piece just seems to evolve effortlessly, but there are other times that try our patience and persistence.

We will always face difficulties in completing a pleasing work of art, but there are measures that we can take to minimize our frustration. Proper materials and a comfortable workspace will contribute greatly to your success, allowing you to have a satisfying and enjoyable experience.

If possible, situate your workstation in an out-of-the-way location that allows you to have a permanent setup and where you can work without interruption. This will save the time and distraction of having to repeatedly put materials away. One of the best aspects of working in colored pencil is that you do not need a large or complicated arrangement. All you need is a quiet corner, your pencils, a few accessories and you are ready to go!

Begin With a Good Photo

A pet portrait is a labor of love, so give yourself the advantage of beginning with a photo that will inspire you as you work. I strongly believe that starting with a good reference photo will assist the artistic process immensely. Alleviate the frustration involved in working from a bad picture by taking the time and making the extra effort to get an exceptional shot.

First, be prepared to take lots and lots of photos. Whether you are using film or digital images, taking multiple photos seems to be the only way to guarantee that you will end up with something special. Pet photography requires a good deal of patience and perseverance in order to succeed. Some animals are skittish when a camera comes out, others just love to pose; whatever the case, you most likely won't get them to do exactly what you would like. The only

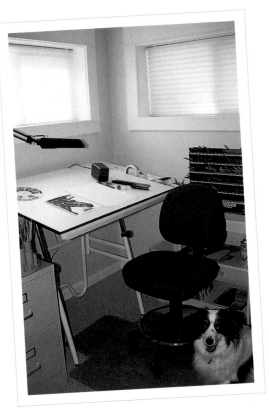

Anne's Studio—A Quiet Retreat
The location of your studio and a functional workstation make a world of difference. Improve concentration and work more efficiently with good equipment. A comfortable chair, adequate lighting, handy materials and a friendly companion make working a joy!

solution that I have found is to let the animals be natural and hope that the camera captures them in unique and captivating situations.

I take both full-body and close-up shots, in either case I fill the frame as much as possible. That way whatever pose I choose, the animal is the heart of the picture. I don't worry too much about background; in fact, I try to minimize the amount of surroundings

in the picture. The animal is my focus and I make sure to place it front and center.

Another recommendation is to use lighting to your advantage. Light creates mood, and shadows give an object shape. Therefore, I do all my photography without a flash attachment. In my opinion, a flash is too direct and obscures the interesting shadows created when a subject is in daylight. Instead of using a flash, I adjust my film speed or change locations in order to make use of natural light. I prefer filming in late afternoon or early evening because of the inherent warmth of the light and the interesting angles and shadows the light creates. Sometimes I shoot in the shade with reflected light on the subject. Whatever the case, I move the pet around to several different locations and light situations so that, hopefully, I will end up with a special shot that just glows. Remember, light and shadows allow you to create a wonderful and realistic pet portrait.

What a Difference Lighting Makes!
See how bland and washed out Max appears in the photo on the left. The eyes are blank behind the overpowering force of the flash. The facial features are flattened and appear to be one-dimensional, and the fur has almost no distinguishing characteristics. Compare that to the photo on the right, filmed in angled sunlight. The eyes are luminous and have reflections, the nose glistens and the tongue looks moist. Shadows define the side of the face and give it form—the picture glows.

Choosing Your Photo—You Gotta Love It!
Get inspired! Look for mood, an endearing expression or humor in your picture. Choose a photo that gets you so excited that you can't wait to sit down and begin a portrait. Your emotional involvement in the picture will come through to the viewer.

After you have sorted through your images and narrowed them down to a few good possibilities, pick one that best evokes the emotion or sentiment that you would like to portray, or one that projects a feeling all its own. Consider composition, lighting and color, but be sure you feel strongly about your choice. Inspiration is the best beginning there is, so love the one you choose.

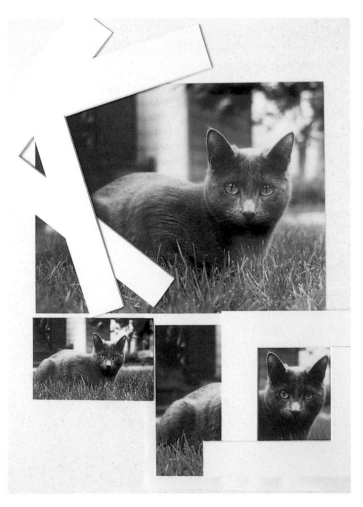

Focus on the Feeling
I love the scrutinizing gaze on this cat's face and, by using L-brackets to frame the picture, I can zero in on that compelling expression. I can also see that I have several good possibilities for a composition. By arranging the brackets differently, I can compare horizontal and vertical formats or zoom in and see how a close-up would work. I also make sure that I have a clear blow-up of the shot to work from. Clearly, the largest picture will help me see all the elements I would like to portray.

Begin with
the Basics

In addition to a good workplace and an inspiring reference photo, here are some materials and supplies that I consider necessary for success as a colored pencil artist.

Paper

I have found my preferred paper to be Rising Stonehenge, which is usually available through art supply catalogs and stores (don't expect to find it in a craft store). The Stonehenge brand works well for me because I love to apply a lot of color and it is substantial enough to accept many layers. It has a slight texture, which I make use of to create some of the effects in my pieces. I also use the white of the paper to create my highlights. I think you will find it is worth taking the time to seek out a good supplier. If you choose not to use Stonehenge, I recommend that you look for a paper that is pure white, at least two-ply and that has some tooth or texture.

Graphite Pencil

Keep a no. 2 graphite pencil handy for tracing line drawings and making notes in the margins of your paper. Unlike wax-based pencil lines, graphite lines can be easily removed with a gentle eraser. Don't press too hard when tracing your image or you may create impressed lines.

Drafting Brush

This is a vital tool to have when working in colored pencil. It is essential to keep your work area and paper clean, so brush often while you work. If you cannot locate a drafting brush, a clean, broad paintbrush will work well; just be sure the bristles are soft and dense enough to brush away all the debris. If the bristles are too rigid or stiff, they could scratch the paper surface.

Pencil Sharpener

I swear by my basic, inexpensive electric pencil sharpener. There are several suitable brands that are readily available at any office supply store. Battery-powered sharpeners work well if you are at a work-shop or away from a power source. Most electric and battery-powered sharpeners are not intended for use with wax-based pencils, but I find that they last long enough to make it worth replacing my sharpener periodically. Clean your pencil sharpener by inserting a graphite pencil occasionally.

Pencils

As stated in chapter one, my preferred brand of pencils is Sanford Prismacolor. I love the waxy, smooth feel when applied to paper, and the range of over 120 colors is more than adequate for my needs. That doesn't mean that I never use other brands. There are many good possibilities but the Prismacolor pencils are easily available and affordable. Look for the sets at discount retailers, large office supply stores or even craft stores. Sets are usually the best value, so I urge my students to shop around and purchase the largest set they can afford.

The Essentials
The materials pictured in this photo are my personal preferences. However, there are suitable substitutes available at any good art supply store. Be sure you have some version of the items pictured above, as I believe these are the fundamentals for getting started with colored pencils.

Tip
If you want to try out a paper to see if it is suitable for working in colored pencil, test it by applying layers of color with varying levels of pressure. If the paper is too smooth, it will not take a lot of layering and your pencils will simply slide over the surface. If it is too soft, it will rip after a few layers have been applied.

Once you have purchased a set and begin to use it, you may quickly find it necessary to replace frequently used, individual colors. Seek out an art supply store that carries open stock pencils so you can easily replace them as you need. With the growth of Internet art supply sources, more and more online retailers offer a good selection of the Prismacolor brand at competitive prices.

Pencil Extender

Eventually the pencils will be too short to hold in your hand effectively. Don't throw them away—use a pencil extender. Have a few of them on hand as they will enable you to use the pencil until it is quite a short stub. You will lose control if you attempt to work with too short a pencil, so this is a tool that I feel is a necessity.

Erasers

A kneaded eraser is another item that I consider a must when working in colored pencil. Like the pencils, they are widely available and inexpensive. Kneaded erasers are elastic, can be stretched or molded into a ball and work wonders for cleaning the paper as you work. I also keep a plain white eraser on my table for erasing graphite lines when necessary.

Tape

I keep both clear tape and masking tape close at hand at all times and use them in various ways. I use masking tape both to anchor my drawing to the table and to lift color when needed. Touching the masking tape gently to an area and slowly lifting allows the removal of color in that specific spot. Repeating this technique as many times as necessary removes quite a bit of color.

Masking tape comes in a variety of widths, making it useful for lifting large areas. Invisible tape is see-through and suitable for lifting small amounts of color. In both cases, be sure to touch the paper gently and lift slowly to avoid tearing.

Lifting Compounds

Another ideal method for lifting color is removable adhesive putty. This is widely available at craft or office supply stores; it is inexpensive to purchase and comes under a variety of names. Removable putty is simply a tacky, gum-like material that can be molded into a ball, and when pressed onto the paper, lifts a substantial amount of color. Repeating the motion gradually lifts off multiple layers of color.

Tip When lifting color, be aware that you will most likely not be able to take away enough color to get back to pure white paper. If you are concerned that you will inadvertently cover up a highlight and want to be sure to keep that area pure white, use a dab of removable putty to mark where the highlight will be and work around it. When you have finished applying color, just take off the putty and voilá, a nice, clean highlight!

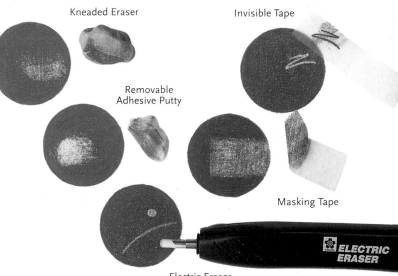

Kneaded Eraser

Invisible Tape

Removable
Adhesive Putty

Masking Tape

Electric Eraser

ELECTRIC ERASER

Comparing Color-Lifting Methods

Removing color is sometimes necessary, but care must be employed so the surface of the paper is not torn or damaged in the removal process. This photo compares the results of using a kneaded eraser, masking tape, invisible tape and removable adhesive putty when lifting color. An electric eraser is also excellent for removing small and very specific areas of color.

Stylus

A stylus, or embossing tool, is usually available in the stationery section of your art or craft center. A stylus is ideal for embossing a signature or impressing elements in the portrait, such as whiskers or delicate highlights. By pressing hard into the paper with the stylus, you can create an indentation that will remain white when color is applied. Work carefully around impressed lines, making sure your pencil skips over the indentation as you apply color.

A Few of My Favorite Things...

The following items are ones that I use often and suggest that you gradually add to your collection of materials. These items may be difficult to locate, not in your budget or may not be necessary for your style of work—I will leave the decision up to you. Just keep in mind that they may enhance your end result or just make working a little easier.

Workable Fixative

Workable fixative is often used as a finishing touch on colored pencil artwork. It provides protection from smudging and dirt and is water-resistant. Workable fixative also allows you to return later and make changes even after you have sprayed it. I like the finish it gives to a picture and it also prevents *wax bloom* (see tip below) from appearing, so I use it often.

Workable fixative can change some colors, so I recommend that you test it before using if you are concerned about its effect. It is a very fine spray and should only be used in a well-ventilated room.

Tracing Paper

This paper comes in handy for tracing a line drawing. It can also be used as a slip-sheet to place between you and the original so that when you rest your hand on the picture you do not smudge color from one area to another. (If you project your artwork for tracing [see page 22] or draw freehand, then you may not need tracing paper.)

Super Glues

Super glues are available under several different product names and can be used for gluing pencil stubs to new pencils, creating an instant pencil extender. If you are frugal, patient and have nimble fingers, you can make use of all those little pencil stubs that would normally be throwaways.

To ensure a lasting bond, hold the stub and the new pencil end-to-end for about twenty seconds. Be sure both surfaces are clean and dry. Use caution when bonding pencils; avoid getting the glue on your fingers or your artwork. Don't repeat my mistake and drop some onto your picture. Luckily, I was able to work around the spot, but it was almost a disaster. Super glues are permanent, so use them carefully!

Graphite Transfer Paper

If you have a lightbox (see page 22) or prefer to trace your line drawing at a sliding glass door or a window (see page 23), then you will not need graphite transfer paper. This paper comes in handy for tracing your image if other options are not available. However, it is more messy and less accurate than the illumination method.

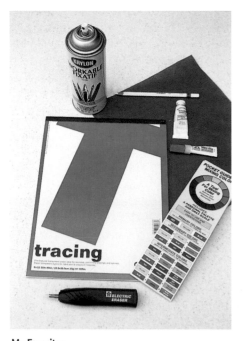

My Favorites
Begin experimenting with different materials and you will quickly have your own set of favorites to assist you with your colorful pet portraits.

A Good Impression
See how nicely an impressed line shows up when surrounded by color. Plan ahead and decide where to place the impressed line before you begin applying color. I always impress my signature and whiskers as soon as I have finished tracing my line drawing onto the paper.

When working with wax-based pencils, you may see a foggy glaze on your work, especially if you have been applying a lot of dark color. This is called *wax bloom* and can easily be dealt with by gently wiping the area with your fingertip or a tissue. Applying several gentle layers of workable fixative will also eliminate wax bloom.

Color Wheel or Color-Mixing Guide

I keep both of these tools at my drawing table at all times. I frequently refer to them for color combination ideas and to see which colors complement each other. With colored pencils, you are layering semitransparent pigment, so colors change when placed one over another. Use the color wheel to inspire you to try some interesting and unusual combinations. You may discover some surprising results. You can find color wheels at art and craft stores, online art retailers or at any good art supply store. You can see a color wheel at my workstation shown on page 16.

A few more of my favorite things are shown below, it won't be long until you have your own favorites.

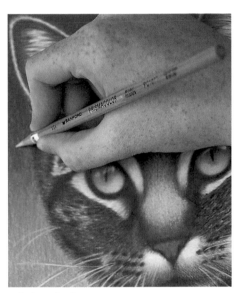

Colorless Blenders
A nice addition to your colored pencil set is a wax-based blender, which can be used to smooth out areas of color or to join edges where needed. It has no pigment and may help save some layering time by mixing colors together, creating a more blended look.

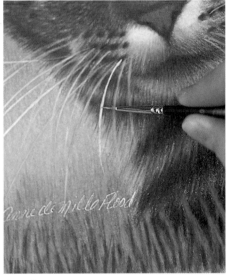

Gouache
Permanent white gouache is helpful for adding detail after you have completed a picture. Occasionally there is a need to enhance some details, such as whiskers or the fine hairs inside the ear. Perhaps you forgot to impress some lines, or you just feel that some features need special effects. Gouache can be liquefied and painted onto the surface of the picture with a fine paintbrush. Once it dries, it is permanent and adds dimension to your piece.

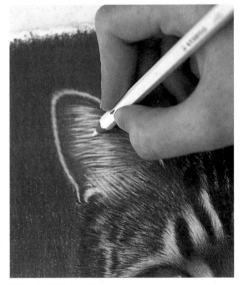

White Stabilo Pencil
This pencil is even more waxy than the White Prismacolor. I often use it for adding details to my work. It works wonderfully for adding whiskers or wisps of fur here and there.

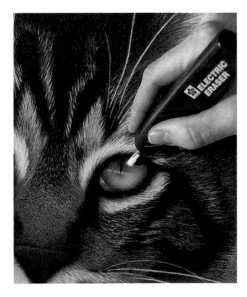

Electric Eraser
If you can splurge and purchase an electric eraser, I highly recommend it. This is one of those tools that quickly becomes a favorite once you learn how to use it. They range widely in price, so choose one that suits your budget. The brand I own fits nicely into my hand and has plenty of power. They are great for removing just a bit of color—such as the highlight in an eye—or for creating an edge. As a caution, an electric eraser kicks up quite a lot of debris and is not suitable for removing large areas—use it sparingly.

Getting It All

On Paper

Once you have your studio setup and a good reference photo, there are a few more steps before we get to add color.

Enlarge Your Reference Photo
You cannot draw what you cannot see. Trying to define the detail in eyes and fur from a 3" × 5" (8cm × 13cm) photo is extremely difficult and therefore I do not recommend it. Once I have decided on a photo that pleases me, I make an enlargement. There are several methods for enlarging pictures, such as color copy blow-ups, photo enlargements or digital prints. Whether you are working with color copies, film or digital images—make sure that the enlargement is clear and color correct. I prefer an 11" × 14" (28cm × 36cm) size, but an 8" × 10" (20cm × 25cm) might suffice.

Start With a Line Drawing
Once you have enlarged your reference photo, it is time to make a line drawing. This can be done in several ways.

If you are comfortable drawing your picture freehand, I recommend that you do so on a piece of scratch paper. Erasing and redrawing lines can cause blemishes on your good paper. Work out ideas first, then create a line drawing that can be transferred to your untouched drawing paper.

If you are not good at freehand drawing, then producing a traced line drawing from the photo is another option. Lay a piece of tracing paper over your reference photo and trace the major lines, including as many details as possible, this will give you a road map to follow.

Tip — You can enlarge your line drawing on any business-copying center's photocopy machines. Most of these businesses have machines that will enlarge black-and-white drawings as large as you like.

If you need to create an oversized line drawing of your chosen photo, you can use a slide projector or photo enlarger. By adjusting the distance of the projector from the wall, you can greatly enlarge the picture and easily trace it to the size you would like.

Transferring Your Line Drawing
In order for your finished piece to be accurate and realistic, it is important that you take care when transferring your line drawing to the drawing paper. Shown below and on the following page, are several methods that will help you accomplish this.

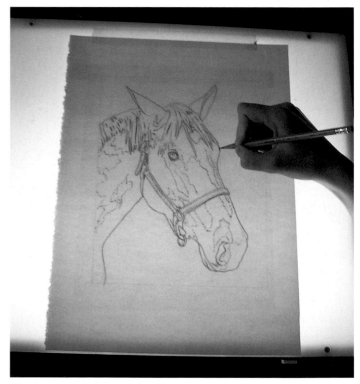

Illuminate Your Line Drawing for Accuracy
A lightbox is a simple but invaluable tool for transferring your image to good paper. When using a lightbox, tape the line drawing to the light box surface, then tape your paper on top of the line drawing. Be sure both sheets are secured so they don't shift around when working. Gently trace the line drawing with a graphite pencil, taking care not to create impressed lines.

Tip

When tracing your line drawing with graphite transfer paper, you will find it helpful to use a colored pen or pencil to trace the drawing. A red pencil will show where the lines have already been traced, preventing missed lines. Always lift your paper up as you work to check and see how your line drawing is progressing. If lines are too light, you will lose them as you apply color. If they are too dark, they will show through the lighter areas of your piece. Try to get them just right!

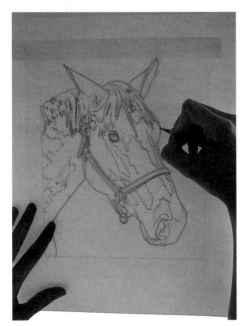

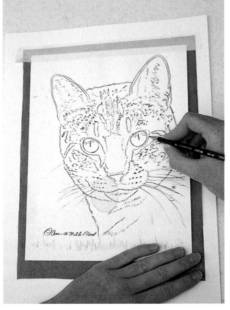

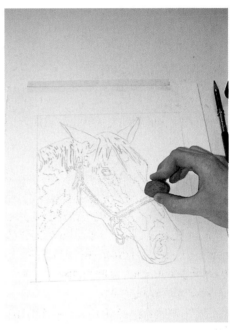

Let There Be Light!

While I prefer the lightbox method of transferring a line drawing, a sliding glass door or a window is a good alternate. However, it is much more difficult to trace while standing up, so be sure both the line drawing and paper are securely fastened to prevent slippage while working. One advantage of using a sliding glass door is that it can accommodate an oversized picture that would not fit on a standard-sized lightbox.

Graphite Transfer Method

Another method of transferring a line drawing is with graphite transfer paper. This paper can be purchased at most art supply and craft stores and has a backing of dark graphite. Place it between the line drawing and the paper with the graphite facing the drawing paper. When the line drawing is traced with a pencil, it transfers onto the drawing paper. This method is somewhat messy, and I recommend blotting the paper with a kneaded eraser when finished. You can create your own graphite backing by applying a heavy layer of graphite pencil to the back of the line drawing, then tracing directly onto your paper.

Begin With a Clean Surface

A clean surface is ideal for working, and graphite lines can smear into the areas that should remain white. Therefore, before you begin applying color, use your kneaded eraser to blot your line drawing and clean up graphite debris. Be careful that you do not lift too much and lose your line drawing!

Mustafa
14" × 11" (36cm × 28cm) • Collection of Gulten Argamak

Basic Fur and Feather
Techniques

Depicting fur and feathers may seem overwhelming at first glance, but what I always say is, "It's just a pattern—so relax." Simply look for shapes within the fur or feathers so you can break them down into patterns of lights and darks. I describe this as *random pattern*—it may not be predictable, but the pattern always repeats itself in some way. I happen to love repetitious design, so I don't mind the exercise of figuring out the pattern. Just approach this in a logical manner—using my techniques—and you won't have any problems.

In this chapter we will discuss some tips to help you effectively render fur and feathers. Once you have mastered the basics, you will sail through those once-complicated feathers and tiresome fur portions of your portrait. Remember, part of being an artist is learning to see complex features in a more simplistic way.

Stroke and Value
Patterns of Fur

As demonstrated in chapter one, there are many different strokes that you can use. And all of those strokes can be used to create the three-dimensional effect of fur.

Stroke Pattern

Whether fur is dappled or solid, it is important to apply each layer with a stroke pattern that characterizes and reflects both the type of fur and the direction it is traveling. If every stroke is applied in a too-precise or repetitious manner, the fur will appear phony and artificial. The fur must move and change with the shape of the animal in order to make the viewer see the pattern without it appearing fake or unnatural.

It's helpful to carefully observe your reference photo and check it often to ensure that your pencil is moving in the same direction as the fur shown in the photo.

Value Pattern

Another important aspect of creating fur is establishing an accurate value pattern. A value pattern can best be described as the darkness and lightness of areas and how they compare with each other. For example, in order to give an object shape and form, a shadow area must be dark enough to contrast with a light area. Shadows and highlights joined by midtone areas form a three-dimensional appearance. If your value pattern of darks and lights is not correct, your image will look flat and lifeless.

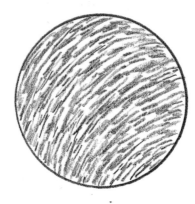

Think Scribble, Not Repetition

See how the pattern in the two samples above differs. When creating a fur pattern, avoid applying strokes in a precise, repetitious manner as in the sample above. Let your hand relax and move loosely to prevent the pattern from becoming too meticulous.

Remember how you scribbled with your crayons as a kid? Try it with your colored pencils—it's fun!

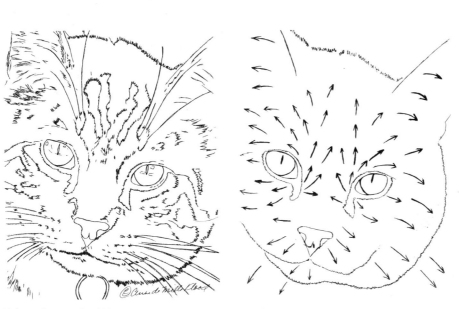

Make an Accurate Road Map

Your line drawing should be considered a road map to guide you as you work, including correct outlines of all the important markings on the animal. Another trick to help you create believable fur is to trace a simple map of the fur direction using arrows to show the pattern. Keep this map next to your drawing while you work to remind you which way the fur has turned in a certain area. (I used this road map to help me complete the finished drawing of Mustafa on the next page.)

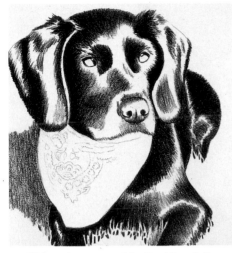

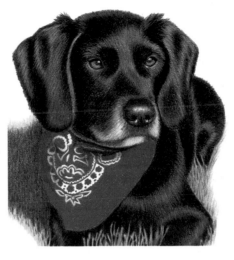

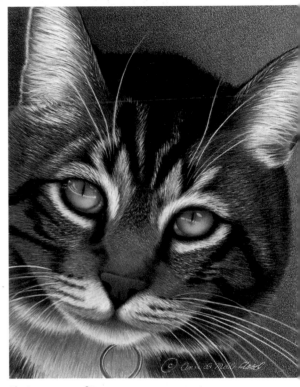

Establish a Value Pattern With a Tonal Foundation

A tonal foundation, or *grisaille*, is an excellent method of figuring out your value pattern before you begin applying color. In this illustration, the first step of creating this Black Lab (above left) was to establish the value pattern with one color, in this case Black. Once all the darks and lights were figured out, the midtones were applied. The final step (above right) was to finish up the piece with some burnishing to enhance the shine. (Another example of establishing the value pattern using a tonal foundation is the feather demonstration beginning on page 37.)

Spinner
10" × 8" (25cm × 20cm)
Collection of Anne and Geoff Stearns

Tip

I often create a black-and-white copy of my reference photo that can serve as a gray scale to help me see only the darks and lights and not be distracted by color. It is not a perfect solution to figuring out my value pattern, but is an added tool to check my values before I begin applying color. It is also invaluable in helping me establish my tonal foundation.

The Importance of Pattern

Clearly, the intricacy and direction of this tabby fur pattern is instrumental in giving shape and form to the subject. The head of this cat would not appear rounded if the fur radiated outward like the spokes of a wheel. Observe how the fur begins around the eyes, nose and mouth and spreads out in a swirling manner away from these features.

Mustafa
14" × 11" (36cm × 28cm)
Collection of Gulten Argamak

A Simple Tool, Great Results

Check your values with a simple tool called a value viewer. Cut two 2" × 3" (5cm × 8cm) rectangles from a piece of pure white card stock and punch a hole in the middle of each. Place one on an area in your reference photo and the other on the same spot on your artwork, then compare the two. You will immediately be able to see if your darks are deep enough and if you have proper light values. It is also valuable for checking an area of color. By isolating the color with the value viewer, you can easily see how much more of a certain color you may need to add.

Tip

If you are having trouble seeing the pattern or direction of the fur, use L brackets to isolate a small section of your reference photo as you work. This will enable you to accurately distinguish what is happening in a small area (see page 17).

Long Fur

An Irish Setter was the model for this colorful fur. The long, flowing shapes were achieved by utilizing a linear stroke and building up a value pattern that clearly shows the hills and valleys of the strands. Midtones were added and blended into the dark and light shapes creating a smooth, curving effect. The highlights were burnished, giving the overall appearance of shiny and elegant fur. A few hairs were impressed along the edges to add to the wispy effect of the long fur.

MATERIALS

General Materials
Graphite pencil • Kneaded eraser
One piece Rising Stonehenge paper

Prismacolor Pencils
Mineral Orange • Dark Umber • Goldenrod
Terra Cotta • Tuscan Red • Black • White

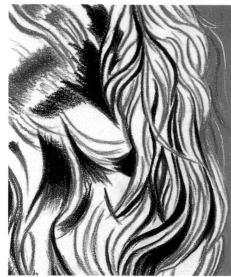

Step 1: Identify the Darks

	Point	Pressure	Stroke
Mineral Orange	S	3	L

Outline the shapes of the strands with Mineral Orange.

	Point	Pressure	Stroke
Dark Umber	S	4	L

Create the darkest shapes using Dark Umber.

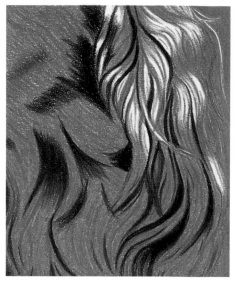

Step 2: Build Midtones

	Point	Pressure	Stroke
Goldenrod	S	3-4	L

Begin establishing the midtone areas with Goldenrod, leaving some areas free of color for highlights.

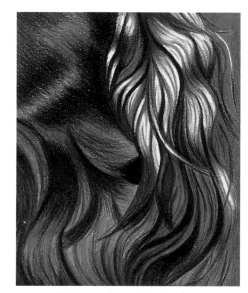

Step 3: Reinforce Darks, Build Midtones

	Point	Pressure	Stroke
Terra Cotta	S	4	L

Continue building the midtone areas using Terra Cotta.

	Point	Pressure	Stroke
Tuscan Red	S	4	L

Reinforce the darks with Tuscan Red.

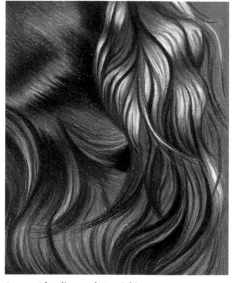

Step 4: Blending and Burnishing

	Point	Pressure	Stroke
Dark Umber	S	4	L

Blend another layer of Dark Umber into the dark areas and create details in the strands.

	Point	Pressure	Stroke
Black	S	4	L

Reinforce some of the deepest areas with Black.

	Point	Pressure	Stroke
White	S	4	B

Finish off by burnishing with White to create shine and to blend the highlights into the midtone areas.

Point		Pressure		Stroke			
D–Dull	**SD**–Semi-dull	1–Very Light	2–Light	**V**–Vertical Line	**C**–Circular	**X**–Crosshatch	**B**–Burnish
S–Sharp	**VS**–Very Sharp	3–Medium	4–Full Value	**ST**–Stipple	**L**–Linear	**LS**–Loose Scribble	

mini-demo

Short Fur

Short fur is characterized by short, distinct strokes that clearly demonstrate the movement of the fur as it curves around the body. A good foundation of accurately applied strokes will help guide you as you build color. Observe the direction that the fur is moving as it progresses and adjust your stroke to reflect this. The form and shape of your animal is largely dependent on how correctly you portray this type of fur. The colors chosen for this mini-demo are intended to depict fur of a light-brown animal.

MATERIALS

General Materials

Graphite pencil • Kneaded eraser
One piece Rising Stonehenge paper

Prismacolor Pencils

Light Umber • French Grey 10% • Cream
Beige • Dark Brown • Jasmine
Mineral Orange • Goldenrod • Sepia

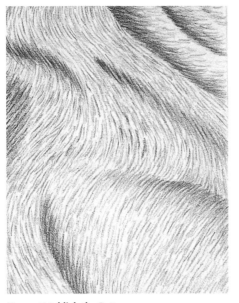

Step 1: Establish the Pattern

	Point	Pressure	Stroke
Light Umber	S	3	LS

Begin by establishing an accurate pattern that reflects both the direction and style of the fur.

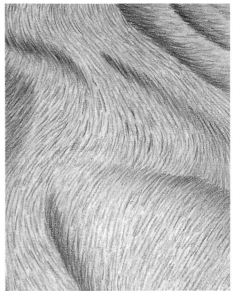

Step 2: Build Color

French Grey 10%, Cream	S	3	LS

Wash the entire area with Cream and French Grey 10%. These two colors are lighter values than the Light Umber base but are intended to begin building the color. Be sure your stroke continues to follow the pattern you have established.

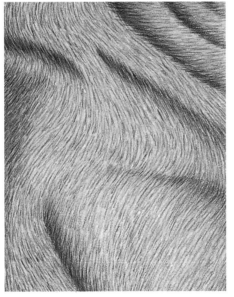

Step 3: Darken the Pattern

Beige	S	3	LS

Apply another wash of Beige.

Dark Brown	S	3-4	LS

Continue to darken the pattern of the fur with Dark Brown. Apply the pattern more densely where the fur folds.

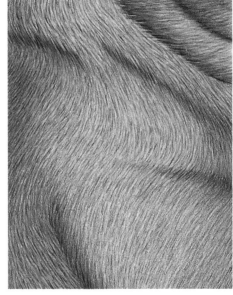

Step 4: Layering and Contouring

Jasmine, Goldenrod, Mineral Orange	S	3-4	LS

Apply more layers of color, increasing pressure and density of stroke where the contours lay.

Sepia	S	3-4	LS

Use Sepia to reinforce and darken the pattern where necessary.

Shiny Fur

Shine can be created by layering and burnishing. In both cases a buildup of color and a correct value pattern add to the lustrous effect. Contrast between light and dark areas is what makes something appear shiny. Shine can occur on both long and short fur and stands out the most dramatically when the surrounding colors are deep and strong. An area of paper left free of color creates the effect of shine, burnishing can add to the glossy effect. Both methods are employed in this demo.

MATERIALS

General Materials
Graphite pencil • Kneaded eraser
One piece Rising Stonehenge paper

Prismacolor Pencils
Cream • Jasmine • Goldenrod • Burnt Ochre
Pumpkin Orange • Tuscan Red • Dark Umber
Deco Blue • White

Avoid blunt or abrupt edges where the fur joins the highlight. Fur has a random pattern, so the edges of highlight areas within the fur are jagged.

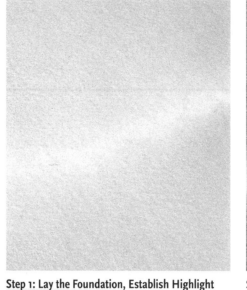

Step 1: Lay the Foundation, Establish Highlight

	Point	Pressure	Stroke
Cream, Jasmine	S	3	LS

Wash the entire area with both Cream and Jasmine. Apply the Jasmine on top of the Cream and leave the highlight free of color. Pull back slightly with the Jasmine so an edge of Cream borders the highlight.

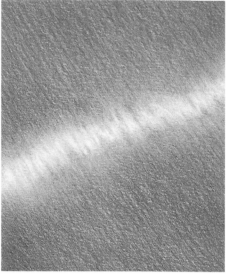

Step 2: Layer to Build Value Pattern

	Point	Pressure	Stroke
Goldenrod, Burnt Ochre	S	3-4	LS

Goldenrod and Burnt Ochre are the darker value colors. Adjust your pressure along the edges where the colors border the highlight. Press harder to gradually darken the fur as it moves away from the shiny area.

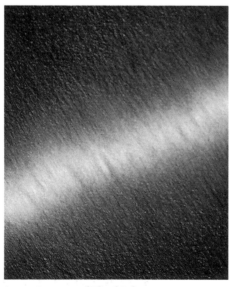

Step 3: Deepen and Blend Colors

	Point	Pressure	Stroke
Pumpkin Orange, Tuscan Red, Dark Umber	S	3-4	LS

Add darker value colors again and blend them together to create a rich, dark mixture. This causes the highlight to stand out and become more dramatic. Run small strands of the darker colors through the highlight, making it appear more fur-like.

Step 4: Burnish and Add Accents

	Point	Pressure	Stroke
Deco Blue, White	S	4	B

Burnish Deco Blue and White back-and-forth across the highlight, toning down the shine and adding some accents that suggest reflected colors. This step can be omitted if you are pleased with the effect you have produced through layering.

Point		Pressure		Stroke			
D–Dull	**SD**–Semi-dull	**1**–Very Light	**2**–Light	**V**–Vertical Line	**C**–Circular	**X**–Crosshatch	**B**–Burnish
S–Sharp	**VS**–Very Sharp	**3**–Medium	**4**–Full Value	**ST**–Stipple	**L**–Linear	**LS**–Loose Scribble	

Curly Fur

Curls are all about seeing shapes, which you can easily figure out and interpret. I like to think of curls as simply a value pattern, which when accurately built up will evolve into the forms that tell the viewer the fur is curly. Laying tracing paper over the reference photo and tracing the basic shapes of the darks will help you see these shapes. Once the darks are established and the value pattern is established, you can proceed to blend the midtones and the curls will emerge.

MATERIALS

General Materials
Graphite pencil • Kneaded eraser
One piece Rising Stonehenge paper

Prismacolor Pencils
Black • Greyed Lavender • Indigo Blue
Black Grape • White • Pink

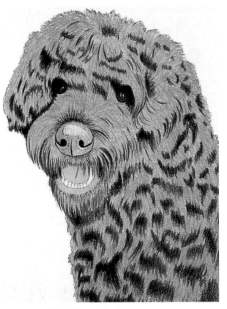

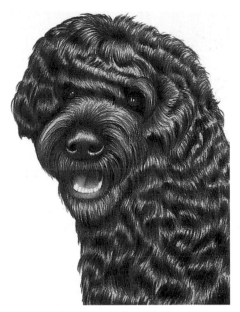

Step 1: Establish the Dark Shapes

	Point	Pressure	Stroke
Black	S	4	L

Establish the basic shapes of the darkest parts of the curls with Black.

Greyed Lavender	S	3	LS

Wash the rest of the figure with a basecoat of Greyed Lavender.

Step 2: Build and Expand the Dark Shapes

Indigo Blue, *Black Grape*	S	4	L

Add color to the dark areas and expand them to form the shape of the curl.

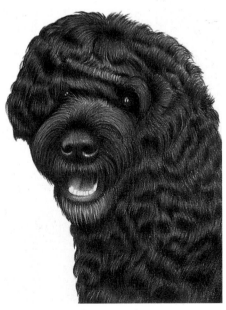

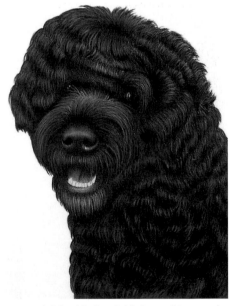

Step 3: Blend the Shapes Together

Indigo Blue	S	4	L

Join the darks with Indigo Blue.

Step 4: Finish With the Highlights and Deepen the Darks

Black	S	4	L

Use Black to darken the valleys of the curls one more time.

White	S	4	B

Burnish the peaks of the curls with White.

Pink	S	4	B

Add touches of reflections on the curls.

Fur is as varied as any facet of nature, and there are many color combinations that can be utilized to achieve a realistic effect. Since there are over 120 colors of Prismacolor pencils to choose from, the question is always—where to start?

My philosophy regarding fur is—the more color the better! I love to mix and blend unusual combinations and often end up using many colors to achieve the density I like. This can be time consuming and may seem tedious, but in my opinion, this method is exactly what makes fur look interesting. Fur also reflects colors in the environment and can be made much more exciting by adding tidbits of color that give an area emphasis.

Generally, I start with the lightest color and gradually work darker. That way, I can always adjust and correct if I feel my color is not developing the way I would like. Remember that the colors are translucent, so you can always add more yellow, orange, brown, or any other color to alter the hue of the fur. An exception to this rule occurs when I am working with very dark fur color. In that case I go straight to the dark value colors such as Indigo Blue, Dark Umber, Tuscan Red, Dark Purple and Dark Green, plus I mix several colors together full value. In any case, I suggest you never use fewer than three colors for any fur combination, as I think this is the minimum needed to give it the complexity it requires.

Following are a few of the combinations I have discovered, I hope they will excite and inspire you. Use these suggestions as recipes for expanding your range of choices, or make them the springboard for your own creative use of color.

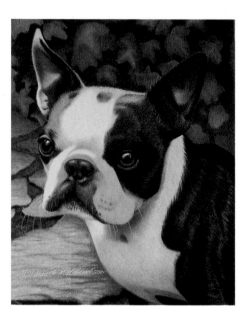

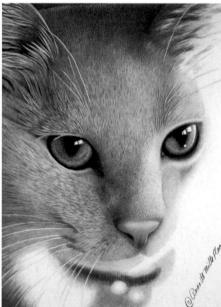

Brindle Fur

Brindle is a mottled and variegated fur pattern common to many breeds. Light colors peek through patches of dark colors, giving the fur an almost painterly appearance.

Brindle fur is similar to calico but much more blended. When building brindle, I burnish often as I work, mixing the colors thoroughly but allowing some of the lighter color to show through here and there. The basecoat for this Boston Terrier was Beige followed by Peach, Yellow Ochre, Mineral Orange, Burnt Ochre, Terra Cotta, Sepia and Black.

Calvin

14" × 11" (36cm × 28cm)

Collection of Linda Lowe and Pam Moorman

White Fur Can Be Colorful

I worked from a black-and-white photo to create this unusual picture. The shot was overexposed, producing dramatic highlights and washing out all detail on one side of the cat. This gave me the opportunity to develop the shadow areas and exercise my creativity.

French Grey 10% served as the basecoat, then I layered combinations of Jasmine, Greyed Lavender, Slate Grey and Imperial Violet. I added detail with Light Umber and reinforced the shadow areas with Indigo Blue. I adjusted my pressure to darken areas that curved away from the viewer or that were in shadow.

Kimba

14" × 11" (36cm × 28cm)

Collection of Donna Tersiisky

Gray Fur

Like many other fur colors, what you see is not always what it seems. Just using gray pencils without any supporting colors looks dull and lacks depth. Therefore, I mixed some warm and cool colors to create a gray that I feel has some dimension.

Shadow's fur was created with a basecoat of Clay Rose. Warm Grey 50% and 90% were used to create the pattern in the fur and establish the darkest areas. Next, Slate Grey was layered and then burnished with Cool Grey 10% and 20%. Black was used to reinforce the dark areas under the chin and around the eyes. White was burnished all around, softening the edges and giving the cat a halo effect.

Shadow
11" × 14" (28cm × 36cm)
Collection of James and Delores deMille

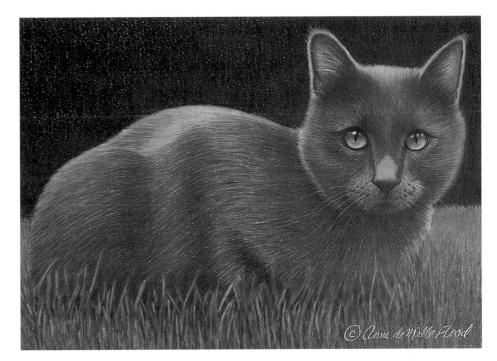

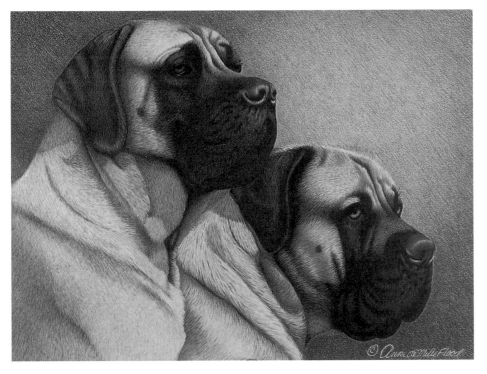

Apricot and Fawn Fur

The two English Mastiffs in this portrait look so dignified and attentive that they might have just come from obedience school. They are both light-colored animals; however, their color differs in that Bonnie, on the left, is considered an apricot color and Clyde, on the right, is fawn.

I created the apricot fur with a basecoat of Cream, followed by Jasmine and Light Umber to form the pattern. I used Mineral Orange, Terra Cotta, Dark Brown and Dark Umber in the folds and darkest areas of the fur.

Beige was the basecoat for the fawn color, then I layered French Grey 10% and Light Umber with a loose scribble stroke to create the pattern. I added Goldenrod, Sienna Brown and Dark Brown to the folds and shadows, as well as some Black for the darkest shapes. See how important the stroke direction is when creating those gently rolling folds around the neck.

Bonnie and Clyde
11" × 14" (28cm × 36cm)
Collection of Eugene and Beverly Fries

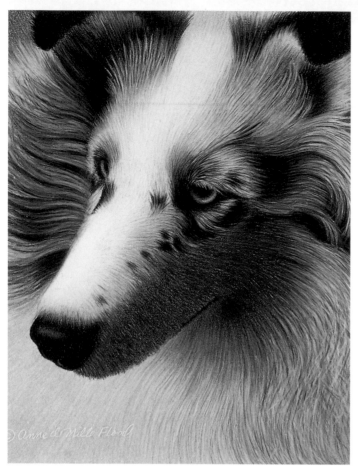

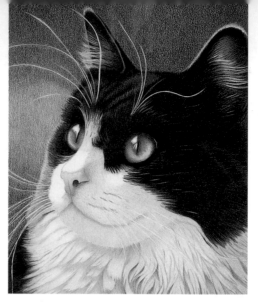

Long, Black Fur

This lovely cat was inspiring to work on because of the innocent and inquiring look in her golden eyes. The black fur was created with a basecoat of Dark Purple, followed by full-value layers of Black Grape and Indigo Blue. The colors combined, and when some Black and Slate Grey accents were added, the overall effect is rich, black fur with some reflected colors.

Gabby
14" × 11" (36cm × 28cm)
Collection of Darrell and Evonne Benedict

Blue Merle Fur

Merle fur is interesting because dark areas merge into lighter areas, intermingling to create a new color.

In this sample, I first created the base of the dark patches with Black Grape and applied French Grey 10% as the base for the rest of the fur. As I built the dark areas with Indigo Blue and some Black, the light areas were simultaneously layered with Slate Grey, French Grey 30% and burnished together with White. All the colors mixed together and the darks and lights then blended to create the merle effect.

Shelty
10" × 8" (25cm × 20cm)
Collection of the Artist

Spotted Fur

The dark spots that characterize this Appaloosa can also be typical of other animals, such as Dalmatians and certain breeds of big cats. The important thing to remember when creating spots in fur is to build the spots as you layer the other colors so they do not look pasted on.

The spots on this horse were first lightly established with Black, then layered with Warm Grey 90% and Indigo Blue. A final coat of Black was applied to the spots after all surrounding fur was completed and jagged points were pushed into the lighter colors to create an uneven edge. I created the surrounding lighter fur with a basecoat of Warm Grey 10% followed by Pink Rose, Celadon Green and Slate Grey. The fur in shadow is Indigo Blue and Black.

Freckles
10" × 8" (25cm × 20cm)
Collection of the Artist

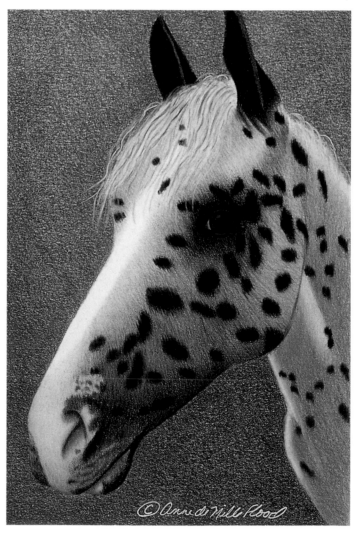

Stroke and Value
Patterns of Feathers

Like fur, feathers create a pattern that appears challenging to render. As with fur, you simply have to figure out how to portray the pattern in a believable and realistic manner.

The feather pattern follows the contour of the bird, and accuracy is essential for forming a three-dimensional look. Take care when creating a line drawing; be sure that the feathers are correctly depicting the shape of the bird. Adding color, shadows and highlights will also help illuminate these shapes and bring the bird to life.

Establish the Value Pattern

My favorite method for determining the feather pattern is to first create what is called a tonal foundation. Value pattern is just as important for feathers as it is for fur, so a tonal foundation is the key to creating an accurate value pattern.

Remember, value is the relative lightness or darkness of a color, and a value pattern is the light or dark areas of the artwork. Contrasting areas give shape and form to your subject. With this method you will map out the dark and light areas before you apply color. You will apply the foundation using pressure, varying from full value to light.

The extra time taken in the beginning to accurately establish this is easily saved later. By having the value pattern completely figured out ahead of time, you will do less layering of color, saving time on the final steps.

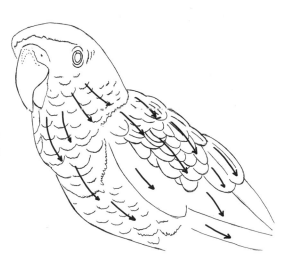

Your Line Drawing Is a Road Map
Create an accurate line drawing. Use arrows as a reminder of the way in which the feathers lay—this will also help you see shapes. This is very important so you remember to make your stroke follow the direction of the feathers when layering color.

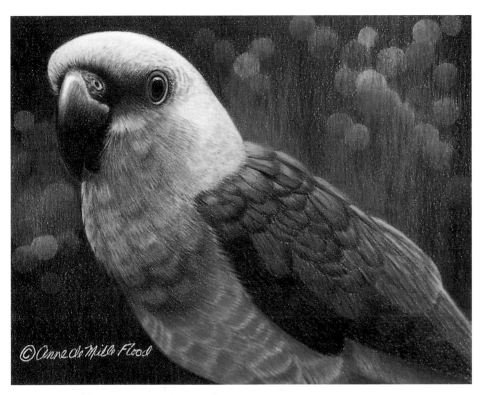

©Anne deMille Flood

Road Map Contributes to the End Result
Feathers wrap around the body of this African Red Bellie and are crucial for giving shape and form to the bird. See how a line drawing can contribute to the end result when you accurately map out the directions and follow the markings as you apply color.

Louie
8" × 10" (20cm × 25cm)
Collection of Laura Shane

Tip

For clarity, look to a gray scale. I often make a black-and-white copy of my reference photo that can serve as a gray scale. This enables me to only see the darks and lights and not be distracted by color. It helps me check values before applying color. Try it!

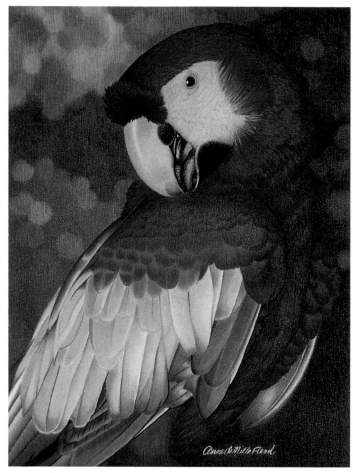

Tip

If the complexity of the feather pattern is confusing, try turning both your reference photo and your artwork upside down and work on them in reverse. This takes away the tendency that we all have to try and draw what we think we see. Sometimes it's necessary to stop thinking so much and just draw what is there.

Don't think feathers—just think shapes!

What Color Makes a Good Tonal Foundation?

I often choose a complementary color for my tonal foundation. For example, I chose Dark Green for the foundation for the red feathers of this Scarlet Macaw. A safe color to choose, if you are unsure, is French Grey 70%. It is neutral and seems to react well no matter what color is layered over it.

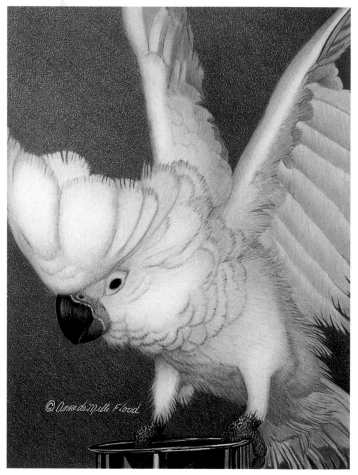

Tip

The best recommendation that I have for saving time is to simply not draw every single feather, just suggest them! If you show some feathers that are complete, the viewer will see the rest of them, even if you don't have each feather just perfect.

Just Wing It

This Umbrella Cockatoo is showing off his impressive wing feathers. Each one looks as though done to completion, but many of the feathers in this portrait are merely suggested. On the chest and crest, just the edges of the feathers are represented with some French Grey 30%, Deco Blue, Greyed Lavender and Deco Aqua.

Feather Pattern on Wings

I just love how the feathers on this macaw wing are slightly ruffled, giving me some great shadows to work with. This is a very detailed feather demo, but it is a great look at how important accuracy is if you are trying to achieve an extremely realistic result. It also shows why it is helpful to figure out the value pattern before you begin to apply color, saving yourself time and confusion later.

MATERIALS

General Materials

Graphite pencil • Kneaded eraser

One piece Rising Stonehenge paper

Colorless blender

White Stabilo pencil

Prismacolor Pencils

Black Grape • Chartreuse • Deco Blue • True Blue

Blush Pink • Tuscan Red • Indigo Blue

Dark Green • Olive Green • Black

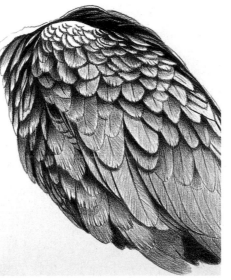

Step 1: Establish a Tonal Foundation

	Point	Pressure	Stroke
Black Grape	S	2-4	L

For this first step, accuracy is critical. Use pressure from full value to light to create the foundation, checking often to make sure your darks are deep enough.

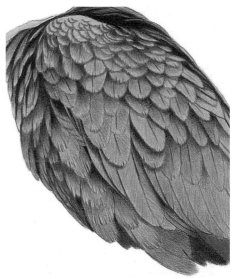

Step 2: Begin Applying Color

Now that the tonal foundation is established you can begin applying the field colors for the feathers.

	Point	Pressure	Stroke
Chartreuse	S	3	L

Apply Chartreuse for the green feathers.

	Point	Pressure	Stroke
Deco Blue	S	3	L

Use Deco Blue for the light-blue feathers.

	Point	Pressure	Stroke
True Blue	S	3	L

Use True Blue for the bright-blue tail feathers.

	Point	Pressure	Stroke
Blush Pink	S	3	L

Layer a few delicate feathers with Blush Pink.

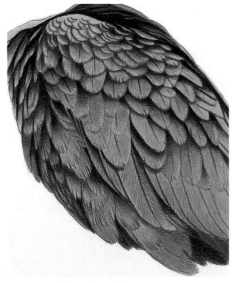

Step 3: Reinforce the Darks

	Point	Pressure	Stroke
Tuscan Red	S	4	L

Use Tuscan Red to darken those shapes that were established by the tonal foundation.

	Point	Pressure	Stroke
Indigo Blue	S	4	L

Add some details to the feathers with Indigo Blue and darken the shadows on the blue feathers.

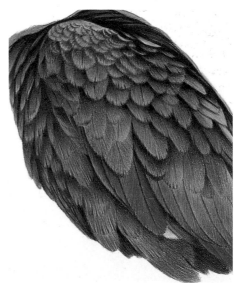

Step 4: Bring the Feathers to Life

	Point	Pressure	Stroke
Dark Green	S	4	L

Deepen the shadows between the feathers.

	Point	Pressure	Stroke
Olive Green, True Blue	S	3	L

Deepen the green and blue feathers.

	Point	Pressure	Stroke
Black	S	4	L

Intensify the darkest crevices with Black.

Point		Pressure		Stroke				
D–Dull	**SD**–Semi-dull	**1**–Very Light	**2**–Light	**V**–Vertical Line	**C**–Circular	**X**–Crosshatch	**B**–Burnish	
S–Sharp	**VS**–Very Sharp	**3**–Medium	**4**–Full Value	**ST**–Stipple	**L**–Linear	**LS**–Loose Scribble		

Shortcuts to Realistic Feathers

The best shortcut I know of when it comes to feathers is to just not be so darn precise. You can actually still achieve credible realism as long as you first establish a pattern that is believable, then apply layers of color and stroke patterns, that suggest feathers. In other words, let the layering process shape the feathers without painstakingly rendering each one. This mini-demo shows that you can skip the detailing in certain areas and shorten your work time considerably.

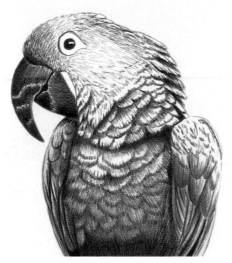

Step 1: Establish the Tonal Foundation

	Point	Pressure	Stroke
Indigo Blue	S	3-4	L & LS

Use Indigo Blue to create the pattern of the feathers without drawing every single one. Use a loose scribble stroke to suggest feather edges.

MATERIALS

General Materials
Graphite pencil • Kneaded eraser
One piece Rising Stonehenge paper

Prismacolor Pencils
Indigo Blue • Greyed Lavender
Violet • Ultramarine • Black
True Blue • Peacock Blue • White

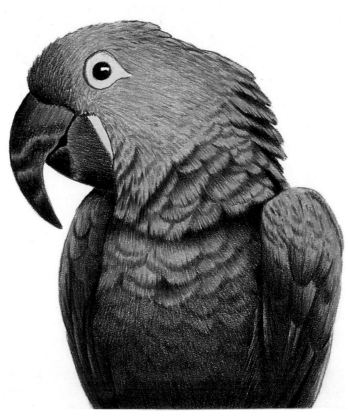

Step 2: Apply the Color Basecoat

Greyed Lavender	D	3	LS

Use Greyed Lavender to wash the lightest areas of the bird.

Violet	D	3	LS

Wash the shadow areas on the chest and wings with Violet. Remember, each layer is helping to develop the feathers.

Point		Pressure		Stroke			
D–Dull	**SD**–Semi-dull	**1**–Very Light	**2**–Light	**V**–Vertical Line	**C**–Circular	**X**–Crosshatch	**B**–Burnish
S–Sharp	**VS**–Very Sharp	**3**–Medium	**4**–Full Value	**ST**–Stipple	**L**–Linear	**LS**–Loose Scribble	

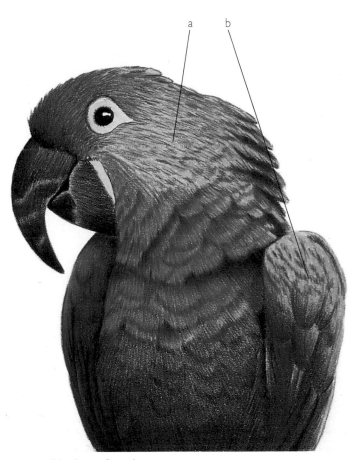

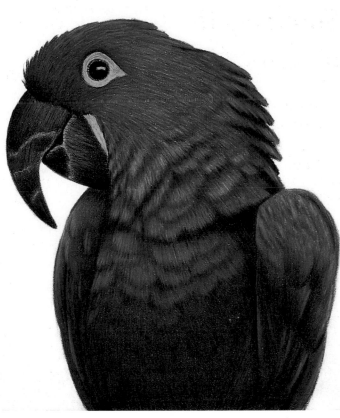

Step 3: Build Color, Define Edges

Use a Semi-dull pencil for this step because the choppy strokes add to the feather effect.

| ***Ultramarine*** | SD | 4 | LS |

First apply Ultramarine to develop feather edges as shown in areas (a) and (b). Use Ultramarine on the shadow areas.

| ***True Blue*** | SD | 4 | LS |

Wash True Blue over the entire body.

| ***Black*** | SD | 4 | L |

Deepen the shadows and add detail only where there are very dark creases. This is not done over the entire bird but only where very deep shadows occur.

Step 4: Mix and Blend

| ***Peacock Blue, Indigo Blue*** | S | 4 | LS |

Blend and mix the feather colors, only where necessary, with Peacock Blue and Indigo Blue.

| ***White*** | S | 4 | B |

Burnish a few highlights onto feathers that are touched by light using White.

| ***Black*** | S | 4 | L |

Deepen the shadows again with Black, and add fine edges to some of the feathers.

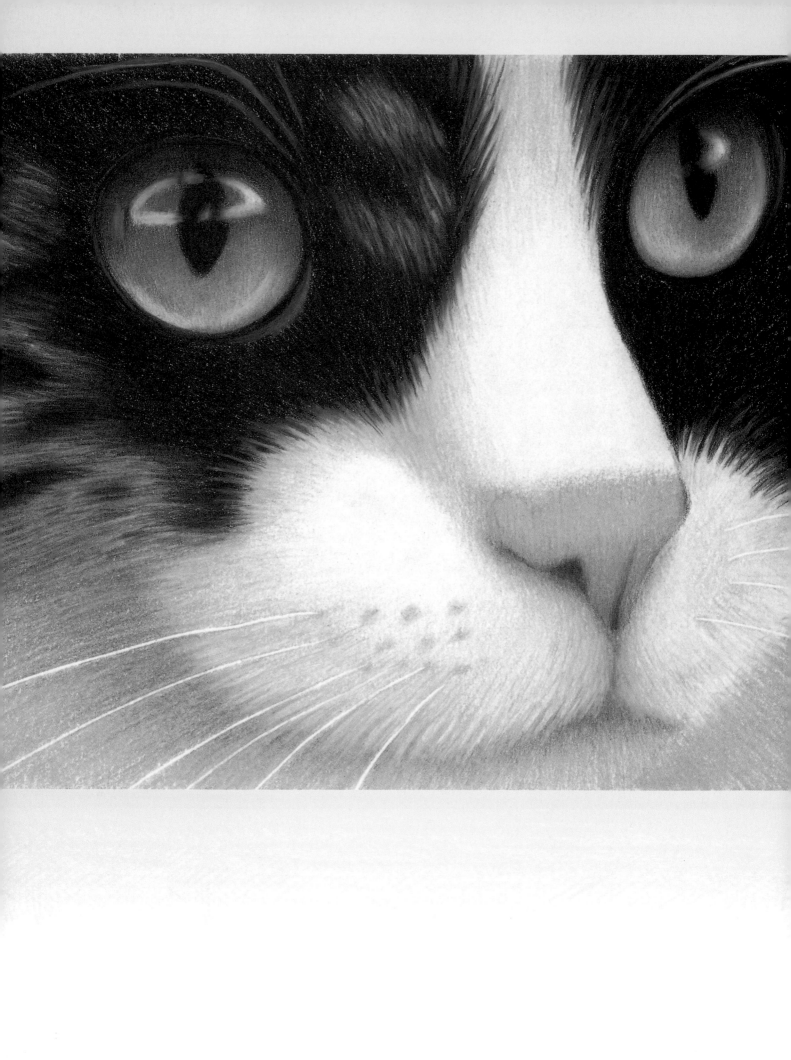

chapter 4

 Truly, eyes are the window to the soul. This applies to humans and animals alike. Eyes are central to any portrait, mainly due to the fact that they are the most revealing feature. Therefore, I take great care and effort to achieve a dramatic and timeless look in the animal subjects' eyes.

In this chapter you will discover how to develop eyes with a delicate mix of layering, stroke and pressure to create a look that will reflect your pet's personality. Educate yourself about the characteristics of the eyes that give them a believable and realistic appearance.

Whether it is the adoring look in the eyes of a dog or the piercingly intelligent gaze of a parrot, it is important to capture the uniqueness of this key feature that will forever be the focal point of your portrait.

Understand the *Anatomy*

Before you begin any portrait it is important to carefully observe the characteristics that make your pet's eyes unique.

Animal eyes have some basic similarities, but there are important differences that you need to be aware of. It is important to closely examine the anatomy of the eye and to understand those features when rendering it.

In this chapter you will learn some of the terms I employ to identify the parts of the eye and to look for the qualities that distinguish each type.

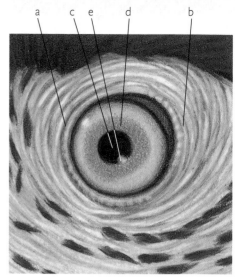

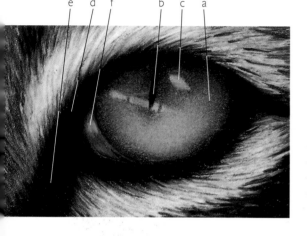

Feline Eye
The cat eye is characterized by the luminous qualities of the iris (a) and the distinctive pupil (b). See how dramatic highlights (c), delicate layering and accurate modeling provide the eye with its spectacular glow. The surrounding skin is often dark and dramatically frames the eye as if the animal is wearing makeup. I refer to this as the eyelid line (d), and it often extends into the tear zone (e). Sometimes an inner eyelid (f) is visible in the corner of the eye.

Avian Eye
The bird eye differs from all the others in that the eyeball is bordered by a feature called the eye ring (a). In some birds there is an area surrounding the eye ring that is free of feathers and is sometimes referred to as the facial patch (b). The pupil (c) is distinct, and the iris (d) can range widely in color from pale yellow to bright reds and blues. Highlights (e) help shape the eye and add shine.

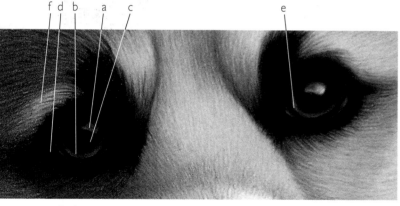

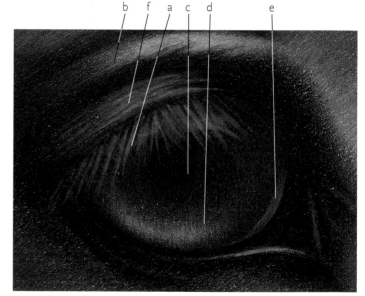

Canine Eye
The canine eye is most notable for the way the pupil (a) blends into the iris (b), often becoming indistinct. Highlights (c) are often one of the significant features because the curve of the eye catches light. The surrounding eyelid is frequently dark and frames the eye dramatically, creating an outline referred to as the eyelid line (d). Sometimes an inner eyelid (e) is visible in the corner of the eye. The orbital bone (f) stands out, catching light and making it a significant feature.

Equine Eye
Horses have very large, protruding eyes that are protected by heavy eye lashes (a) and an orbital bone (b). The eye is often in shadow, appearing as a simple black orb. Sometimes the pupil (c) and iris (d) are both visible, but if not, it is important to render the dramatic reflections and highlights (e) that give the eye shape. The eyelashes (a), eyelids (f) and orbital bone (b) are key elements that surround the eye and when highlighted add dimension to the eye area.

Getting the Glow of a Cat's Eye

This demonstration will teach you the delicate layering process that I use to achieve the jewel-like appearance of the feline eye. You will gradually build up layers of color, starting with three light washes, to establish the foundation of the eye. You will learn how to use pressure and shading to model the shape of the eye while building shadows and adding highlights to enhance the glow. Because this process is so delicate, you must remember to use a needle-sharp pencil point when layering the iris and to brush your paper often to keep dark pencil debris from becoming ground into the translucent layers. You will also learn which colors to use as you build the fur with each step.

This process, though time consuming, is worth the time spent when you complete a picture that captures the mystery and radiance of the feline eye. It is the slow, precise progression of the color buildup that gives you the reflective effect of an eye that just glows.

MATERIALS

General Materials
Graphite pencil • Kneaded eraser
One piece Rising Stonehenge paper

Prismacolor Pencils
Black • Cream
Indigo Blue • Deco Yellow
Tuscan Red • Jasmine
Chartreuse • Goldenrod
Pumpkin Orange • Dark Umber
Peacock Green • Mineral Orange
Apple Green • True Blue • White

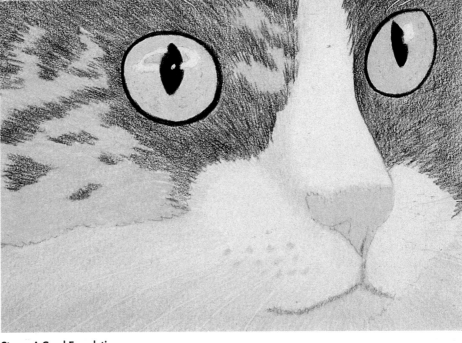

Don't forget to blot your line drawing with a kneaded eraser before beginning the eye color. It is important that graphite lines do not show through the delicate mix of colors that you will apply.

Step 1: A Good Foundation

	Point	Pressure	Stroke
Black	S	4	L

Outline the rim of the iris and wash the pupil. Be sure to make this layer full value.

	Point	Pressure	Stroke
Cream	VS	2	C

Wash the iris with a very sharp point. This step is crucial, so be sure the foundation is smooth and even. Leave the highlight free of color.

	Point	Pressure	Stroke
Black, Cream	S	3	LS

Begin layering the fur with Black and Cream.

Point		Pressure		Stroke			
D–Dull	SD–Semi-dull	1–Very Light	2–Light	V–Vertical Line	C–Circular	X–Crosshatch	B–Burnish
S–Sharp	VS–Very Sharp	3–Medium	4–Full Value	ST–Stipple	L–Linear	LS–Loose Scribble	

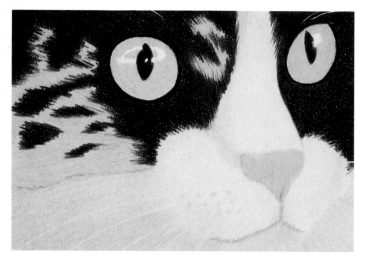

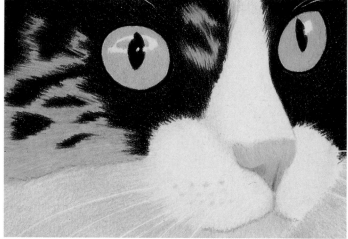

Step 2: Second Wash

Indigo Blue	S	4	L

Wash the pupil and boldly outline the rim of the iris.

Deco Yellow	VS	2	C

Wash the iris again, evenly and smoothly.

Tuscan Red, Jasmine	S	4	LS

Now you can see that Tuscan Red and Jasmine have been added to the fur.

Step 3: Final Wash

Chartreuse	VS	2	C

Wash the iris for the last time. The pupil should appear dark and distinct and the highlight dramatic.

Indigo Blue, Goldenrod	S	4	LS

In this step you can see that these two colors were added to the dark and light areas of the fur.

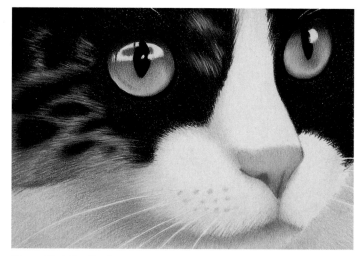

Step 4: Modeling the Eye

Pumpkin Orange	VS	3	C

Now begin to create shape by modeling the eyeball. Look back at page 14 and review modeling if you are unsure.

Tuscan Red	VS	3-4	C

Reinforce the shadow area at the top of both eyes. Wash the pupil and outline the rim of the iris.

Dark Umber, Pumpkin Orange	S	4	LS

Now the fur becomes darker and richer with the addition of Dark Umber and Pumpkin Orange.

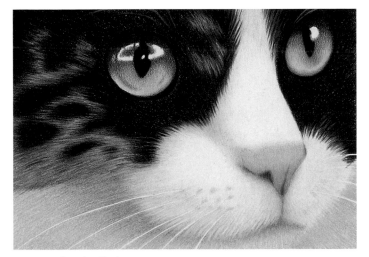

Step 5: Darken the Shadows

Peacock Green	VS	3-4	C

Continue to model the eyes and darken the shadow area at the top of the eyeball. This color is layered over the Tuscan Red that you used in the last step. This combination should create a beautiful shadow color.

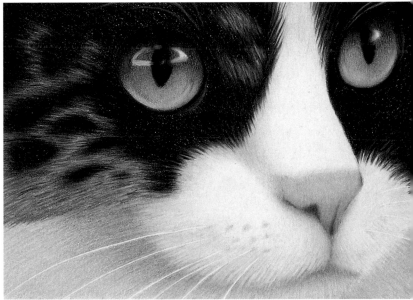

Step 6: Finishing Up

Indigo Blue	VS	3-4	C

Darken the shadow area at the top of the eyeball. Go really dark just under the upper eyelids.

Mineral Orange	VS	3	C

Delicately add a small amount around the pupil.

Apple Green	VS	3	C

Add to the iris, but do not cover the entire eye. Leave some Mineral Orange showing through.

True Blue	S	3	C

Add to the highlight.

White	SD	4	B

Burnish the highlight and the eyelid line. Add a few hairs above the eyes.

Black	S	4	LS

Layer Black over the dark areas of the fur and blend into the light patches.

An Important Step

This step, which finishes the eye, is important to spend time on. If the eye looks flat or lifeless, this is your opportunity to go back and reinforce shadows or improve the shape of the eye through modeling. Also, work with the colors listed here until you achieve an eye that glows.

Horse Eye

This mini-demo will teach you how to combine the elements of layering color, burnishing highlights and establishing shadow areas to create a dramatic and outstanding equine eye. The orbital bone is highlighted and contrasts with the shadow areas created by the eyelashes and eyelid. The wrinkles and folds surrounding the eyeball are gradually layered and add more dimension to the eye area. The dark, round eyeball is embellished with White to create highlights and make it appear rounded. Learn how all these techniques add up to produce an eye that is soft, yet powerful.

MATERIALS

General Materials
Graphite pencil • Kneaded eraser
One piece Rising Stonehenge paper

Prismacolor Pencils
Black Grape • French Grey 10%
Indigo Blue • French Grey 70%
Slate Grey • Pink Rose
Black • Jasmine
Clay Rose • Celadon Green
French Grey 50% • White

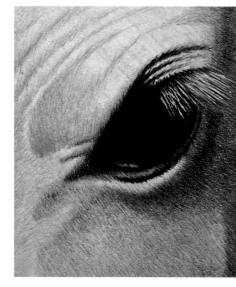

Step 1: Establish the Eyeball, Begin the Fur

	Point	Pressure	Stroke
Black Grape	S	4	C

Wash the entire eyeball and leave the eyelashes free of color. Begin building wrinkles in the eyelid. Keep the stroke going in the right direction.

	Point	Pressure	Stroke
French Grey 10%	S	3	LS

Wash the entire fur area surrounding the eye. The fur frames the eye and needs to be built simultaneously.

Step 2: Darken the Eyeball, Begin Shadows

	Point	Pressure	Stroke
Indigo Blue	S	4	C

Wash the entire eyeball again. Work around the eyelashes.

	Point	Pressure	Stroke
French Grey 70%	S	3	LS

Begin creating wrinkles on the orbital bone. Watch those hills and valleys.

	Point	Pressure	Stroke
Slate Grey	S	3-4	LS

Darken the shadow area to the right of the eye. Scatter throughout the fur pattern.

	Point	Pressure	Stroke
Pink Rose	S	3	LS

Add to the lower corner of the eye and the edges of the eyelid. This denotes the skin under the fur.

Point		Pressure		Stroke			
D–Dull	**SD**–Semi-dull	**1**–Very Light	**2**–Light	**V**–Vertical Line	**C**–Circular	**X**–Crosshatch	**B**–Burnish
S–Sharp	**VS**–Very Sharp	**3**–Medium	**4**–Full Value	**ST**–Stipple	**L**–Linear	**LS**–Loose Scribble	

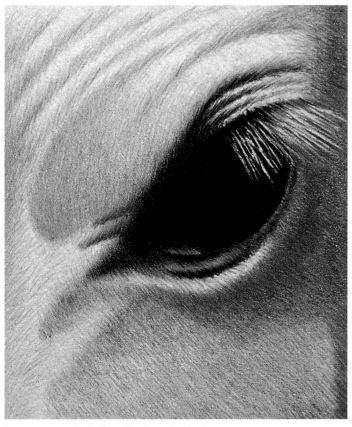 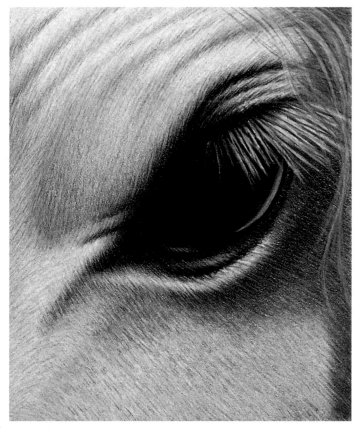

Step 3: Darken the Eyeball, Continue the Fur Pattern

Black	S	4	C

Wash the entire eyeball.

Jasmine	S	3	LS

Add to the wrinkles and eyelid.

Clay Rose	S	3-4	LS

Add to the wrinkles and eyelid. Darken the shadow to the right of the eye. Scatter throughout the fur pattern.

Step 4: Highlight the Eyeball, Finish the Fur

Celadon Green	S	2-3	LS

Scatter throughout the fur pattern and add to the wrinkles.

French Grey 50%	S	2-3	LS

Scatter throughout the fur pattern and add to the wrinkles and shadow area.

Slate Grey	S	2-3	LS

Also scatter Slate Grey throughout the fur pattern and add to the wrinkles and shadow area.

White	SD	4	B

Burnish the existing eyelashes then add a few more. Burnish the large reflection on the eyeball.

Dog Eye

The attentive and devoted gaze in a dog's eyes is matchless.

This canine mini-demo will teach you the basics of building eye color and creating reflections, but the love and loyalty the eyes convey must be added with the care you bring to your pet's portrait. Capture your pet at a special moment with a photograph and then put that emotion into your picture. This demo will not only illustrate the steps for creating a beautiful eye but also show how building up the surrounding fur frames the eye, and is crucial for the final result.

Look for the characteristics of your dog's eyes that convey a sentiment you would like to remember. The eyes speak volumes. Take the time to build the eyes carefully and you will create a loving memory that speaks to you forever.

MATERIALS

General Materials
Graphite pencil • Kneaded eraser
One Piece Rising Stonehenge paper

Prismacolor Pencils
Black • Yellow Ochre
Indigo Blue • Tuscan Red
Sunburst Yellow • French Grey 10%
Light Peach • Black Cherry
True Blue • Deco Blue
Pumpkin Orange • Rosy Beige
Blush Pink • White

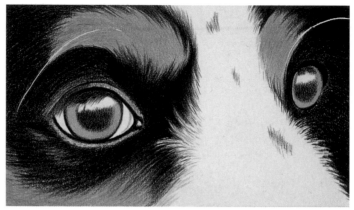

Step 1: Wash Pupil and Outline Iris

	Point	Pressure	Stroke
Black	S	3	L

Wash the pupil and outline the iris. Add some eyelashes. Leave the highlight free of color. (This is a large highlight, so don't minimize it.)

Yellow Ochre	S	3	C

Wash the iris with an even smooth layer.

Indigo Blue, Yellow Ochre	S	4	L

Begin layering dark fur around the eye with Indigo Blue. Apply Yellow Ochre to the orbital bone and leave the white fur free of color.

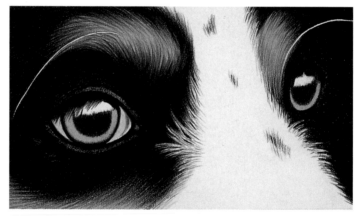

Step 2: Continue Pupil and Iris, Begin White of Eye.

Tuscan Red	S	4	L

Darken the pupil and edge of the iris, add a touch in the corner of the eye.

Sunburst Yellow	S	4	C

Wash the iris evenly again.

French Grey 10%	S	3	C

Wash the white of the eye.

Light Peach	S	3	C

Wash the white of the eye and layer over French Grey 10%.

Black Cherry, Sunburst Yellow	S	4	L

Continue to layer the fur as shown.

Point		Pressure		Stroke			
D–Dull	**SD**–Semi-dull	**1**–Very Light	**2**–Light	**V**–Vertical Line	**C**–Circular	**X**–Crosshatch	**B**–Burnish
S–Sharp	**VS**–Very Sharp	**3**–Medium	**4**–Full Value	**ST**–Stipple	**L**–Linear	**LS**–Loose Scribble	

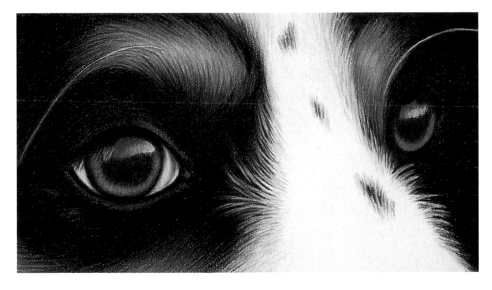

Step 3: Adding the Highlight and Iris

True Blue, Deco Blue S 3 L
Layer both colors onto the highlight and add some to outside edge of the iris. Add some True Blue to the eyelid.

Pumpkin Orange S 3 C
Wash the iris, add a touch to corner of the eye.

Pumpkin Orange S 3 L
Layer over the lighter areas of the fur.

Deco Blue S 3 L
Begin to build the edges of the white fur.

Step 4: Finishing Touches

Black S 4 C
Darken the pupil and thicken the edge of the iris. Darken the eyelid line.

Tuscan Red S 4 C
Layer the iris.

Rosy Beige,
Blush Pink S 3 L
Add to the corner of the eye.

White SD 4 B
Burnish the highlight, white of the eye and edges of the upper and lower eyelids.

Rosy Beige,
French Grey 10% S 3 L
Continue to build white fur on the bridge of the nose as shown

White SD 4 B
Burnish the edges of the white fur where it joins the dark fur. Burnish a few eyebrow whiskers.

Black S 4 L
Add some black to the dark fur where necessary.

Bird Eye

In this mini-demo, you will learn how to achieve the bright, intelligent look in the eye of this African Grey Parrot by first establishing a distinct pupil then surrounding it with a light, clear iris. By building the eye ring and facial patch you will learn how to use layering combined with burnishing to create the effects of folds and creases.

If you work on them simultaneously, all three areas of the eye, facial patch and feathers benefit. Therefore, the feather information has also been included in this mini-demo. Though simple to render, this is a good example of an eye that is surrounded by a very intricate and detailed feather pattern. When you practice this eye you may find yourself spending more time on the feathers than the eye area, but you will see the importance of how they are interrelated.

MATERIALS

General Materials
Graphite pencil • Kneaded eraser
One piece Rising Stonehenge paper

Prismacolor Pencils
Black • Rosy Beige
Warm Grey 50% • Cream
Warm Grey 10% • Clay Rose
Slate Grey • Warm Grey 30%
Jasmine • Black Grape
Warm Grey 90% • White

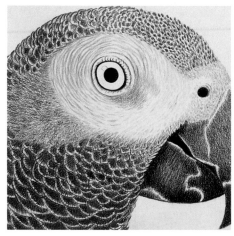

Step 1: Establish the Pupil

	Point	Pressure	Stroke
Black	VS	4	C

Wash the pupil and outline the outer edge of the iris.

	Point	Pressure	Stroke
Rosy Beige	S	3	L

Begin establishing the pattern of the wrinkles in the facial patch and eye ring.

	Point	Pressure	Stroke
Warm Grey 50%	S	3	L

Establish the feather pattern.

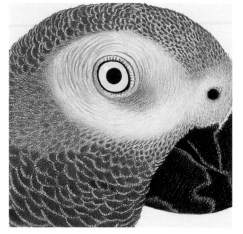

Step 2: Begin the Iris

	Point	Pressure	Stroke
Cream	VS	3	C

Wash the iris with a smooth, even layer.

	Point	Pressure	Stroke
Warm Grey 10%	S	3	L

Wash the eye ring and facial patch. Be sure to follow the direction of the pattern.

	Point	Pressure	Stroke
Clay Rose	S	3	L

Continue to build the pattern of the facial patch and eye ring.

	Point	Pressure	Stroke
Slate Grey, Clay Rose	S	3	L

Layer both Slate Grey and Clay Rose over the Warm Grey 50% in step 1.

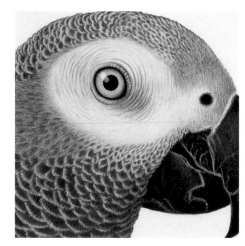

Step 3: Wash Pupil and Iris

	Point	Pressure	Stroke
Warm Grey 30%	VS	3	C

Wash the iris for the last time.

	Point	Pressure	Stroke
Jasmine	VS	3	C

Add to the outside edge of the iris and blend.

	Point	Pressure	Stroke
Black Grape	S	4	C

Wash the pupil and outer edge of the iris.

	Point	Pressure	Stroke
Slate Grey	S	3	L

Continue to build the pattern of the eye ring and facial patch.

	Point	Pressure	Stroke
Warm Grey 90%	S	3-4	L

Finish layering the feathers.

	Point	Pressure	Stroke
White	SD	4	B

Burnish the reflection on the eyeball. Burnish the facial patch and eye ring. Burnish the edges of the feathers.

Point		Pressure		Stroke			
D–Dull	**SD**–Semi-dull	**1**–Very Light	**2**–Light	**V**–Vertical Line	**C**–Circular	**X**–Crosshatch	**B**–Burnish
S–Sharp	**VS**–Very Sharp	**3**–Medium	**4**–Full Value	**ST**–Stipple	**L**–Linear	**LS**–Loose Scribble	

Since vision is such an important part of its survival, the eye of a bird is large for its body. In some species the iris is highly colorful and in others it blends so well with the pupil that the whole eye appears to be a shiny black orb. There can also be a simple ring surrounding the eye or a large facial patch with or without feathers. The following color combinations offer you ways to render an accurate eye for your bird portrait. Since not every eye can be depicted, I have chosen a few popular species that have characteristics that can be applied to other situations.

You can see by these four eye samples how diverse bird eyes can be. Understanding some anatomy, combined with careful observation of your reference photo, will help you create that eye perfect.

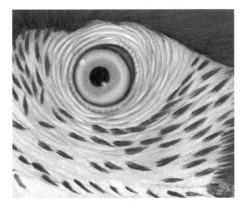

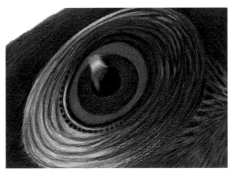

Black-headed Caique Eye
The pupil was established with a full-value wash of Black then Indigo Blue. The inner ring of the iris was layered with a medium-value wash of Indigo Blue then a full-value layer of French Grey 70%.

The outer ring of the iris was washed with full-value washes of Pumpkin Orange, Poppy Red and Scarlet Lake. The reflection was burnished with White.

The eye ring was first washed with French Grey 10%. Then the creases were created with Black Grape. I continued to build the creases with Indigo Blue, then washed the entire eye ring with Greyed Lavender.

Black Grape was added to darken the shadow areas, and Black was used to reinforce the darkest parts of the eye ring. Some of the wrinkles were burnished with White to enhance their shape.

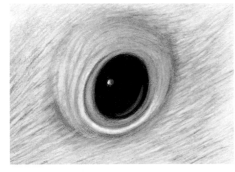

Cockatoo Eye
The eyeball was established with three full-value washes of Black, Black Grape and Indigo Blue. I left the highlight free of color.

The eye ring was then created with a wash of French Grey 10% and the creases were established with Greyed Lavender. The eye ring was built further by adding Rosy Beige to the creases, and some shadows were added with Blue Violet Lake. The eye ring was finished by burnishing White on the creases, and touches of Deco Blue were added to the innermost ring.

Finally, a white reflection was burnished on the eyeball and a touch of Deco Blue was added to the highlight.

Macaw Eye
The pupil was first established using three full-value washes of Black, Black Grape and Indigo Blue. Two highlights were left free of color. The iris was washed with Jasmine, and a layer of Cool Grey 50% was added to the inner ring of the iris. The iris was then outlined with Black Grape.

The facial patch and eye ring were washed with French Grey 10%. Then some feathers were added with Scarlet Lake and Crimson Red. I continued washing the iris with Beige and French Grey 30% to the inner ring of the iris.

I continued to build the pattern in the facial patch and eye ring with Greyed Lavender and Rosy Beige. Some Mineral Orange was added to the outside edge of the iris. Finally, I burnished highlights and creases in the facial patch and eye ring with White.

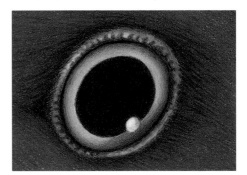

Eclectus Parrot Eye
First, the pupil was established with a full-value wash of Black Grape and Indigo Blue. I made sure to leave an area of highlight. The iris was layered with a medium-pressure wash of Beige and French Grey 30%. The eye ring was created by first establishing it with Black Grape. It was then washed with a medium-pressure layer of French Grey 70%. The pupil was finished with another full-value wash of Black, and a touch of True Blue was added to the highlight. The iris was completed with Mineral Orange added to the outside edge of the iris and softly blended. I did not cover the entire iris with the Mineral Orange layer. The eye ring was finished by adding French Grey 90% to the creases, and the high points were burnished with White.

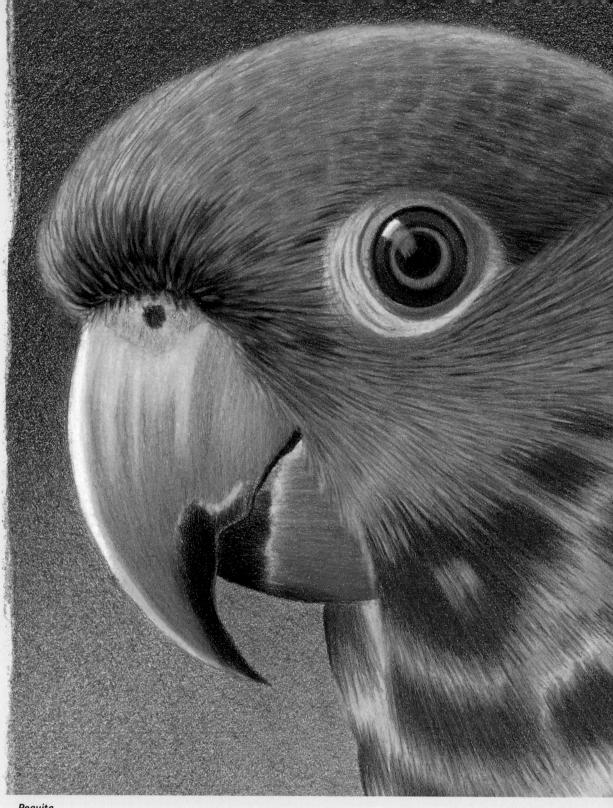

Poquita
10" × 8" (25cm × 20cm) • Collection of Laura Shane

Facial Features

Depicting facial features requires thorough observation and careful planning to not only achieve realism but also to include the most important ingredient—emotion. We all know that each animal has its own unique personality; that's what endears them to us. That's also why you must pay attention to not only anatomy and detail but also expression. I once removed a portrait from the frame and enlarged the pupil just enough so the client's African Gray Parrot did not look angry. This minute but important detail changed the feeling of the picture dramatically.

You can do a great job with the rest of the picture and blow it by simply not paying attention to the feeling that is coming across in the eyes, nose, mouth and, yes, even the ears.

This chapter is full of mini-demos and information on how to render noses, beaks, tongues, teeth and even whiskers. However, always make it a goal to see beyond the anatomy of the animal to the emotion of the pet.

Whiskers

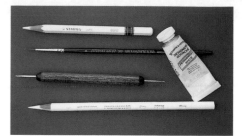

Whiskers are an important facial feature and most fur-bearing animals have them. They can be an integral and dramatic part of the face.

Whiskers need special attention because they are one of the first things to establish before you begin applying color and the last item to complete when you are finished with everything else.

Make clean, smooth impressions with the stylus when you begin then as a last step, enhance them with color. You can also add whiskers with your White pencil, gouache and a paintbrush, or a White Stabilo pencil. Try each and decide for yourself which works best for you.

Make the Job Easier With the Right Tools
Here are some helpful tools to aid you in creating whiskers for your animal. A White Prismacolor pencil is often adequate to burnish in a few whiskers, overlapping the face and the background. At the beginning, use a stylus to create smooth impressed lines. A very fine paintbrush and some gouache work well to add some lines after all other colors have been applied. The White Stabilo pencil has a thicker application than the Prismacolor pencil and can be used in the same manner, giving a more opaque appearance to the whisker.

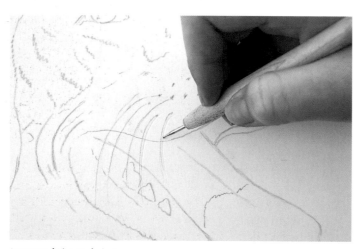

Impressed Line Technique
Embossing some whiskers immediately after you have transferred your line drawing is a good place to start. Press down next to (not directly on) the graphite lines or you will impress the graphite into your paper.

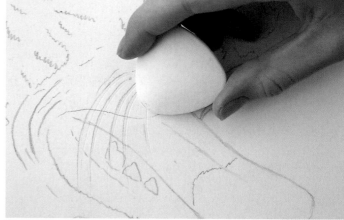

Clean Up Before You Proceed
Once you have completed impressing the whiskers, gently erase the graphite lines so they do not show through the subsequent layers of color.

Impressed Line, the Good and the Bad
The sample on the top shows how an impressed line should look, and the sample on the bottom demonstrates an undesirable, wobbly line. Rest your hand on the paper and make a smooth, sweeping motion with the stylus. If your hand is unsteady, the outcome will look shaky. Likewise, if your hand is not stable, causing you to stop and start, the whisker will look blunt and crooked. Also, be sure to press hard so the indentation is deep enough to prevent pencil strokes from filling it in.

Tip
If you own a lightbox, you can impress the whisker lines while you still have the drawing paper on it. You can see the whisker guidelines through your drawing paper, and by using this method you will not have to worry about avoiding the graphite lines.

Painting with Gouache

There may be occasions when you forget to impress your lines before you begin applying color. You may also discover that your White pencil is not dramatic enough to overcome a dark background, or that all the whiskers just look too much alike. This is the time to use the permanent gouache (see page 21) to paint a few whiskers that will stand out.

The key to successfully painting the whiskers with gouache is to blend it with just a little bit of water so it has a creamy consistency. Experiment on scratch paper before you apply it to your drawing. If the consistency is too dry it will not spread smoothly, and if it is too watery it will look thin. Use an extremely fine brush and make long, sweeping strokes that follow the direction of the whiskers that you are portraying. The gouache should flow easily, allowing you to make a complete whisker in one sweeping motion.

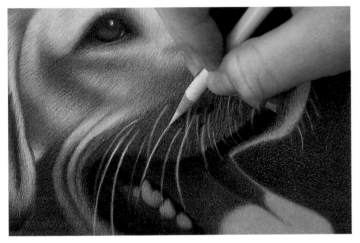

Adding Color Brings Out Reflections
Whiskers reflect the colors of the environment around the animal, so I love to add some interest to them by putting color into the impressed lines. See how the whiskers in this photo take on dimension with the addition of Deco Blue. Adding some color also helps the whiskers stand out against a light background. I used a needle-sharp point and carefully added color, then burnish over with a White pencil to give them a smooth, shiny look.

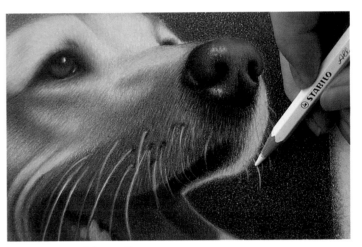

When to Use a Stabilo Pencil?
In addition to the White Prismacolor pencil, I sometimes like to add some whiskers with my White Stabilo pencil. The Stabilo is slightly more opaque than the Prismacolor pencil and can give a more dense appearance. Both are translucent, so the semi-transparency of the white comes across as delicate and subdued. I use this technique in addition to the impressed line because I think both styles complement one another and help prevent too much uniformity. Remember to overlap the background when necessary.

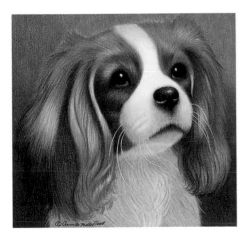

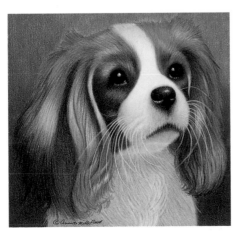

When to Add More?
This photo shows a Cavalier King Charles Spaniel with only impressed whiskers and no other enhancements. Notice that the whiskers appear too plain and sparse.

Add Some Drama
Here, you can see how the different techniques combine to give this beautiful spaniel more dramatic whiskers. In addition to impressed, some whiskers have been applied with a White Prismacolor pencil and some painted on with gouache. A bit of color has been added to the impressed whiskers to make them look more pleasing.

Champion, HMS Pure Joy
10" × 8" (25cm × 20cm)
Private Collection

Horse Nose and Mouth

If you have ever touched the nose of a horse, you were probably impressed by the velvety feel of the skin and fur.

In this mini-demo you will learn how to capture the softness of the nose using circular strokes and burnishing techniques.

You will learn to establish the darkest shadows inside the nostrils and around the lips by first applying Black. The adjoining skin is built with a layering process and blended together to create an almost fuzzy appearance where it merges with the fur. Burnishing a few hairs and accents with White gives this believable nose and mouth an almost tangible effect.

MATERIALS

General Materials
Graphite pencil • Kneaded eraser
One piece Rising Stonehenge paper

Prismacolor Pencils
Jasmine • Black • Terra Cotta • Indigo Blue
French Grey 30% • Tuscan Red • Dark Umber
Warm Grey 90% • Clay Rose • Slate Grey • White

Step 1: Begin the Fur, Identify the Darks

	Point	Pressure	Stroke
Jasmine	S	3	L

Establish the basecoat of the fur, be sure the stroke direction is correct.

	Point	Pressure	Stroke
Black	S	4	L

Establish the darkest areas inside the nostril and around the mouth. Press hard and get those darks deep enough.

Tip

It is important to begin working on the background early in the process. This gives you a good framework for the subject. Try completing the background surrounding this nose and mouth, then work on your focal point. You may be surprised at how it helps.

I used layers of Light Aqua, Blue Violet Lake, Imperial Violet, Aquamarine, Violet and Indigo Blue to get this lovely background color.

Point		Pressure		Stroke			
D–Dull	**SD**–Semi-dull	**1**–Very Light	**2**–Light	**V**–Vertical Line	**C**–Circular	**X**–Crosshatch	**B**–Burnish
S–Sharp	**VS**–Very Sharp	**3**–Medium	**4**–Full Value	**ST**–Stipple	**L**–Linear	**LS**–Loose Scribble	

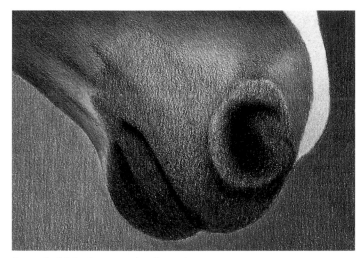

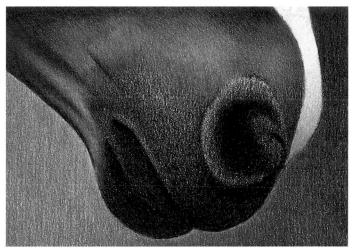

Step 2: Build the Fur, Layer the Lips and Nose

Terra Cotta	S	3	L
Continue to layer the fur.			
Indigo Blue	SD	3-4	C
Model the lips and nose, adjusting pressure to create contours.			
French Grey 30%	S	3	L
Add to the tip of the blaze (the white stripe down the center of the face).			

Step 3: Finish the Fur, Blend the Fur Into the Skin

Tuscan Red, Dark Umber	S	3-4	L
Layer the fur with both colors.			
Warm Grey 90%	S	4	C
Continue to model the nose and lips.			
Clay Rose	S	4	B
Add to the tip of the blaze. Burnish where Indigo Blue and Warm Grey 90% merge.			

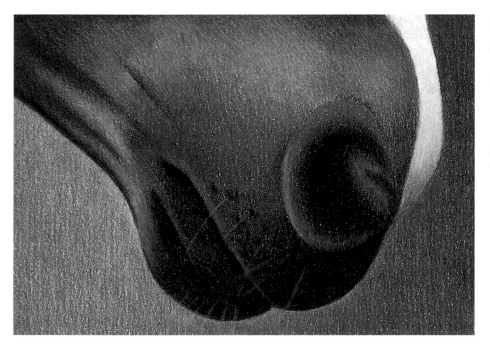

Step 4: Burnish and Add Whiskers

Slate Grey	S	4	B
Burnish along the edges of the nostrils and lips.			
Black	S	4	C
Darken the shadows on the lips and inside the nostril. Press hard and get them dark.			
White	S	4	B
Burnish some whiskers. Burnish along the edges of the nostril. Overlap the background with a few whiskers.			

Dog Nose

Who hasn't experienced the sensation of a wet nose being pressed against a hand asking for a pat on the head or the opportunity to chase a ball?

In my opinion, dog noses are one of the easiest and quickest facial features to render. A dog's nose is not only crucial to its acute sense of smell but is also one of the characteristics that contributes to its endearing facial features.

In this demo, you will learn how to render both the moistness and the texture that is so typical of canine noses. By using a few colors, the correct stroke, and a good value pattern you will create a realistic nose.

MATERIALS

General Materials
Graphite pencil • Kneaded eraser
One piece Rising Stonehenge paper

Prismacolor Pencils
Black • Indigo Blue
Henna • Goldenrod • White

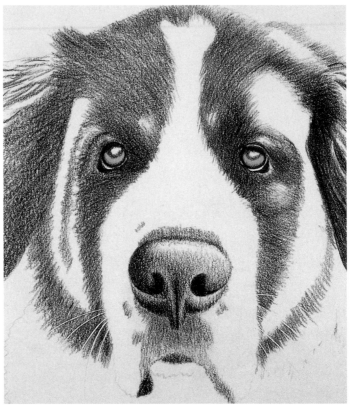

Step 1: Establish a Value Pattern

	Point	Pressure	Stroke
Black	SD	3-4	C

Model the nose, adjusting pressure to create the shapes and contours. Be sure to leave some spots free of color to suggest moistness. Darken inside the nostrils with a full-value application. Be sure to build the surrounding fur each time you do a step. The value pattern is very important.

Tip Whenever working on lips, gums, noses or tongues, be sure to create some moistness by burnishing some white specks here and there. Some small highlights give the viewer the impression that light is reflecting off of a wet spot, making the area more interesting.

Point		Pressure		Stroke			
D–Dull	**SD**–Semi-dull	**1**–Very Light	**2**–Light	**V**–Vertical Line	**C**–Circular	**X**–Crosshatch	**B**–Burnish
S–Sharp	**VS**–Very Sharp	**3**–Medium	**4**–Full Value	**ST**–Stipple	**L**–Linear	**LS**–Loose Scribble	

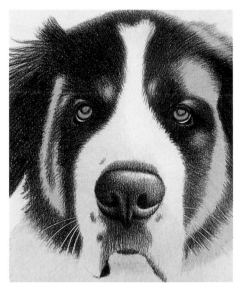

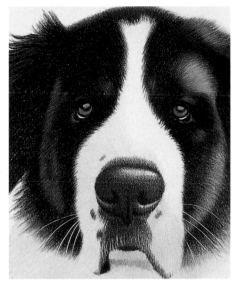

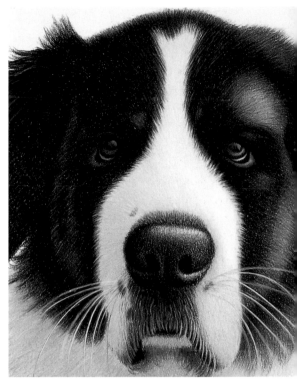

Step 2: Continue to Build the Value Pattern

Indigo Blue SD 3-4 C
Continue to model the nose following the value pattern you established with the Black.

 Think about the texture of the nose as you work, use a circular strokes and the texture of the paper to help you achieve the effect. As you continue to layer, keep in mind that dog noses have an almost rough appearance.

Step 3: Add Some Color

Henna S 3 C
Layer midtone areas where color is evident. Do not add to the inside of the nostrils.

Step 4: Finish the Darks, Enhance the Highlights

Black S 4 C
Darken inside of the nostrils and the darkest shadow areas.

Indigo Blue S 3 C
Finish modeling the midtones.

Goldenrod S 3 ST
Stipple touches of Goldenrod on the moist highlights.

White S 4 B
Burnish a few white specks around the highlights to enhance the appearance of moistness.

Tongues and Teeth

Often, when I am choosing a photograph for a portrait, I must decide whether or not to portray the subject with the mouth open or closed. (Sometimes it is impossible to get a shot with the mouth closed, especially in a dog picture.) If I have a choice, I evaluate how it will benefit the portrait to include the tongue and teeth. If the tongue is really saying something to me, I include it.

In this demonstration you will learn how to create both tongues and teeth since they so often appear together. This demonstration shows the steps for a canine tongue since that is the most common tongue that you will encounter, but you can apply the same colors and techniques to horses and cats. Tongues and teeth do not have a lot of texture, so burnishing is commonly used to give them their smooth and sometimes glossy appearance.

MATERIALS

General Materials

Graphite pencil • Kneaded eraser
One piece Rising Stonehenge paper

Prismacolor Pencils

Black Grape • Jasmine
French Grey 10% • Blush Pink • Cream
Indigo Blue • Pumpkin Orange • Black
Pink • Tuscan Red • Mahogany Red
Dark Umber • French Gray 50% • White

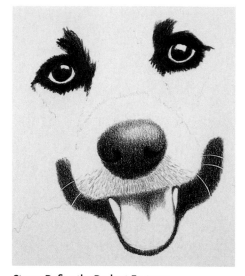

Step 1: Define the Darkest Features

	Point	Pressure	Stroke
Black Grape	S	4	L

Outline and fill in the lip area. Begin the shadow on the tongue. The lips frame the tongue, so it's a good idea to begin with them.

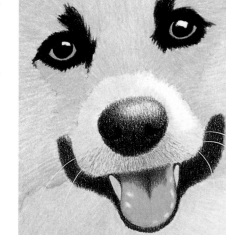

Step 2: First Washes

Jasmine	S	3	L

Wash the tongue. Leave the highlights free of color.

French Grey 10%	S	3	L

Wash both teeth, the French Grey 10% is a good base color to use whenever you are drawing teeth.

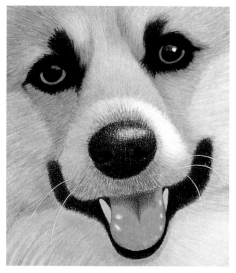

Step 3: Build Color All Over

Blush Pink	S	3	L

Wash the entire tongue again, but don't cover up those highlights.

Cream	S	3	L

Layer over French Grey on both teeth.

Indigo Blue	S	4	L

Layer over Black Grape on the lips.

Point		Pressure		Stroke			
D Dull	**SD**–Semi-dull	**1**–Very Light	**2**–Light	**V**–Vertical Line	**C**–Circular	**X**–Crosshatch	**B**–Burnish
S–Sharp	**VS**–Very Sharp	**3**–Medium	**4**–Full Value	**ST**–Stipple	**L**–Linear	**LS**–Loose Scribble	

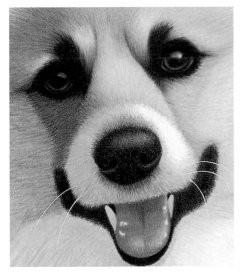

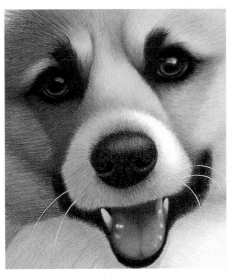

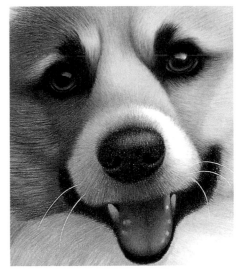

Step 4: Begin Modeling the Tongue

Pumpkin Orange S 3 L
Begin to model the tongue. This is not a wash, so begin creating shape with this color.

Black S 4 L
Apply one more layer to the lips.

Step 5: Build Tongue Color

Pink S 3 L
Apply Pink to the lighter area of the tongue.

Tuscan Red S 3-4 L
Use this color to continue to model the tongue. Apply it to the shadow areas, edges and crease, also apply some to the base of the teeth.

Step 6: Darken All Parts

Mahogany Red S 3 L
Wash the entire tongue.

French Grey 50% S 3 L
Wash the teeth, they are in shadow so they need to be dark.

Dark Umber S 3-4 L
Darken the shadow on the tongue. Darken the base of the teeth.

Step 7: Finishing Touches

Black S 3-4 L
Darken the shadow under the upper lip.

White SD 4 B
Burnish the highlights on the tongue. Burnish the teeth. Burnish some shine onto the lips. Add the whiskers. This step gives the tongue, lips and teeth their moist appearance.

Annie
14" × 11" (36cm × 28cm)
Collection of Holly Martineau

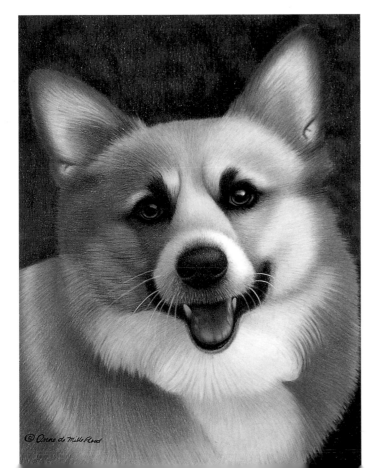

Feline Noses

The feline nose is relatively simple to portray, but always remember to render the adjoining fur as you work on the nose. The shape of the nose is simple and straightforward, but it is necessary to correctly shade it to make it appear to stand out from the face. The nose is the central feature of the face and therefore holds importance for the creation of the fur pattern.

Feline noses vary in color from light pink to dark black. Refer to the cat demonstrations in chapter six to find a nose color combination that matches your cat. Here are a few additional color combination ideas to help you on your way.

Cat Noses
This nose illustrates some of the important features to remember when rendering the nose. Be sure the nostrils are darkened adequately, and shade to the bottom of the nose to give it the effect of curving downward. The skin around the edges of the nose must appear to join the fur, which should radiate away from the nose, giving shape to the face. Don't forget to define the crease that runs down the center of the nose.

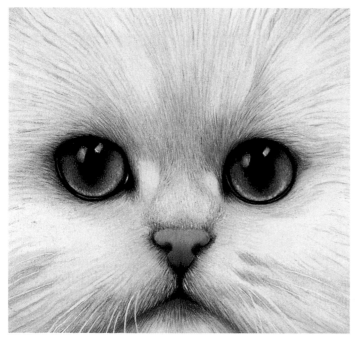

Each Nose is Different
I created the nose of this Himalayan with a wash of Jasmine followed by Blush Pink, Peach, and Mineral Orange. I added Henna to darken near the bottom of the nose. Inside the nostrils is layered with Tuscan Red, Dark Umber and Black.

Misty
14" × 14" (36cm × 36cm)
Collection of the Artist.

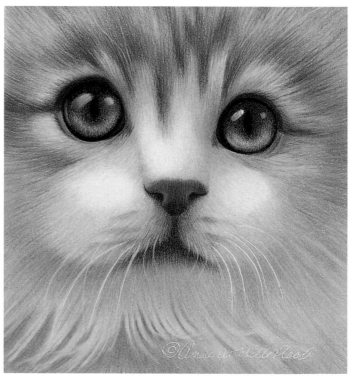

Use Several Colors
I began the nose of this orange tabby with a wash of Jasmine followed by washes of Blush Pink and Pumpkin Orange. I then used Tuscan Red to darken inside the nostrils and the bottom of the nose. I finally added a wash of Raspberry and layered Dark Umber inside the nostrils and on the bottom edge of the nose.

Pumpkin
8" × 10" (20cm × 25cm)
Collection of the Artist

Bird Beak

The beak variations among the differing bird species is notable, but overall beaks are relatively easy to render. This mini-demo will help you identify some of the methods of rendering two of the most common aspects of avian beaks.

The macaw beak in this demo has differing areas of coloration and texture, and you will learn how to render these characteristics in four easy steps. The upper part of the beak is smooth and glossy and the lower part is dark and cracked. You can easily apply this knowledge to other species with similar characteristics.

MATERIALS

General Materials
Graphite pencil • Kneaded eraser
One piece Rising Stonehenge paper

Prismacolor Pencils
Indigo Blue • Black • Cream • Black Grape
Yellow Ochre • Deco Pink • Peach • White

Step 1: Begin the Beak

	Point	Pressure	Stroke
Indigo Blue	S	3	L

Wash the lower beak and leave some crooked lines free of color to designate a crack. Wash the side and tip of the upper section of the beak as shown.

Black	S	4	L

Wash the darkest shape between the upper section and lower section of the beak.

Step 2: Wash the Upper Section of the Beak

Cream	S	3	L

Wash the upper section of the beak. Make sure your stroke is following the curve of the beak.

Black Grape	S	3-4	L

Layer this over the Indigo Blue.

Step 3: Add Color, Darken with Black

Yellow Ochre	S	3	L

Add to the upper beak as shown.

Black	S	4	L

Darken between the upper and lower section of the beak. Darken the lower edge of the beak.

Step 4: Finishing Touches

Deco Pink	S	4	L

Wash the upper beak.

Peach	S	4	L

Add streaks to the upper beak.

Indigo Blue	S	4	L

Wash the lower beak and the dark areas again.

White	SD	4	B

Burnish some streaks on the upper beak. Burnish a few lines on the lower beak to create the appearance of cracks.

Point		Pressure		Stroke			
D–Dull	**SD**–Semi-dull	**1**–Very Light	**2**–Light	**V**–Vertical Line	**C**–Circular	**X**–Crosshatch	**B**–Burnish
S–Sharp	**VS**–Very Sharp	**3**–Medium	**4**–Full Value	**ST**–Stipple	**L**–Linear	**LS**–Loose Scribble	

Bird Beak
Color Samples

Birds vary extensively in color and so do their beaks. Beaks also range widely in texture, size and shape; however, their diversity does not mean that they are difficult features to render. You can see from the samples shown here that often you only need to apply a few colors to achieve the desired effect and the process can be quite simple and quick. Look at these samples and use the information to apply to other situations, and remember, simplicity is the key.

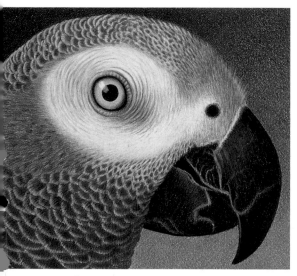

African Gray Parrot
This beak is easy to render in just a few quick steps. It has some cracks that you have to pay attention to, but other than that it is not difficult. First, I established the value pattern with a tonal foundation of Black using medium- to full-value pressure. I left some crooked lines free of color to denote the cracks in the beak. Next, I washed the entire beak with a medium-pressure layer of Black Grape and Indigo Blue, even over the cracks. I was careful to follow the curve of the beak with linear strokes. Then I reinforced the darkest areas of the beak with full-value Black and burnished White over the cracks. I also used my White pencil to add some areas of shine on the beak.

Kimbaroo
7" × 8" (18cm × 20cm)
Private Collection

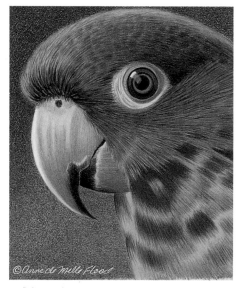

Red-throated Conure
For this conure I started with a wash of French Grey 10% on both the upper and lower sections of the beak. Next I established the dark markings, again on both the upper and lower sections with French Grey 70% and Black. Then a wash of Beige was applied to the light areas, and Light Umber was used to create the streaks in the upper section. I also washed the lower section with Light Umber. Finally, Mineral Orange was layered over the Light Umber, and White streaks were burnished on. Touch-up was done with the Black pencil to darken the space between the two sections of the beak.

Poquita
10" × 8" (25cm × 20cm)
Private Collection

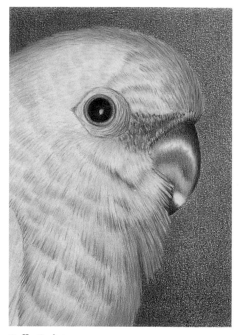

Goffin Cockatoo
There is quite a bit of shine on this cockatoo beak, so it is important to leave a large, light area and to build the colors up around it to create contrast and make it appear shiny. I started with a wash of French Grey 10% over the entire beak and then applied a layer of French Grey 70% to darken the tip and upper edge of the beak. I then applied a wash of Rosy Beige over the entire beak with the exception of the shiny area. Then Blue Violet Lake was layered over most of the Rosy Beige, but not all. Indigo Blue was applied to again darken the tip and upper edge. Finally, White was burnished over the light area to give a smooth, glossy highlight.

Miki
10" × 8" (25cm × 20cm)
Collection of the Artist

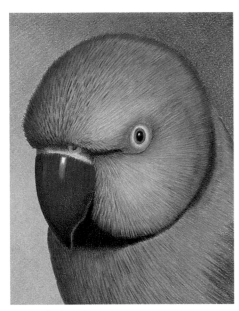

Ring-necked Parakeet

This is another example of a beak that can be rendered in a few simple steps. First, I established the shadow areas by layering them with Indigo Blue. Then I applied three consecutive washes of Carmine Red, Crimson Red and Magenta to the entire beak with the exception of the highlight. I never like to use fewer than three layers of color in any given spot, so three shades of red were applied to give it depth. White was burnished over the highlight to make it look shiny and the dark areas were reinforced once again with Indigo Blue.

Oscar
10" × 8" (25cm × 20cm)
Collection of the Artist

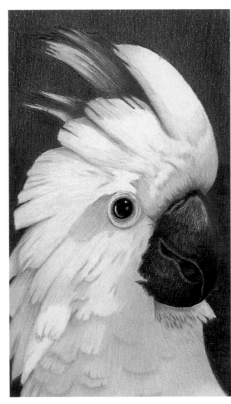

Moluccan Cockatoo

This is a beak that appears cracked and also a little dusty. Cockatoos are called "powder birds" because of the powdery effect you can often see on their beaks. I developed this beak by applying Indigo Blue and Black Cherry as my first washes. Then Black was applied to darken portions of the beak, creating the effect of texture. Finally, I burnished White all over to create the powdery effect and applied Indigo Blue to darken where necessary.

Molucca
14" × 11" (36cm × 28cm)
Collection of the Artist

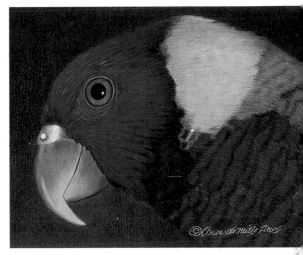

Rainbow Lorikeet

This is an example of a very colorful beak, just the type that I love to work on. I started with a first wash of Spanish Orange for both the upper and lower sections of the beak. Then both sections were modeled using Pale Vermilion. See how the linear stroke follows the shape of the beak—very important. Yellowed Orange was used to burnish the entire beak and Poppy Red was applied to just the edges. A bit of White was burnished to add some shine on the upper section of the beak.

Tango
8" × 10" (20cm × 25cm)
Collection of the Artist

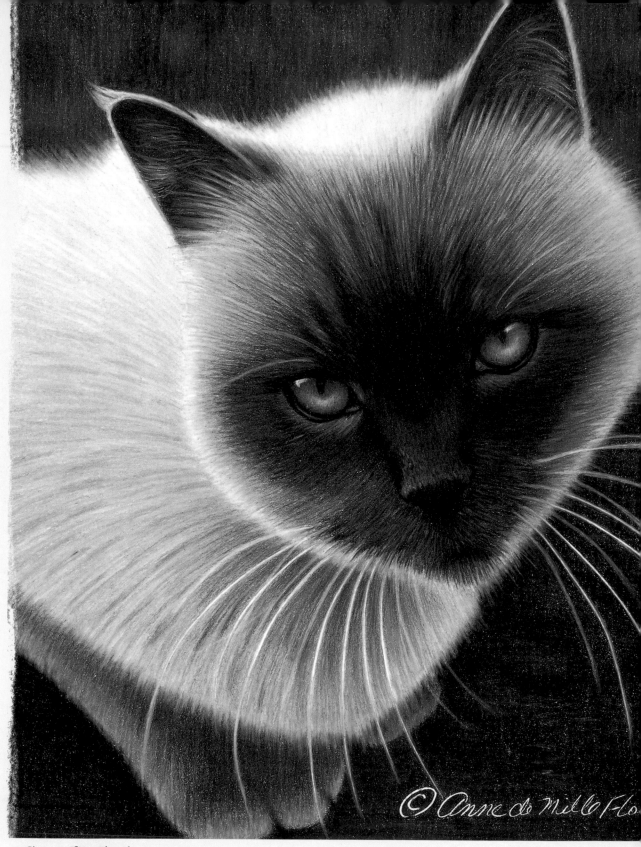

© Anne de Mille Flo

Siamese, If You Please!
10" × 8" (25cm × 20cm) • Private Collection

Cats are far and away the most popular subject for any animal artist, and their allure is undeniable. I continue to be fascinated by their aloof mystique, and capturing their spirit of independence is always an inviting challenge.

There is no more interesting feature than the uniqueness of the feline eye and the way it reflects light. The most common comment I hear about my cat portraits is how the eyes just seem to glow.

For many of us the family cat serves as our inspiration, and if you can get the cat to cooperate long enough to be photographed, it can be a wonderful model. Cats were the first animal subject that I attempted and the result was extraordinary. The portrait of our cat Heather jump-started my pet portrait business. Sadly, she is no longer with us, but I have her to thank for turning my business around. She will be forever remembered in that precious rendition on our living room wall, watching and waiting.

Tabby Cat

The fur of this tabby is both complex and multifaceted. You'll be challenged to create the complex pattern with many layers of color. As you build color, be sure that your strokes are loose and open, creating the choppy pattern that is typical of tabby fur. Make the dark markings in the face dramatic and distinct by using full-value colors. The forceful gaze of the eyes is a delightful

opportunity for you to create intensity through the use of finely applied layers, highlights and delicate modeling of the eye.

The background is out of focus and darkened near the top of the picture, giving you the chance to nicely frame the sunlit ears, and the grass in the foreground is a pleasant setting for this dramatic kitty.

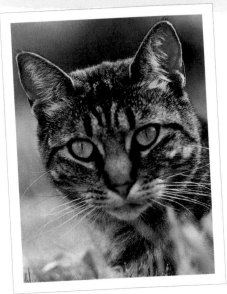

Tabby Cat Reference Photo

MATERIALS

General Materials
Graphite pencil • Kneaded eraser
One piece Rising Stonehenge paper
Stylus or embossing tool
White Stabilo pencil

Prismacolor Pencils
Chartreuse • Indigo Blue
Cream • Black Grape • Black
Tuscan Red • Light Umber • Jasmine
Dark Umber • French Grey 10%
French Grey 30% • Jade Green
Peach • Blush Pink • Peacock Green
Goldenrod • Sepia • Henna • Apple Green
Dark Green • Deco Blue • Slate Grey
White • Blue Slate • Greyed Lavender

Tabby Cat Line Drawing
Before you begin, enlarge the line drawing to the size that you would like the finished piece to be. Then transfer the line drawing by gently tracing the image onto the Stonehenge paper with a no. 2 pencil. Impress the whiskers and your signature with an embossing tool. Erase the graphite whisker lines, then blot the entire line drawing with a kneaded eraser. Sweep the paper with a drafting brush and you are ready to begin applying color.

Point		Pressure		Stroke			
D–Dull	**SD**–Semi-dull	**1**–Very Light	**2**–Light	**V**–Vertical Line	**C**–Circular	**X**–Crosshatch	**B**–Burnish
S–Sharp	**VS**–Very Sharp	**3**–Medium	**4**–Full Value	**ST**–Stipple	**L**–Linear	**LS**–Loose Scribble	

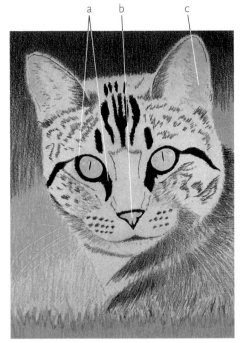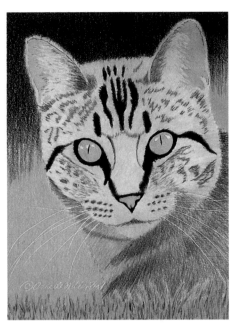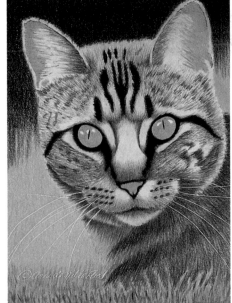

Step 1: Frame the Eyes and Establish Markings

	Point	Pressure	Stroke
Chartreuse	S	3-4	V

Cover the entire background with Chartreuse using varying pressure.

Indigo Blue	S	4	V

Apply Indigo Blue to the upper part of the background framing the ears.

Chartreuse	SD	4	L

Begin establishing the grass pattern.

Cream	VS	3	C

Gently and evenly wash the entire iris with Cream. Leave the highlights free of color.

Black Grape	S	4	L

Outline the eyes and fill in the pupil. Thicken the outline as shown (a) and extend into the tear zone.

Black	S	3-4	LS

Establish the markings in the fur, mimicking the stroke direction of the reference photo. Differentiate between the darkest and the midvalue markings by using pressure.

Black Grape	S	4	L

Outline the edges of the nose and fill in the nostrils.

Cream	S	3	V

Cover the end of the nose (b) with Cream.

Cream	S	3	L

Begin establishing the fleshy part of the ears (c) with Cream. Do not work into the area where there is fur.

Step 2: Layering to Build Color

Tuscan Red	SD	4	V

Layer Tuscan Red over Indigo Blue at the top of the picture. Make it dark where it frames the ears.

Jasmine	SD	4	V

Layer Jasmine over Chartreuse in the midtone area of the background.

Dark Umber	SD	3-4	L

Begin establishing a pattern in the grass with Dark Umber (just the dark shapes).

Jasmine	VS	3	C

Wash the iris with Jasmine.

Dark Umber	S	4	L

Fill in the pupil, tear zone and the rim around the eye with Dark Umber.

French Grey 10%	S	3	LS

Apply to the entire head of the cat.

French Grey 30%	S	3	LS

Apply to the chest and body. Begin establishing the pattern of the fur by using a directional scribble stroke.

Cream	S	3	V

Layer Cream on the end of the nose.

Jasmine	S	3	L

Continue to build the fleshy area inside the ears with Jasmine.

French Grey 10%	S	3	L

Use French Grey 10% to establish the fur pattern inside the ears.

Step 3: Developing the Patterns

Do nothing to the background for this step.

Light Umber	SD	3-4	L

Continue to build the grass pattern with Light Umber.

Jade Green	VS	3	C

Wash the entire iris of both eyes with Jade Green. This is your last layer of foundation, so make it smooth and even.

Light Umber	S	3-4	LS

Look carefully at the reference photo; begin building the fur pattern on the head and body. Be sure your stroke mimics the direction of the fur as shown in the photo. It should be loose and open where necessary and more dense where the fur is in shadow.

Peach, Blush Pink	S	3	V

Wash the end of the nose with Peach and Blush Pink.

Peach, Blush Pink	S	3	L

Layer Peach and Blush Pink inside the fleshy area of the ears.

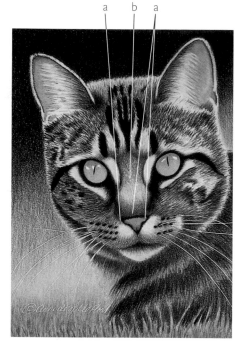
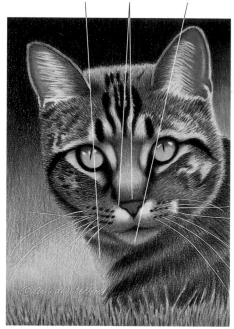
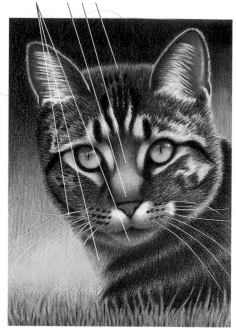

Step 4: The Pattern Takes Shape

Peacock Green S 3-4 V
Wash the entire background with Peacock Green. Use heavy pressure near the top surrounding the ears.

Goldenrod SD 3-4 L
Continue building the pattern in the grass with Goldenrod.

Goldenrod VS 2-3 C
Begin modeling the shape of the eyes. Be sure to accentuate the shadow area under the upper eyelid.

Sepia S 3-4 LS
Continue to build the pattern throughout the head and body with Sepia.

Goldenrod S 3 V
Wash the end of the nose with Goldenrod.

Sepia S 3-4 V
Build up the sides and top (a) of the nose with Sepia.

Sepia S 3-4 ST
Stipple the bridge of the nose—between the eyes (b).

Goldenrod S 3 L
Layer Goldenrod over the fleshy area inside of the ears.

Sepia S 3 L
Continue to build the fur pattern inside the ears.

Step 5: The Eyes Take Shape

Chartreuse S 4 V
Press hard with Chartreuse and blend the mid-tone and dark area of the background together.

Dark Umber S 3-4 L
Continue to add details to the grass by defining the dark shapes between the blades of grass with Dark Umber.

Dark Umber, VS 3 C
Tuscan Red
Continue modeling the shape of the eye with Dark Umber and Tuscan Red; designate shadows and form the shape of the eye. Don't lose the highlight!

Black S 4 L
Apply Black to the pupil and the rim surrounding the eyes.

Light Umber, S 3-4 LS
French Grey 30%
Work Light Umber and French Grey 30% into mid-tone areas of the fur; darken areas that are in shadow, such as the chin (a) and chest (b).

Henna S 3 V
Cover the end of the nose with Henna.

Dark Umber S 3 V
Work Dark Umber into the nostrils and around the sides of the nose. Apply to the top (c) of the nose.

Henna S 3 L
Add Henna to the fleshy area inside of the ears.

Step 6: Bringing It All Together

Apple Green S 4 L
Use Apple Green to finish the grass pattern.

Dark Green VS 3-4 C
Keep modeling the shape of the eyes and strengthening the shadow areas with Dark Green.

Deco Blue S 3 L
Use Deco Blue to add some color to the highlights.

Black S 3-4 LS
Use Black to finish the fur pattern over the entire cat. Apply fine Black hairs overlapping the background. Be sure to get those facial patterns dark and dramatic.

Slate Grey S 3-4 LS
Use Slate Grey to add to the shadow areas of the fur such as under the chin, on the chest and the side of the face (a).

Black S 4 L
Use Black to finish off darkening the areas of the nose such as the nostrils and sides of the nose.

Black S 4 ST
Stipple between the eyes (b).

French Grey 30% S 3 C
Apply French Grey 30% to the bridge of the nose (c); the circular stroke will give it a soft appearance.

White, Slate Grey SD 4 B
Burnish with both colors along the top edge of the head where it meets the background (d).

Tuscan Red, S 3-4 L
Dark Umber
Apply Tuscan Red and Dark Umber to darken the fleshy area inside the ears.

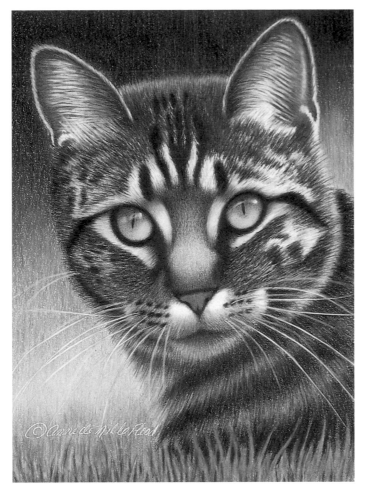

Now is a good time to take a few steps back and look at the overall effect that you've achieved. Ask yourself if you have a realistic and pleasing image that you would be proud to display.

Is the pattern in the fur as complex as in the picture, or is it too blended together? If so, you may not have been open enough with your stroke. Is the fur pattern moving in the right direction and creating the shape of the head and body? If not, did your strokes follow the visible pattern in the reference photo?

Do the eyes look round and shiny? If not, did you darken the shadows enough so they give the eye shape? Are the reflections distinct or did you lose the highlight as you worked?

Does the background frame the cat, and is it dark enough to accentuate the light edges of the head and ears? If not, darken it more.

Step 7: Finishing Touches

The grass and the background are now complete.

White VS 4 B
Delicately burnish the Deco Blue highlights on the eyes with White. Be sure a small amount of white paper is still showing.

White S 4 B
Add details to the fur by burnishing white hairs on the dark pattern where necessary.

Blue Slate S 4 B
Add some color to the lighter areas of the fur that are in shadow with Slate Blue.

White Stabilo pencil S 4 B
Use the White Stabilo pencil to add some additional whiskers by burnishing long whiskers onto the picture where desired.

Greyed Lavender, Deco Blue VS 4 B
Create reflections in the impressed line whiskers by adding some Deco Blue and Greyed Lavender to the indentations.

Nikki
14" × 11" (36cm × 28cm)
Collection of Kathy Knierien

Siamese Cat

The Siamese mask is the defining characteristic of this charming cat. The cautious, yet curious blue eyes are framed by the dark outline of the mask. The light gray fur surrounds the dark features of the face and enhances the mask-like qualities.

This is a good opportunity to work on fur that is deceptively simple. You will see that in order to achieve the contrast between the dark and light fur, you will need to layer the mask repeatedly. You must be sure to get the mask value deep enough to make it a dramatic feature that frames the beautiful blue eyes of this Siamese.

MATERIALS

General Materials
Graphite pencil • Kneaded eraser
One piece Rising Stonehenge paper
Stylus or embossing tool
White Stabilo pencil (optional)

Prismacolor Pencils
Dark Umber • Jasmine • Indigo Blue
Cloud Blue • French Grey 10%
Terra Cotta • Black • Blue Slate • Beige
Tuscan Red • Violet • Black Grape
French Grey 30% • Olive Green • Sepia
Peacock Blue • French Grey 70%
Peacock Green • Clay Rose
Warm Grey 90% • Slate Grey
Cool Grey 90% • Light Umber • White

Siamese Cat Reference Photo

Siamese Cat Line Drawing
Transfer the line drawing to paper. Blot the graphite line drawing with a kneaded eraser. Impress the whiskers and your signature with an embossing tool before applying color.

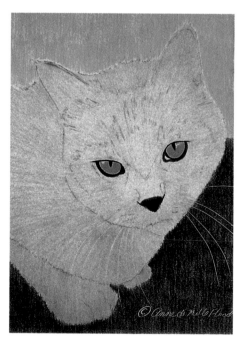

Step 1: First Washes

	Point	Pressure	Stroke
Dark Umber	S	3	V

Apply Dark Umber to the bottom two-thirds of the foreground.

	Point	Pressure	Stroke
Jasmine	S	3	V

Apply Jasmine to the upper one-third of the background.

	Point	Pressure	Stroke
Indigo Blue	S	4	L

Outline the eye and fill in the pupil with Indigo Blue.

	Point	Pressure	Stroke
Cloud Blue	VS	3	C

Wash the iris with Cloud Blue. Be sure to leave the highlight free of color.

	Point	Pressure	Stroke
French Grey 10%	S	3	LS

Wash the entire cat with a foundation of French Grey 10% and follow the fur direction with your stroke.

	Point	Pressure	Stroke
Indigo Blue	S	4	L

Wash the end of the the nose with Indigo Blue.

	Point	Pressure	Stroke
French Grey 10%	S	3	LS

Wash the entire ears with French Grey 10%.

Point		Pressure		Stroke			
D–Dull	**SD**–Serni-dull	**1**–Very Light	**2**–Light	**V**–Vertical Line	**C**–Circular	**X**–Crosshatch	**B**–Burnish
S–Sharp	**VS**–Very Sharp	**3**–Medium	**4**–Full Value	**ST**–Stipple	**L**–Linear	**LS**–Loose Scribble	

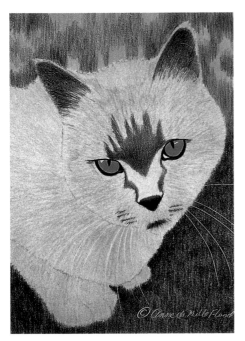
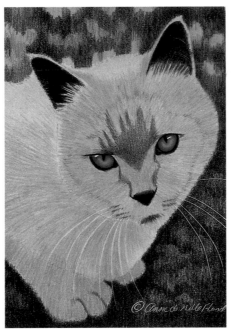
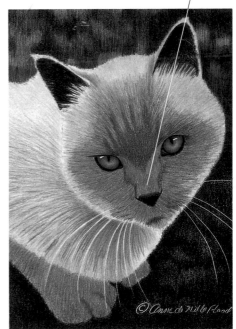

Step 2: Identify the Dark Areas

Terra Cotta SD 3 V
Scatter random patches of Terra Cotta in the background and foreground.

Black VS 4 L
Reinforce the dark colors of the rim and pupil with Black.

Blue Slate VS 3 C
Wash the iris again with Blue Slate.

Black S 3 LS
Establish the markings on the face, edge of the nose and mouth.

Beige S 3 LS
Wash the midtone areas with Beige.

Black S 3 L
Darken the end of the nose with Black.

Black S 4 L
Darken the inside of the ears with Black.

Step 3: Layer to Create Pattern and Shape

Tuscan Red SD 4 V
Scatter patches of Tuscan Red throughout the background and foreground.

Violet VS 3 C
Begin modeling the shape of the iris with Violet.

Black Grape VS 4 L
Darken rim, pupil and corner of the eye with Black Grape.

French Grey 30% S 3 LS
Continue to build the fur pattern.

Black Grape S 3 L
Reinforce the end of the nose with Black Grape.

Black Grape S 4 L
Cover the entire inside of the ears with Black Grape.

Step 4: Continue Layering and Modeling

Olive Green S 4 V
Wash the entire background with Olive Green.

Sepia S 4 V
Wash the foreground with Sepia.

Peacock Blue VS 3 C
Continue modeling the shape of the eyes with Peacock Blue.

French Grey 70% S 3 LS
Establish the mask on the face and darken the chest and legs with French Grey 70%.

French Grey 70% S 3 LS
Layer French Grey 70% on the top of the nose (a).

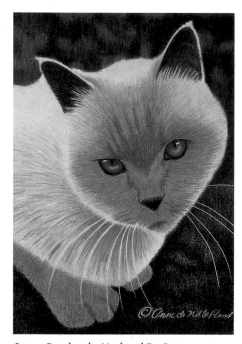
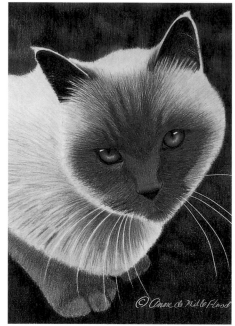
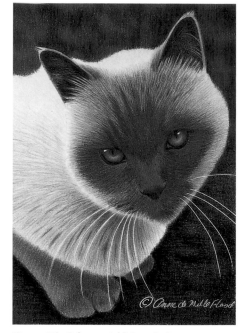

Step 5: Develop the Mask and Fur Pattern

Peacock Green S 3 V
Wash the entire background with Peacock Green.

Black S 4 V
Create shapes in the foreground with Black.

Indigo Blue VS 3 C
Continue modeling the shape of eyes with Indigo Blue.

Clay Rose S 4 LS
Layer Clay Rose to build the mask on the face, and continue to build the fur pattern on the chest and legs.

Clay Rose S 3 C
Layer Clay Rose on top of the nose.

Warm Grey 90% S 4 L
Layer the inside of the ears with Warm Grey 90%.

Step 6: Darken the Mask

Black Grape S 4 V
Wash the entire foreground with Black Grape.

Terra Cotta S 4 V
Add random shapes to the background with Terra Cotta.

Dark Umber VS 3 C
Continue modeling the shape of the eyes with Dark Umber.

Warm Grey 90% S 4 LS
Continue to model the mask on the face, and build the fur pattern on the chest and legs with Warm Grey 90%.

Slate Grey S 3 ST
Stipple Slate Grey on the top of the nose.

Black S 4 L
Layer the inside of the ears with Black.

Step 7: Mix Colors to Add Complexity

Peacock Blue S 3 V
Dark Umber S 3 LS
Wash the entire background with Peacock Blue, then scribble some shapes in the foreground with Dark Umber.

Slate Grey S 3 C
Add Slate Grey to the midtone areas of the iris, very carefully blending around the pupil.

Terra Cotta S 3 C
Add Terra Cotta to the highlights in the eyes.

Black Grape, S 4 LS
Cool Grey 90%
Darken the mask with Black Grape and Cool Grey 90%.

Slate Grey S 3 LS
Light Umber, Clay Rose
Continue to build the midtone values and pattern in the fur with Slate Grey, Light Umber and Clay Rose.

Cool Grey 90% S 3 ST
Stipple the top of the nose with Cool Grey 90%.

White S 4 B
Press hard to burnish wispy hairs inside the ears.

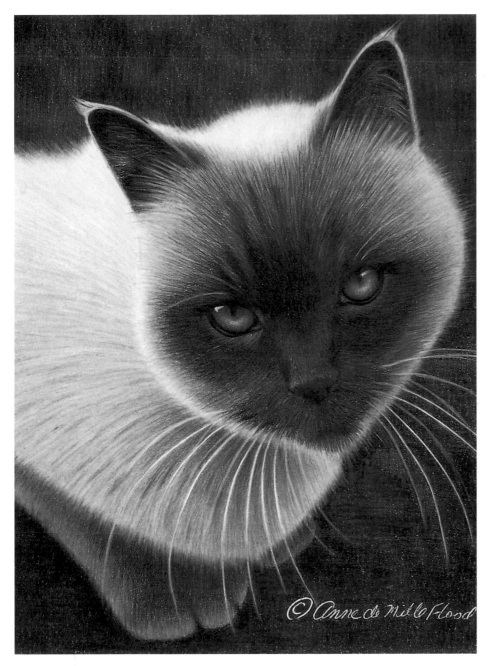
©anne de Mille Flood

Step 8: Finishing Touches

Dark Umber S 4 V
Wash the background with Dark Umber.

White S 4 B
Burnish the highlights in the eyes.

Dark Umber, Black S 4 LS
Darken the mask and all the areas that need it with Dark Umber and Black.

White S 4 B
Burnish the edges of the fur where they meet the background.

Dark Umber, White S 4 ST
Layer the top of the nose with Dark Umber and stipple with some White.

White S 4 B
Burnish along the edges of the ears with White.

Blue Slate S 4 L
Add Blue Slate to the impressed whiskers.

White S 4 B
Burnish some additional whiskers, and add a few delicate hairs above the eyes. Sharpen the tips of the existing impressed whiskers where necessary.

Siamese, If You Please!
10" × 8" (25cm × 20cm)
Private Collection

Evaluate Your Finished Piece

Layering colors to create the complexity of this seemingly simple Siamese cat is essential. Your cat should have a mask that is in contrast to the light gray fur surrounding it. If your mask is not distinct, go back and layer more of the dark colors to achieve the intensity needed to make it dramatic.

Check the edges of the cat's fur where it meets the background and see if you have burnished enough to give it the fuzzy appearance that makes the cat appear soft.

The background should be dark enough to create a halo effect around the cat, setting it off and framing it.

Tip When burnishing a light color into a darker color, you may see the darker color being pulled into the light area. This may make the edge look messy. To avoid this effect, wipe the tip of your White pencil occasionally. Also, burnish only where the two edges meet. Do not make large, sweeping strokes back-and-forth or you will drag too much of the dark color into the light area.

Fluffy *White Cat*

This sample shows once again the importance of bright, glowing eyes and how integral they are to a portrait. The brilliant, intense eyes contrast nicely with the soft, white fur.

At first glance, this white fur may seem difficult to portray because it appears that there is not a lot of color to work with. You may look at your reference photo and just see varying shades of white and not the potential for bringing those shadows to life. White fur is my favorite because I can be very creative and utilize unusual color combinations to make the shadows more dramatic. I leave some white paper where the light source is hitting the subject, and the viewer's eye interprets the whole image as varying degrees of white. Use this sample as a recipe for future situations when you would like to depict white fur.

I also encourage you to experiment with color combinations beyond what you see here. Use this sample as a starting point to get creative with your use of color. In my opinion, you can rarely have too many colors—even when the subject is white.

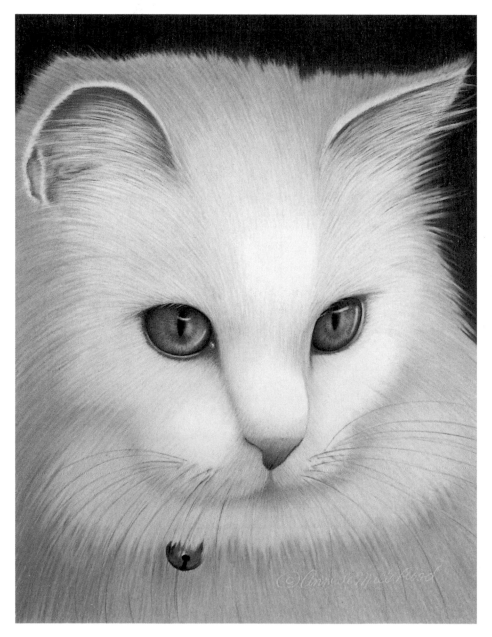

Snowflake
14" × 11" (36cm × 28cm)
Collection of Geri Peterson

EYES

Color				Instruction
Cream	VS	2	C	Apply an even, smooth first wash over entire iris; leave the highlight free of color.
Black Grape	S	4	L	Fill in pupil and outline edge of the iris.
Jasmine	S	3	L	Apply a layer to eyelid line.
Deco Yellow	VS	2	C	Wash iris again, except the highlight.
Indigo Blue	S	4	L	Add to pupil and outline edge of iris.
Pink Rose	S	3	L	Apply a layer to eyelid line.
Deco Blue	VS	3	C	Begin modeling the iris.
Limepeel	VS	3	C	Continue to model the eye and create shape by layering the outside edges of the iris.
Burnt Ochre	VS	3	C	Continue to model the eye, making sure to darken under upper eyelid. Darken edges of iris and add pattern near the pupil.
Olive Green	VS	2	C	Wash a light layer over the entire iris.
Henna	S	3	L	Apply a layer to the eyelid line.
Dark Umber	VS	3	C	Finish modeling the eye by darkening the outer edge of the iris and under the upper eyelid. Also apply a layer to the eyelid line.
Black	S	4	L	Apply a final layer to the pupil.
White	S	4	B	Burnish the highlight and add some reflection to the eyelid line.

NOSE AND EARS

Color				Instruction
Cream, Light Peach, Pink Rose	S	3	L	Apply washes of these three colors to the end of the nose and the fleshy areas inside the ears. Work around fur pattern inside the ears to create the effect of skin showing through the fur.
Yellow Ochre, Clay Rose	S	3	L	Begin to model the end of the nose with these two colors and add some definition to the inside of the ears. Be sure to apply inside the nostrils.
Henna	S	3	L	Apply a layer to the lower portion of the nose where it is in shadow. Apply a layer inside the ears.
Dark Umber	S	3	L	Darken the lower portion of nose.
White	SD	4	B	Burnish some hairs inside the ears, overlapping the background where necessary.

FUR

Color				Instruction
Warm Grey 10%	SD	4	LS	Apply first wash of white fur with a loose scribble stroke. Leave some areas free of color to denote highlights.
Warm Grey 20%	SD	4	LS	Apply this color to areas of fur that are more in shadow.
Light Peach	S	4	LS	Layer over all areas covered by Warm Grey 10% and 20%. Do not cover areas of highlight in the fur.
Pink Rose, Jade Green	SD	4	LS	Build the darker areas of the fur by layering these two colors in shadow areas.
Warm Grey 30%	SD	4	LS	Add this color to the shadows and add some streaks to the light areas.
Clay Rose	S	3	LS	Darken shadows again.
Mediterranean Blue	S	3	LS	Add accents with touches of this color throughout the fur.
White	SD	4	B	Press hard and burnish over all areas of the fur, blending the colors together. Pay special attention to the edge of the fur where the background meets the white fur. Burnish along this edge and make overlapping strokes with the White pencil. Clean the pencil point frequently to prevent it from dragging dark color into the white fur.

BACKGROUND

Color				Instruction
Black Grape, Peacock Green	SD	4	V	Apply washes of these two colors to the background, working carefully the around the edges of the cat to create a jagged pattern where the fur and background meet.
Tuscan Red, Indigo Blue	S	3	V	Continue to finish background with washes of these two colors until you are satisfied that the shade you have created frames the cat favorably. Go back and apply more of a prior color if you are not pleased. Complete the background before you burnish edge of the fur with the White pencil.

WHISKERS

Color				Instruction
Mediterranean Blue, Lavender, Limepeel	S	4	L	Make long, sweeping strokes to denote whiskers that will stand out against the white fur. You may also use these colors to add streaks of color inside the ears.
White Stabilo pencil	S	4	L	Finish off whiskers by applying a few more with this color.

Long-Haired Striped Cat

This beautiful cat's intense expression is nicely framed by the tiger-like markings and fullness of the fur surrounding the face. I also like this portrait because it gives me the opportunity to repeat a few pointers regarding reference photos.

In the case of this cat, she was extremely shy and did not want to be photographed. I think you can see by her expression that her eyes seem to be saying, "Stay away!" It took several attempts to get a shot of her, another reminder that the photography portion of portraiture can sometimes require a lot of time and patience. But taking numerous shots and waiting for the right moment are often worth the effort.

The long, striped fur is a good example of how to establish pattern through a process of layering color from the lightest to the darkest and building the stripes with each successive layer. Use the color chart to see how the fur developed, and remember to portray the effect of the colors flowing into one another with each step. The collar of white fur is burnished into the darker fur where the two areas merge. A colorless blender pencil was employed at the end to blend the fur colors. Press hard as you apply color to get the layered effect that occurs in this type of fur.

Tip

Remember that any background can be adjusted as you layer if you are not satisfied with the color combination or the effect you are getting. The colors I list are only suggestions that you can use as a springboard. I encourage you to try alternate colors or a different stroke pattern as you gain confidence and begin to develop your own style.

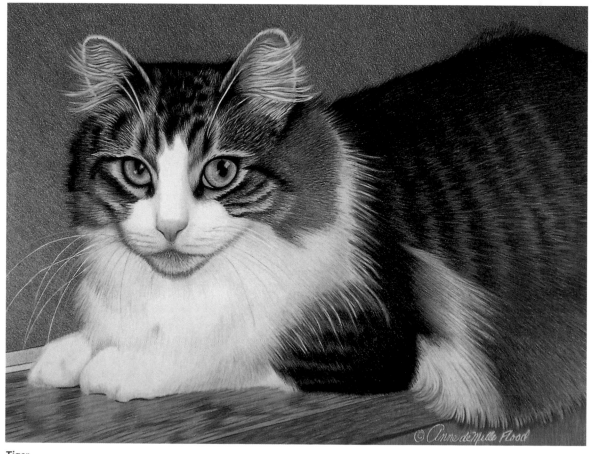

Tiger
12" × 16" (30cm × 41cm)
Collection of Emily Turner

Background

Deco Blue, Chartreuse	S	3	X	Wash entire background with a layer of each color.
Light Aqua	S	3-4	X	Apply another layer but begin to adjust pressure so that there is some variation in the layers.
Imperial Violet	S	3-4	X	Apply another layer with varying presure.
Peacock Blue	S	3-4	X	Wash entire background.
Indigo Blue	S	3	X	Apply in upper-right corner of background.

Eyes

Cream	VS	3	C	Wash the iris.
Black	VS	4	L	Fill pupil. Delineate edge of iris and eyelid line.
Jasmine	VS	3	C	Wash iris.
White	SD	4	B	Burnish iris to blend Cream and Jasmine together.
Deco Yellow	VS	3	C	Apply another smooth, even wash to the iris.
True Blue	VS	3	C	Layer area around pupil.
Terra Cotta	VS	3	C	Model outer edges of iris.
Dark Umber	S	4	L	Reinforce dark areas of pupil and edge of iris. Layer over eyelid line.
Black	S	4	L	Darken pupil, edge of iris and eyelid line one more time.
White	S	4	B	Burnish highlight on eyes.

Striped Fur

Beige	SD	4	LS	Establish basecoat over head and body, except white areas.
Jasmine	SD	3	LS	Layer over Beige.
Light Umber	SD	3-4	LS	Begin establishing dark stripes and markings on face and body.
Goldenrod	SD	3-4	LS	Apply a layer to midtone areas between stripes, blending the two areas together.
Mineral Orange	SD	3-4	LS	Layer over Goldenrod.
Dark Brown	SD	3-4	LS	Continue to build dark stripes and markings, blending into midtone areas.
Sepia	SD	3-4	LS	Continue to build the stripes and markings.
Dark Umber	SD	3-4	LS	Use for the darkest markings only.
Black	SD	3-4	LS	Enhance the darkest markings.

White Fur

French Grey 10%	S	3	L	Layer areas of white fur that are in shadow. Leave some paper free of color.
Greyed Lavender	S	3	L	Add to edges of white fur, along chin line and paws and to create definition in the white fur.
French Grey 20%	S	3	L	Darken edges again and layer over areas of Greyed Lavender.
Rosy Beige	S	3	L	Add along the edges and apply streaks throughout the white fur where it is darkest to give definition to fur and darken shadows.

Nose

Cream	S	3	V	Wash end of nose.
Light Peach	S	3	V	Wash end of nose again.
Jasmine	S	3	V	Begin modeling nose.
Blush Pink	S	3	V	Continue modeling nose.
Mineral Orange	S	3	V	Apply to lower part of nose that is in shadow and inside the nostrils.
Pink	S	3	V	Layer over Mineral Orange and inside nostrils.
Tuscan Red, Dark Umber	S	4	L	Layer inside edge of nostrils with both colors.

Whiskers

White	S	4	B	Burnish some whiskers with long sweeping strokes and be sure to overlap background.
Greyed Lavender	S	4	B	Apply some whiskers with long sweeping strokes, overlapping the areas of white fur.

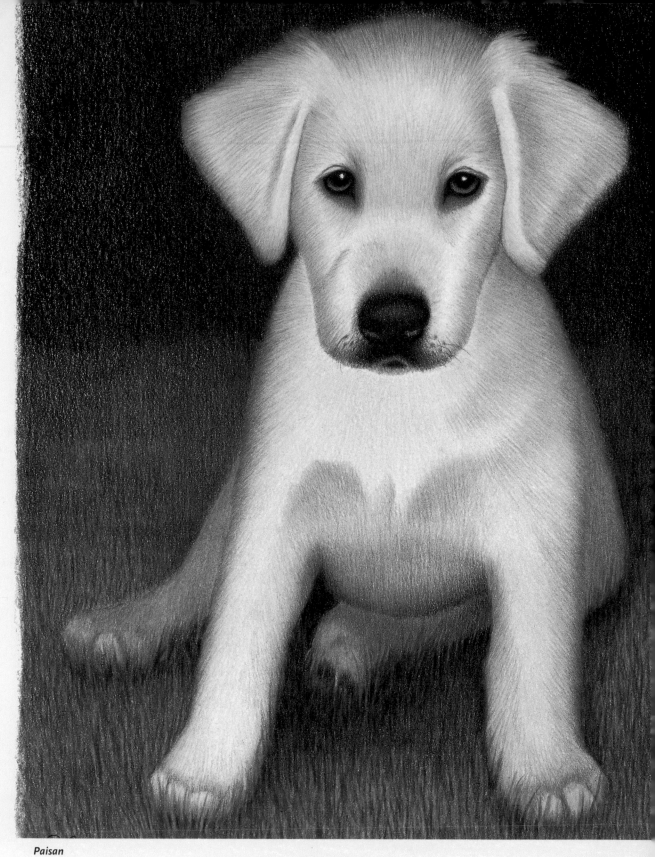

Paisan
12" × 9" (30cm × 23cm) • Collection of the Artist

Dogs

Anyone who owns a dog thinks theirs is the cutest and the smartest; however, I know for sure that my dog, Max, truly is. I have to admit that this chapter was my favorite to work on because Max was one of my first colored pencil portrait subjects. He is my loyal companion and never lets me forget that no matter how much there is to do, our walk is the best part of the day. I believe that most dog owners, like me, consider their dogs more than just pets, —they are friends, and that's what makes them such a popular subject for portraiture.

I have chosen four popular breeds to give you a good choice of fur color and type. Short and long fur, as well as tricolor and solid, are demonstrated on the following pages.

Apply what you have learned in previous chapters about fur technique and color to make your dog's portrait unique.

West Highland Terrier

This demonstration focuses on long fur and will show you how to apply some unusual colors combined with long, linear strokes to create a soft, layered appearance.

You will be challenged to work with a reference photo that is cropped on one side with poor lighting, a dilemma you may often face when working on your own. Learn how to overcome some of the disadvantages of poor photography with a few tips that I will share in the next few pages.

This Westie demonstrates how nicely colors can mix and blend to create a wonderful illusion of soft neutrals. Even though there are many colors in the fur, the use of complementary colors layered over one another gives the effect of shadows that are colorful yet muted. This is one of my favorite methods of building color and giving shape to a subject.

This subject also teaches you to adjust colors in your portrait if the reference photo is too dark or the colors are not pleasing. The finished subject does not match the reference photo, but you can see how nicely the changes work.

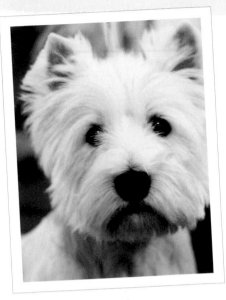

Westie Reference Photo
A not-so-good reference photo such as this can still be used to create a pleasing portrait. Learn to make changes if necessary and still have a successful result.

Westie Line Drawing
Before you begin, enlarge the line drawing to the size that you would like the finished piece to be. Then transfer the line drawing by gently tracing the image onto the Stonehenge paper with a no. 2 pencil. Impress your signature with an embossing tool. Blot the entire line drawing with a kneaded eraser. Sweep the paper with a drafting brush and you are ready to begin applying color.

MATERIALS

General Materials
Graphite pencil • Kneaded eraser
One piece Rising Stonehenge paper
Stylus or embossing tool
Colorless blender

Prismacolor Pencils
French Grey 10% • Indigo Blue • Black • Peach
Cloud Blue • Beige • Black Grape • Jasmine
Deco Blue • French Grey 30%
French Grey 50% • Dark Umber
Rosy Beige • Blue Slate • Clay Rose
Pumpkin Orange • Mediterranean Blue
Celadon Green • White • Henna • Peacock Blue
Slate Grey • French Grey 90%

© *Anne du Mills Flood*

 tip
The dog in the above photo is cropped on the right, preventing you from seeing clearly how the fur appears on that side. A good way to remedy this is to make a mirror image of your line drawing and place it under the Stonehenge paper. Match up the sides of the face as closely as possible and use the mirror image lines to give you a guide to create the fur on the side that is cropped. Do not trace exactly, as you do not want both sides of the fur to be exactly the same; you just want an outline that is balanced.

Point		Pressure		Stroke			
D–Dull	**SD**–Semi-dull	**1**–Very Light	**2**–Light	**V**–Vertical Line	**C**–Circular	**X**–Crosshatch	**B**–Burnish
S–Sharp	**VS**–Very Sharp	**3**–Medium	**4**–Full Value	**ST**–Stipple	**L**–Linear	**LS**–Loose Scribble	

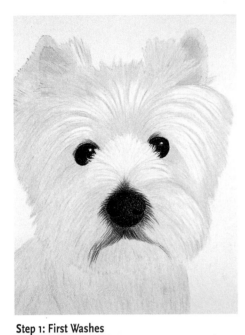

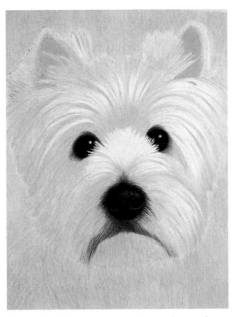

Step 1: First Washes

	Point	Pressure	Stroke
French Grey 10%	SD	3	L

Begin the fur with a wash over the entire head and chest. Make long, sweeping strokes that follow the direction of the fur. Leave some streaks free of color to show where the light areas will be.

Indigo Blue	S	3	C

Wash the entire eyeball but leave the highlight.

Black	S	4	L

Apply the first layer of the eyelid line.

Indigo Blue	S	3	C

Wash the entire nose with a circular stroke that begins to suggest texture.

Indigo Blue	SD	3	L

Add some streaks under the nose, working into the fur.

Black	S	4	C

Fill in the nostrils.

Peach	S	2	L

Wash the inside of the ears.

Step 2: Build Color and Begin the Background

Cloud Blue	S	3	V

Wash the entire background.

Beige	SD	3	L

Continue to build the fur with a layer of Beige over the first coat of French Grey 10%.

Black Grape	S	3	C

Wash the eyeball, outline the eyelid and work into the fur surrounding the eyes.

Black Grape	S	3-4	C

Reinforce the nostrils and begin modeling the nose by adjusting pressure to create shape and contour. Work into the fur surrounding the nose.

Jasmine	S	3	L

Layer over Peach inside the ears.

Step 3: Begin to Create Shape

Deco Blue	S	3	V

Wash the entire background.

French Grey 30%	SD	3	L

Begin creating shadow areas in the fur with streaks of this color. This is not a wash, so apply it randomly throughout the head and ears.

French Grey 50%	SD	3	L

The chin (a) and chest area (b) are in shadow, so wash both areas with this color.

Dark Umber	S	4	C

Wash the eyeball and eyelid line.

Black	S	3-4	C

Model the nose again, darkening the edges and inside the nostrils.

Rosy Beige	S	3	L

Wash the inside of the ears.

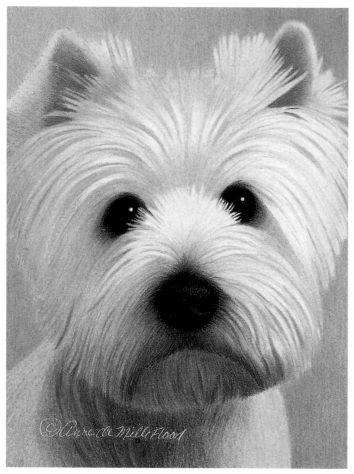

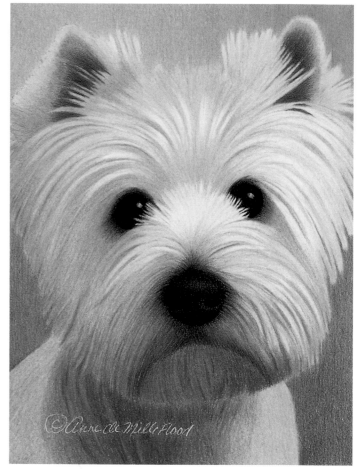

Step 4: Continue to Layer Color

Blue Slate S 3 V
Wash the background, except the upper-left corner.

Rosy Beige SD 3 L
Use this color to layer over the French Grey 30% on the head and ears. Again, make it a random application of streaks to give the fur a layered appearance.

Clay Rose SD 4 L
Layer over the French Grey 50% on the chin and chest area.

Indigo Blue S 3 C
Wash the entire nose.

Pumpkin Orange S 4 L
Layer near the center of the ears to give them a curved shape.

Step 5: Finish the Eyes and Nose

Mediterranean Blue S 3 V
Layer the lower part of the background.

Celadon Green SD 4 L
Layer over the Rosy Beige and Clay Rose on the entire head and chest.

White SD 4 B
Burnish the highlight in the eyes and the tip of the nose.

Henna S 4 L
Layer near the center of the ears to give them a curved shape.

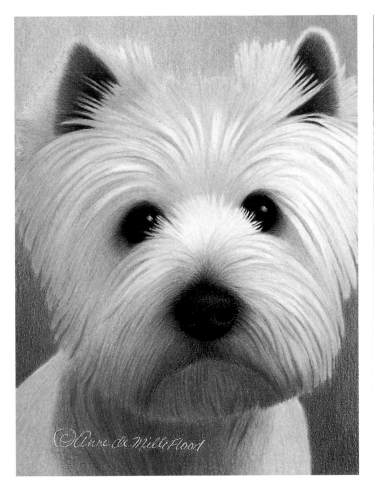

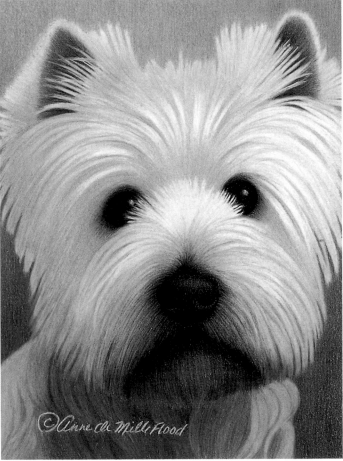

Step 6: Finish the Ears

Peacock Blue S 4 V
Darken the lower portion of the background.

Slate Grey SD 4 L
Darken the chin and chest area.

Peach SD 4 L
Apply randomly throughout the fur. This color will give some special emphasis and accent some of the streaks.

Dark Umber S 4 L
Darken just the center of the ears. Now they should look like they are curving inward.

Slate Grey S 4 L
Darken the inside edge of the ears.

Step 7: Finishing Up

Indigo Blue S 4 V
Darken the lower portion of the background and blend with a colorless blender.

Indigo Blue, Black Grape SD 4 L
French Grey 90% D 4 L
Use the above three colors to make sweeping linear strokes to intensify the shadow areas on the chin and chest. Press hard and make those shadows dark enough so they appear to recede.

White D 4 B
Burnish over the Black Grape and Indigo Blue along the edge of the chin to make it appear to overlap the chest area.

Peter
12" × 9" (30cm × 23cm)
Private Collection

demonstration

Golden Retriever

Every photo has its strengths and weaknesses. In the case of this Golden Retriever puppy, the lighting is both good and bad. I like the halo effect that the backlit light source creates, but it casts the eyes and nose in shadow, making it hard to see any definition in those areas. You can still work from this photo, but you must make adjust-

ments and use some tricks to get enough information to add the details that make it work. I will give you some tips to help deal with a less-than-perfect photo, but remember, photography of animals can be difficult, so if you don't have a perfect shot, learn to correct the flaws as you go.

Golden Retriever Reference Photo

MATERIALS

General Materials

Graphite pencil • Kneaded eraser
One piece Rising Stonehenge paper
Stylus or embossing tool

Prismacolor Pencils

Violet • Black • Yellow Ochre
Peacock Green • French Grey 10%
Black Grape • Indigo Blue
Beige • Burnt Ochre • Mulberry
Peach • Terra Cotta • Peacock Blue
Celadon Green • Mineral Orange
Dark Umber • Tuscan Red
Light Umber• Clay Rose
French Grey 30% • White

Golden Retriever Line Drawing
Before you begin, enlarge the line drawing to the size that you would like the finished piece to be. Then transfer the line drawing by gently tracing the image onto the Stonehenge paper with a no. 2 pencil. Impress the whiskers and your signature with an embossing tool. Erase the graphite whisker lines, then blot the entire line drawing with a kneaded eraser. Sweep the paper with a drafting brush and you are ready to begin applying color.

Remember that if a part of the animal is cropped, such as the ear in this line drawing, move the animal more to the center and sketch the ear. You can use the other ear as a model and draw it in reverse, or make a mirror-image line drawing to help you redraw the missing part.

In the case of a reference photo that has areas of deep shadow, such as the eyes in this shot, you may not be able to see enough detail to make an accurate line drawing. Placing the photo on a lightbox is often enough illumination to clarify those areas. If that is not clear enough, hold the reference photo closely against a lightbulb and you may be able to see the definition that is missing. If those methods fail, a third possibility is to use another photo that has a good, clear shot of the feature in question as your reference for that section. I often take a close-up of just the subject's eyes so I can use it as backup if my reference photo is too dark.

Point		**Pressure**		**Stroke**			
D–Dull	**SD**–Semi-dull	1–Very Light	2–Light	**V**–Vertical Line	**C**–Circular	**X** Crosshatch	**B**–Burnish
S–Sharp	**VS**–Very Sharp	3–Medium	4–Full Value	**ST**–Stipple	**L**–Linear	**LS**–Loose Scribble	

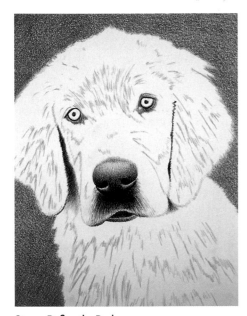 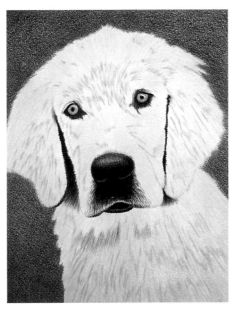 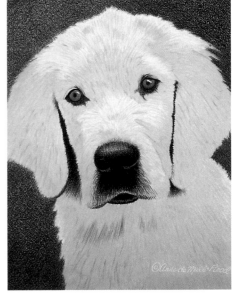

Step 1: Define the Darks

	Point	Pressure	Stroke
Violet	SD	3	X

Wash the entire background.

Black	SD	3	L

Establish dark shadow areas between the ears and face.

Yellow Ochre	SD	3	L

Outline major markings in the fur.

Black	S	3	C

Wash the pupil and outline the iris. Apply the first layer to the eyelid line.

Black	S	3-4	C

Begin modeling the nose. Remember, you are establishing both shape and texture with this step. Wash the lips and layer the fur under the nose.

Step 2: Begin the Light Fur

Peacock Green	S	3	X

Wash the background again.

French Grey 10%	SD	3	LS

Wash the entire dog, following the contour of the body with the stroke pattern.

Black Grape	SD	4	L

Layer over Black in the darkest areas of the fur.

Black Grape	S	4	C

Layer over the Black on the pupil in the eye. Layer over the Black on the eyelid line.

Yellow Ochre	VS	3	C

Wash the iris with a smooth, even layer.

Indigo Blue	S	3-4	C

Continue to model the nose and darken the mouth. Layer the fur under the nose.

Step 3: Begin to Add Shape and Contour

Indigo Blue	SD	3	X

Darken the upper-right corner and lower-left corner of the background.

Beige	S	3	LS

Layer over all the fur and adjust pressure to darken areas that give contour to the dog. Now it begins to take shape.

Burnt Ochre	VS	3	C

Wash the iris again and remember to make this layer smooth and even.

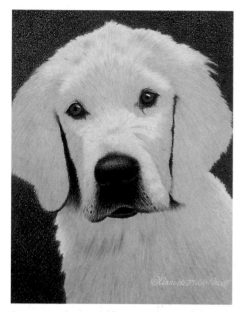 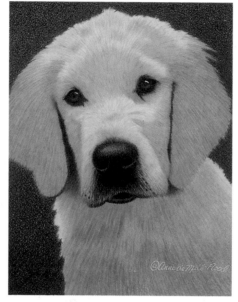 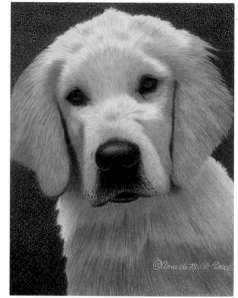

Step 4: Continue to Add Pattern and Shape

Mulberry SD 3 X
Wash the entire background, including both corners.

Peach S 3 LS
Layer over Beige in the fur, adding color where there is contour in the fur. Use a loose scribble stroke to build pattern in the fur.

Terra Cotta VS 3 C
Wash the iris again; don't lose the highlight.

Black Grape S 3 L
Wash the lips and fur under the nose.

Black Grape S 3 C
Continue to model the nose and make sure there is a lighter area at the top.

Step 5: Layer to Enhance the Fur Color

Peacock Blue SD 3 X
Wash the background.

Celadon Green SD 3 LS
Layer over Peach in the fur. Layer over the entire chest area. This color will darken the contours and shadows.

Mineral Orange SD 3 LS
Layer over all other areas including the ears, chest, sides of muzzle and around the eyes.

Dark Umber VS 3 C
Layer over the pupil, edge of the iris and eyelid line. Be sure to add to the shadow under the upper eyelid.

Black S 4 C
Darken the edges of the nose, the fur, under the nose and layer over the lips. Also, darken inside the nostrils.

Step 6: Continue to Build the Fur Pattern

Tuscan Red SD 3 X
Layer over the the upper right and lower left of the background.

Light Umber SD 3 LS
Layer over the entire chest and add details to the light areas of the fur.

Burnt Ochre SD 3-4 LS
Continue to build the fur pattern in the ears, on the chest and around the eyes with this color.

Black S 3 C
Add to the pupil and the edge of the iris in the eye. Darken the shadow under the upper eyelid.

Indigo Blue S 3 L
Add to the highlight in the eye.

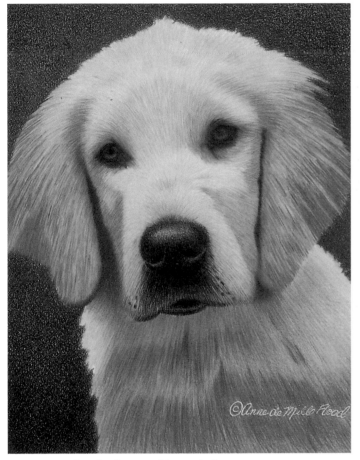

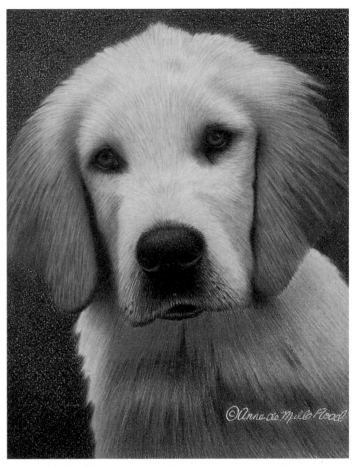

Step 7: Strengthen the Shapes and Pattern in the Fur

Peacock Green SD 3 X
Layer over Tuscan Red in the corners of the background.

Beige SD 4 LS
Press hard and blend this color into the light areas of the fur.

Terra Cotta SD 4 LS
Add to the ears and the fur around the eyes. Use a loose scribble stroke to promote and enhance the fur pattern.

Tuscan Red SD 4 LS
Layer in areas of shadow and continue to create a pattern in the fur on the ears with a loose scribble stroke.

Step 8: Finishing Up

Clay Rose S 3 LS
Add to the chest area.

Light Umber S 3 LS
Add pattern to the light areas of the fur.

French Grey 30% SD 3 LS
Add pattern to the light areas of the fur as you did with the Light Umber.

Dark Umber SD 4 LS
Darken te shadows and shapes where necessary, especially in the ears and on the chest.

Black SD 4 L
Add to the deepest shadows in the fur.

Black VS 4 C
Darken the skin surrounding the eye.

Black S 4 L
Apply a few whiskers with sweeping strokes.

White S 4 B
Burnish the highlight in the eye. Burnish along the edge where the fur and background meet, creating a halo effect. Burnish along the edge of the nostrils and the top of the nose. Burnish along the lower lids of the eyes.

Hunter

14" × 11" (36cm × 28cm)
Collection of the Artist

St. Bernard

You can see the dramatic effect of the tri-color combination that makes up the fur of this magnificent St. Bernard. Before applying color, impress some whiskers using a stylus.

You'll first establish the darks with a correct value pattern, then build the midtones, merging both sections and creating multi-colored fur that transitions smoothly from light to dark. This is set off by the large white blaze that runs down the center of the face. You can see how shading one side of the muzzle gives the face shape, and the highlight on the right suggests a strong light source from that direction.

The prominent nose shows the importance of creating texture, while the endearing eyes are a lesson in layering and burnishing.

Leave a White Background

To create a portrait with a white background such as this, you must be sure to blot the background frequently and constantly sweep debris from your work area. Dark colors create a lot of dust that can smear into clean, white paper and create a dingy appearance. Prevent this by being extra careful with each layer and constantly blotting the white area with reusable adhesive.

Harleigh
8" × 10" (20cm × 25 cm)
Collection of the Artist

FUR

Black Grape	S	3-4	L	Establish value pattern of dark fur areas.
Jasmine	S	3	L	Begin first layer of the midtone areas.
Indigo Blue	S	4	LS	Layer over Black Grape.
French Grey 10%	S	3	LS	Work on white fur by washing side of nose and chest area that are in shadow.
Goldenrod	S	3	LS	Wash midtone areas.
Pumpkin Orange	S	3	LS	Wash midtone areas.
Dark Umber	S	4	LS	Wash dark fur areas and blend into midtones.
Rosy Beige	S	3	LS	Wash areas of white fur that are layered with French Grey 10%.
Jasmine	S	3	LS	Add to white fur on left side of chest and under the chin.
Terra Cotta	S	3	LS	Blend into midtones.
Tuscan Red	S	3	LS	Join edges where midtones and dark colors merge.
Black	S	4	LS	Darken shadows where necessary.
Celadon Green	S	3	LS	Layer left side of chest and under the chin.
French Grey 30%	S	3	LS	Layer left side of nose.

EYES

Black Grape	S	4	L	Wash pupil, leave highlight free of color. Outline rim of iris. Wash droopy areas under the eyes.
Jasmine	VS	3	C	Wash iris.
Indigo Blue	S	4	L	Wash pupil, leave highlight free of color. Outline rim of iris. Wash droopy areas under eye.
Goldenrod	VS	3	C	Wash iris.
Dark Umber	S	4		Wash pupil, leave highlight free of color. Outline rim of iris. Complete droopy areas under the eyes.
Pumpkin Orange	VS	3	C	Wash iris. Add some to white of eyes.
True Blue, Deco Blue	S	4	L	Add to highlight in eye. Add to white of eyes.
Terra Cotta	S	3	C	Wash iris.
Black	S	4	L	Darken pupil and rim of eyes.
White	S	4	B	Burnish highlight in eyeball. Burnish lower lid of eyes. Burnish white of eye.

NOSE

See Dog Nose mini-demo in chapter 5—Facial Features, page 57.

WHISKERS

White	S	4	B	Burnish a few whiskers as a final step.
Deco Blue	S	4	B	Add color to impressed whiskers as a final step.

Yellow Lab
Puppy

This adorable puppy presents some special challenges for the artist. First, the light source is coming from directly in front of the puppy, causing shadows at the outside edges of the figure. This is more challenging than lighting that comes from the side, due to the fact that a frontal light source tends to flatten the features and washes out some of the important contrasts that create shape. Also, the light color and indistinct fur pattern combine to give you very little information to work with. Therefore, it is up to you to pro-vide the visual clues necessary to give the subject shape.

You can see that the dark background that surrounds the puppy creates a distinc-tive framework for the pet. I think this works well, because it contrasts with the delicate shading that defines the dog.

You'll learn that a subject like this requires good color choices and multiple layers to create enough pattern to give it form and definition.

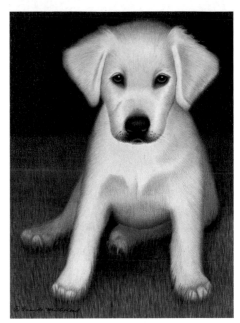

Paisan
12" × 9" (30cm × 23cm)
Collection of the Artist

FUR

French Grey 10%	SD	3	LS	Wash entire head and body.
Light Peach	SD	2	LS	Wash entire head and body.
French Grey 30%	S	3	LS	Begin establishing the shadow areas and create fur pattern.
Peach	S	3-4	LS	Layer over French Grey 30%, continuing to establish shadows and fur pattern.
Slate Grey	S	3	LS	Layer over outside edges of figure and begin establishing dark shadows on belly and rear legs.
Light Umber	S	3	LS	Layer over Slate Grey and continue to define fur pattern.
Sepia	S	4	LS	Wash over darkest shadow areas, such as the belly and rear legs.
Black	S	4	LS	Add touches of Black for darkest shadows.

EYES

Dark Umber	S	4	C	Wash pupil and delineate eyelid line. Leave a highlight.
Goldenrod	S	4	C	Wash iris.
Black	S	4	C	Wash pupil and delineate eyelid line.
Mineral Orange	S	4	C	Wash iris.
Sepia	S	4	C	Thicken eyelid line.

NOSE

Henna	S	3	C	Wash entire nose.
Black Grape	S	4	C	Fill in nostrils and begin to model the nose.
Indigo Blue	S	4	C	Fill in nostrils and continue to model the nose.
Black	S	4	C	Darken nostrils and outer edges of nose.

GRASS

Black	S	4	L	Establish a few dark shapes around toes and feet.
Apple Green	D	4	L	Wash entire grassy area.
Goldenrod	D	4	L	Intersperse some patches throughout the grassy area.
Burnt Ochre	SD	4	L	Intersperse some patches throughout the grassy area.
Olive Green	SD	4	L	Wash entire grassy area.
Dark Green	SD	4	L	Loosely cover all of the grass with strokes of Dark Green. Be sure to overlap toes and feet with some of each color as you build the grass.

BACKGROUND

Peacock Green	SD	4	V	Wash entire background.
Tuscan Red	SD	4	V	Wash entire background.
Indigo Blue	SD	4	V	Wash entire background and overlap the grass where the two areas come together.

WHISKERS

Black	S	4	B	Burnish a few whiskers around nose.

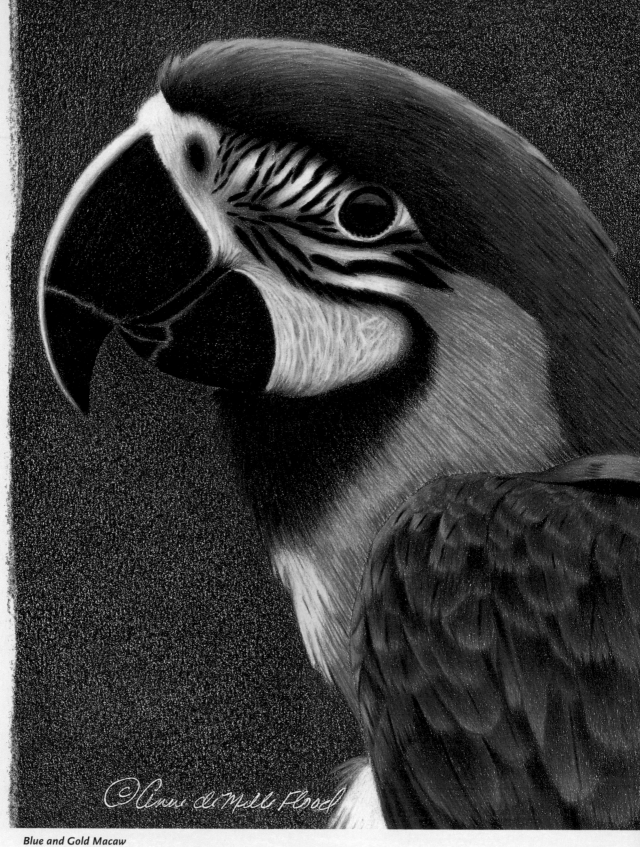

Blue and Gold Macaw
14" × 11" (36cm × 28cm) • Collection of the Artist

Birds

The incredible variety of the animal kingdom is no more clearly evident than in the avian world. I can still remember the first time I saw a Scarlet Macaw up close and could not wait to get home and portray that fabulous rainbow of colors. Since then I have completed over thirty bird portraits and never lose my fascination with the vibrant splendor of birds.

Their range of color, shape, size and adaptation is almost limitless. For this chapter I have chosen four examples that I hope will help you determine a strategy when starting your own picture of a favorite bird. From the soft and delicate pattern of a solid-colored canary to the bold and beautiful multicolored macaw, these samples are popular types of birds that many people own. If yours is not pictured here, use the information in previous chapters to adapt the color, texture and features specific to your bird.

Cockatiel

The cockatiel pictured in this demonstration is a good example of how to render feathers that do not have a lot of definition. This bird is lightly colored and for the most part the feather pattern is indistinct. However, the gray wing feathers will need to be represented individually. The rest of the bird can be easily created by layering colors and utilizing shadows to shape the body without delineating the individual feathers.

This demonstration also shows that you can enhance the subject even more by darkening and simplifying the background. I believe that backgrounds should frame the focal point and not compete with it. The choice of the complementary blues and violets to frame this light-yellow bird clearly demonstrates how to enhance a subject.

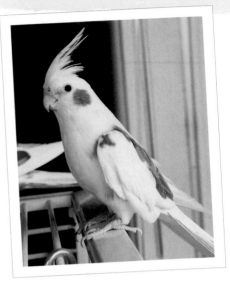

Cockatiel Reference Photo

MATERIALS

General Materials
Graphite pencil • Kneaded eraser
One piece Rising Stonehenge paper
Colorless blender

Prismacolor Pencils
French Grey 10% • French Grey 30%
Indigo Blue • Violet • Cloud Blue
Black • Beige • Pink Rose
Cream • Ultramarine • Jasmine
French Grey 70% • Clay Rose
Slate Grey • Deco Yellow
Blue Slate • Mineral Orange
Light Umber • Sunburst Yellow
Pumpkin Orange • White • Dark Umber

Cockatiel Line Drawing
Before you begin, enlarge the line drawing to the size that you would like the finished piece to be. Then transfer the line drawing by gently tracing the image onto the Stonehenge paper with a no. 2 pencil. Blot the graphite line drawing with a kneaded eraser. Sweep the paper with a drafting brush and you are ready to begin applying color.

Point		Pressure		Stroke			
D–Dull	**SD**–Semi-dull	**1**–Very Light	**2**–Light	**V**–Vertical Line	**C**–Circular	**X**–Crosshatch	**B**–Burnish
S–Sharp	**VS**–Very Sharp	**3**–Medium	**4**–Full Value	**ST**–Stipple	**L**–Linear	**LS**–Loose Scribble	

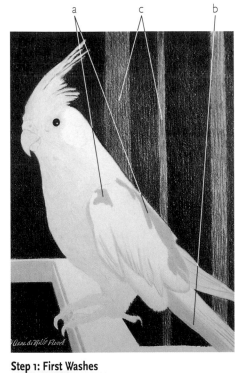

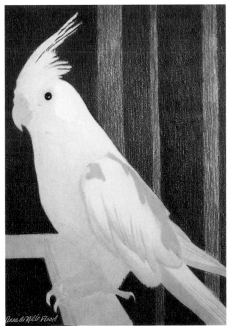

Step 1: First Washes

	Point	Pressure	Stroke
French Grey 10%	D	3	L

Use a directional stroke and a dull pencil point to wash the entire body and head, including the beak. This step begins to define shape.

French Grey 30%	SD	3	L

Wash the dark gray feathers (a) and under the tail (b). Again, follow the feather direction.

Indigo Blue	S	4	C

Wash the entire eyeball with a full-value layer; be sure to leave the highlight free of color.

French Grey 10%	S	3	C

Begin the feet with a wash using a circular stroke. This begins to create the rough texture of the feet.

French Grey 30%	S	4	V

Wash the inside edge of the cage.

Violet	SD	3-4	V

Wash the entire background, adjusting pressure to create vertical stripes (c).

Step 2: Begin Layering

Cloud Blue	SD	3	L

Layer over all the French Grey 10% and 30% on the head and body. Leave the cheek free of color. There is some blue in the feathers!

Black	VS	4	C

Layer over the Indigo Blue on the eye but don't loose that highlight.

Beige	S	3	L

Wash the entire beak again.

Pink Rose	S	3	C

Wash both feet again, remembering to create texture with the stroke.

Cloud Blue	SD	4	V

Wash the entire cage.

Black	SD	4	V

Add to the left side of the picture in the background.

Prevent Messy Edges by Creating a Barrier

It can be difficult to keep a dark background from bleeding into a lighter subject where the two edges come together. This close-up shows how to first create a barrier with the darker color using an even, circular stroke. Then the darker color is applied right up to the barrier. This technique allows a quicker application of color without the worry of creating a messy, uneven edge.

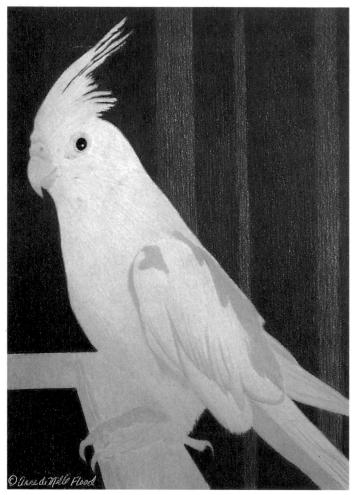

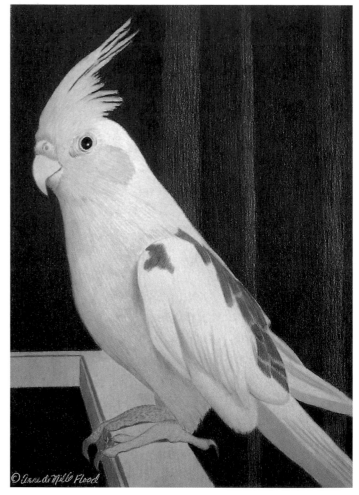

Step 3: Continue the Washes

Cream	SD	4	L

Wash the entire head and body, except for the dark gray wing feathers.

French Grey 30%	S	3	L

Begin the eye ring and add detail to the beak.

French Grey 10%	S	3	C

Wash the front foot.

French Grey 30%	S	3	C

Wash the back foot and continue to build texture in both feet.

Ultramarine	S	3	V

Wash the entire background.

Step 4: Begin to Create Shape

Jasmine	SD	4	L

Layer over the entire body, head and tail feathers, including the cheek. Leave the lighter-colored wing and gray feathers free of this color.

French Grey 70%	S	4	L

Layer over dark gray feathers.

French Grey 70%	S	3	L

Add detail to the eye ring by defining some wrinkles. Add detail to the beak and begin to layer the toenails.

Clay Rose	S	3	C

Create a speckled pattern on the feet with a loose, circular stroke.

Slate Grey	S	4	V

Add detail to the cage.

Indigo Blue	SD	3	V

Wash the entire background.

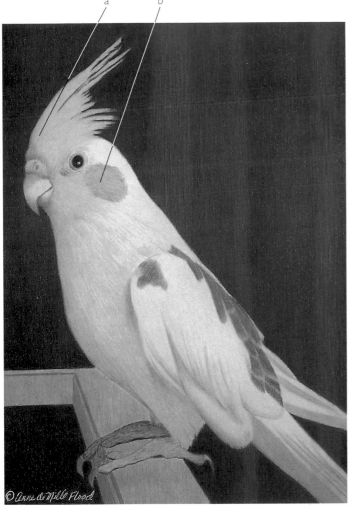

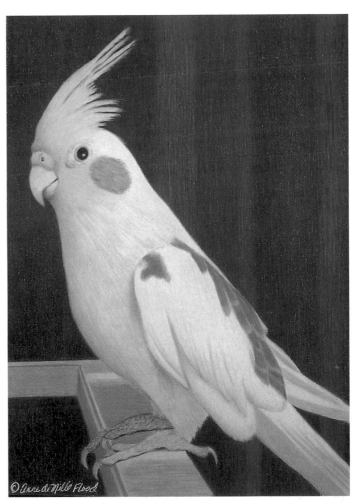

Step 5: Define the Feathers, Finish the Background

Deco Yellow S 4 L
Layer over the head (a) and cheek (b). Add some to the tail feathers.

Blue Slate S 3 L
Define the edges of the wings.

Mineral Orange S 4 L
Define the bright spot on the cheek (b).

French Grey 70% S 4 L
Darken the gray feathers.

Blue Slate S 3 L
Add to the eye ring

Light Umber S 3 L
Add detail to the beak.

Blue Slate S 4 V
Wash the entire cage.

Blue Slate S 4 V
Layer over the light streaks in the background.

Violet S 4 V
Apply this color as a final layer over the entire background.

Colorless blender SD 4 V
Blend the entire background.

Step 6: Finish the Feathers

Sunburst Yellow SD 4 LS
Add to the head, cheek and tail feathers.

Pumpkin Orange S 4 LS
Enhance the spot on the cheek.

Slate Grey S 4 L
Add to the chest where it is in shadow and layer over the dark gray feathers.

White SD 4 B
Burnish the head feathers and along all the edges.

White SD 4 B
Burnish around the eye ring.

Dark Umber S 4 L
Add details to the beak and define the edge between the upper and lower section of the beak.

White SD 4 B
Burnish along the edge of the beak.

Sassy

14" × 11" (36cm × 28cm)
Private Collection

Macaw

This gorgeous Blue and Gold Macaw exemplifies the value of using the grisaille (see page 27) method in your work. The grisaille gives you a clear road map of the configuration of the feathers and forces you to figure out the pattern before you begin to apply color. This method can be very time consuming in the first few steps but saves hours of extra work later by allowing you to reinforce what you have previously laid down.

The first step clearly shows how the darks, lights, shadows and shapes have been blueprinted for you to build on. Even though this macaw has three distinct color areas, I chose Black Grape as the underlying color for the grisaille. Black Grape also makes a good base for the beak and dark facial feathers. With the values correctly established, applying color is much easier!

The brilliant colors of the macaw, combined with a strong light source, require lots of underlying preparation to give this bird its dramatic three-dimensional look.

Macaw Reference Photo
Eliminate and simplify an unsuitable background such as the one behind this macaw. Often when it comes to backgrounds, less is more. Some well-chosen complementary colors are frequently the best solution to set off the subject nicely.

MATERIALS

General Materials
Graphite pencil • Kneaded eraser
One piece Rising Stonehenge paper
Colorless blender

Prismacolor Pencils
Black Grape • Clay Rose • Dahlia Purple
Chartreuse • Deco Blue • Canary Yellow
Aquamarine • Indigo Blue
Yellowed Orange • Pink Rose
Dark Umber • Pale Vermilion
Peacock Green • True Blue
Dark Green • Poppy Red
Black • Dark Purple
Peacock Blue • Violet
Pumpkin Orange • White

Macaw Line Drawing
Before you begin, enlarge the line drawing to the size that you would like the finished piece to be. Then transfer the line drawing by gently tracing the image onto the Stonehenge paper with a no. 2 pencil. Blot the graphite line drawing with a kneaded eraser. Sweep the paper with a drafting brush and you are ready to begin applying color.

Point		Pressure		Stroke			
D–Dull	**SD**–Semi-dull	**1**–Very Light	**2**–Light	**V**–Vertical Line	**C**–Circular	**X**–Crosshatch	**B**–Burnish
S–Sharp	**VS**-Very Sharp	**3**–Medium	**4**–Full Value	**ST**–Stipple	**L**–Linear	**LS**–Loose Scribble	

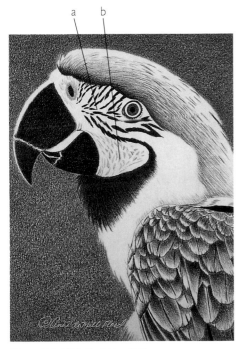

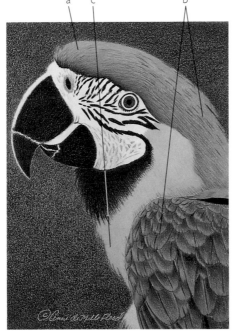

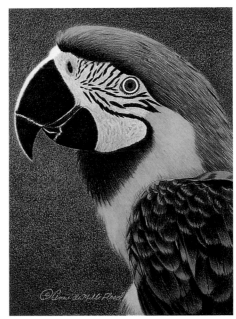

Step 1: Establish the Value Pattern

	Point	Pressure	Stroke
Black Grape	S	3	L

Use the grisaille method to create the feather pattern on the wing, head and throat. Be sure you are satisfied before continuing.

Black Grape	VS	3-4	C

Fill in the pupil, iris and delineate the rim of the eye and eye ring.

Black Grape	S	4	L

Apply the first layer to the beak, leaving areas free of color to designate cracks and highlights. Establish the small feathers in the facial patch (a).

Clay Rose	VS	3	L

Begin to establish the wrinkle pattern in the facial patch (b).

Dahlia Purple	S	3	X

Wash the entire background.

Step 2: Begin to Add Color

Chartreuse	S	3	L

Wash the crown of the head (a). Don't forget about stroke direction.

Deco Blue	S	3	L

Wash the back of the head and wing (b).

Canary Yellow	S	3	L

Wash the throat area (c).

Aquamarine	S	2-3	X

Apply to the background, starting in the lower-left corner, use gradually lighter pressure as you go upward. There is just a whisper of Aquamarine in the upper-right corner.

Step 3: Reinforce the Grisaille

Indigo Blue	S	3-4	L

Reinforce the grisaille on the wing and head and darken any shadow areas as necessary. Get your value pattern correct and the feathers will begin to look three-dimensional.

Indigo Blue	S	4	L

Layer over Black Grape on the beak.

Yellowed Orange	S	4	L

Layer over Canary Yellow on the throat, blending into the Black Grape.

Pink Rose	S	3	C

Wash the facial patch, working carefully around the dark feathers.

Tip

When I create a background such as the one pictured here, I start by covering the background with a complete layer of color applied in one direction. The next layer is applied in the opposite direction so that any imperfections from the first layer are quickly covered up. It's easy to get a rough appearance in color application if you continually layer in the same direction. That is why the crosshatch works so well, because it can correct the choppy areas as you continue to add color. Be sure to keep a sharp point as you layer, so the color dips down into the texture of the paper, creating a stippled effect.

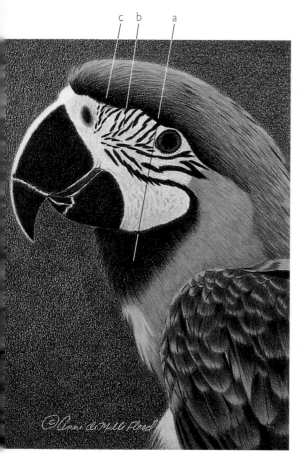

c b a

Step 4: Reinforce the Colors

Dark Umber S 4 L
Layer over the dark feathers and under the beak (a) and small feathers in the facial patch (b). Also add to the shadow area where the face and feathers meet (c).

Dark Umber VS 3 L
Delineate the eye ring and wash the eyeball and pupil.

Pale Vermilion S 4 L
Layer over the Yellowed Orange on the throat.

Peacock Green S 3 X
Layer in the lower-left corner of the background. As you go upward, gradually use lighter pressure.

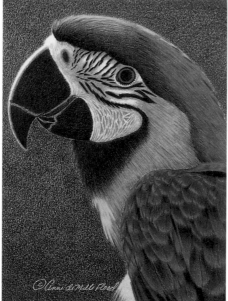

Step 5: Brighten the Feathers

True Blue S 4 L
Layer over all the blue feathers.

Dark Green S 3 L
Layer over the green feathers on the top of the head, leaving the crown of the head free of Dark Green.

Poppy Red S 4 LS
Add streaks to the yellow throat feathers with loose, choppy strokes.

Clay Rose VS 3 C
Add to the iris of the eye.

Clay Rose S 3 L
Continue to define and enhance the wrinkle pattern in the facial patch. Add definition to the crack in the beak with this color.

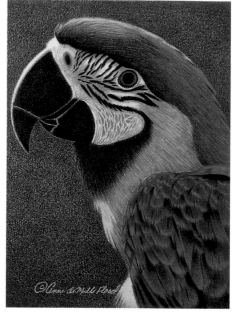

Step 6: Add Details With Black

Black S 4 L
Darken the small feathers in the facial patch. Reinforce shadows and add details to the wing and head feathers. Layer over the beak and darken the space between the upper and lower sections of the beak.

Black S 3 C
Darken the pupil of the eye, also reinforce the eye ring.

Dark Purple S 3 X
Wash the entire background.

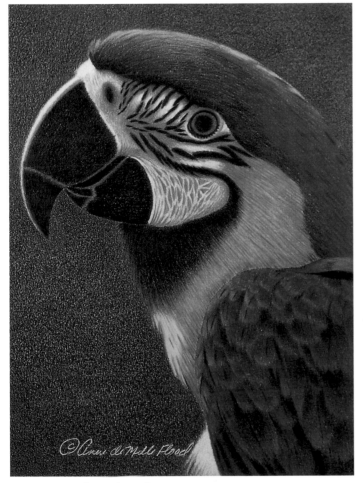

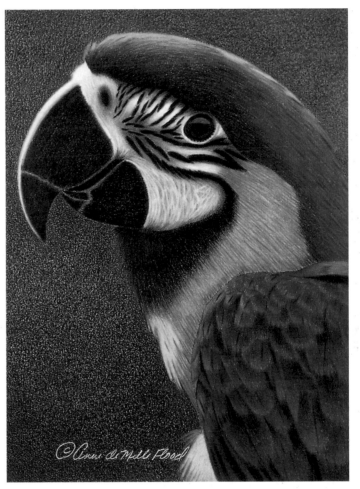

Step 7: Deepen the Feather Colors

Peacock Blue	S	4	L

Layer over all the blue feathers and press hard to blend well.

Violet	S	4	L

Add to the shadow areas on the blue feathers.

Pumpkin Orange	S	4	L

Add some more streaks to the yellow throat feathers. Add to the cracks in the beak. Add some details to the facial patch.

Aquamarine	S	3	X

Layer in the lower-left corner of the background.

Yellowed Orange	S	3	X

Add to the upper-right corner of the background.

Step 8: Finishing Touches

Clay Rose	S	3	L

Reinforce the shadows and details in the facial patch.

White	SD	4	B

Burnish the along the highlight on the beak. Burnish the white feathers on the chest. Burnish over the entire facial patch. Add a highlight to the eye.

Chartreuse	SD	4	B

Burnish the green area along the crown of the head.

Deco Blue	SD	4	B

Burnish the blue area along the back of the head.

Colorless Blender	SD	4	L

Blend all the edges of the bird where they meet the background. This will help prevent the halo effect that can occur if the subject and background are not joined completely. Blend all the feather areas.

Blue and Gold Macaw

14" × 11" (36cm × 28cm)
Collection of the Artist

Canary

This solid yellow canary is a good example of how complements can work together to give delicate definition as an undercoat before the body color is applied. Greyed Lavender applied first is the complement of the yellows which are to follow, and it creates the blueprint for the feather pattern, which is both soft and subtle. This is not a bird that needs each feather to be individually drawn. Instead, the process of using stroke, color and layering is intended to suggest the deli-cate feathers of this songbird. The subse-quent layers of color work together to add texture to the pattern and give shape to the body.

The cool blues of the background show how you can both frame and enhance the subject through the use of color. The finely blended background is a good example of how a colorless blender can aid in creating a smooth transition of color from light to dark.

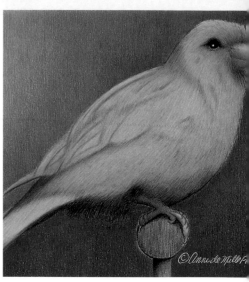

Apollo
10" × 8" (25cm × 20cm)
Private Collection

FEATHERS

Greyed Lavender	S	4	LS	Create a grisaille which indicates feather pattern and shadow areas on body and head.
Deco Yellow	S	3	LS	Wash entire body and head following feather direction with your stroke.
Spanish Orange	S	3	LS	Wash body and head again.
Goldenrod	S	4	LS	Apply to shadow areas on body and head.
Canary Yellow	S	3	LS	Wash body and head again.
Pumpkin Orange	S	4	LS	Apply loosely to add detail to pattern and to darken shadow areas on body and head.
Mediterranean Blue	S	3	LS	Apply to shadow areas on body.
White	SD	4	B	Burnish along top of head.

BEAK AND FOOT

Light Peach, Jasmine	S	3	C	Wash beak and foot with both colors.
Light Umber	S	4	L	Delineate edge between upper and lower sections of beak. Establish wrinkle pattern in foot.
Mineral Orange	S	4	C	Apply to lower part of the beak and bottom half of upper part. Apply to shadow areas on foot.
White	SD	4	L	Burnish top of upper part of the beak.
Dark Umber	S	3	C	Enhance the wrinkle pattern in the foot. Add details to the eye ring.

EYE

Indigo Blue, Black	S	4	C	Wash eyeball with a full-value layer of each color, leave highlight free of color.
Light Peach, Jasmine	S	3	L	Apply a layer of each color to eye ring.
Mineral Orange	S	3	L	Continue to layer eye ring.
Dark Umber	S	3	L	Add details to the eye ring and darken shadow area above eye.

BACKGROUND

Deco Blue, Blue Slate	SD	3	V	Wash entire background with both colors.
True Blue	S	2-4	V	Apply full value, starting on lower right, and fading upward on background. Use light pressure in upper-left corner.
Colorless blender	SD	4	V	Blend entire background.
Peacock Blue	S	2-4	V	Apply to lower right and fade upward on background.
Indigo Blue	S	2-4	V	Apply to lower right and fade upward.
Colorless blender	SD	4	V	Blend entire background again.

Budgerigar

Budgerigars, more commonly known as "budgies", are the most popular pet bird in the world. Their complex feather pattern and brilliant colors make them a wonderful subject for colored pencil portraits.

The budgie pictured here is a good example of how important it is to create an accurate and detailed feather pattern. This sample shows how the complex overlaying of the feathers is essential to the shape of the head, wings and tail feathers. Starting with a good, clear reference photo and a precise line drawing will enable you to correctly render these multifaceted features. This picture exemplifies why colored pencils are so perfect for rendering a realistic and detailed portrait.

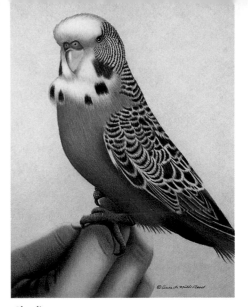

Charlie
14" × 11" (36cm × 28cm)
Private Collection

FEATHERS

Black Grape	S	3	L	Establish dark feather pattern of back, head and some tail feathers. Establish spots on throat.
Deco Blue	S	3	L	Begin blue feathers with a wash on chest and some tail feathers.
Greyed Lavender	S	3	L	Begin to shape white feathers around throat and top of head. Add to edge of dark feathers.
Violet	S	3	L	Establish patches on each cheek.
Sepia	S	3	L	Layer over Black Grape on back, head and tail feathers.
Slate Grey	S	3	L	Layer over Greyed Lavender on throat and head. Establish feather pattern in blue areas of chest and tail feathers.
Black Grape	S	3	L	Layer over Violet on cheeks.
Black	S	3	L	Darken throat spots. Add to dark feathers on wings, back, head and tail feathers.
Aquamarine	S	3	L	Layer over blue areas of chest and tail feathers.
White	S	4	B	Burnish white feather areas on head and throat. Burnish edges of dark feathers.
Peacock Blue	S	4	L	Darken blue feather areas where body is in shadow on lower chest and tail feathers.
Violet	S	4	L	Add to spots on cheeks. Add to darkest shadows of blue feathers.

EYE

Black	S	3	C	Wash pupil and delineate eye ring.
Sepia	S	3	L	Add a layer to pupil and eye ring.
Jasmine	VS	3	L	Fill in iris of eye.

BEAK

Jasmine	S	3	L	Wash beak and leave a highlight.
Slate Grey	S	3	L	Add to beak to create pattern.
Jasmine	VS	3	L	Wash beak again.
Sepia	S	3	L	Add shadows to beak.
White	S	3-4	B	Burnish highlight on beak.

FEET

Light Peach	S	3	C	Wash feet.
Black Grape	S	3	C	Begin creating textured pattern on feet. Darken toenails.
Slate Grey	S	3	C	Add more texture to feet.
Black	S	3-4	L	Add to toenails and to underside of feet.
White	S	3-4	B	Burnish some texture on feet and add a touch to toenails.

BACKGROUND

Cloud Blue	S	3	X	Wash background several times with a crosshatch stroke until you have an even layer of color.

HAND

Cream, Light Peach	S	2	V	Wash entire hand.
Jasmine, Peach, Blush Pink	S	3	V	Begin to model the hand with these colors, applying them over most of the skin except the lightest areas along thumb and middle finger.
Goldenrod, Terra Cotta, Pink, Pumpkin Orange, Tuscan Red, Dark Umber	S	3-4	V	Continue to model the hand with all of the colors, adjusting pressure to darken where there are creases and dark shadows.

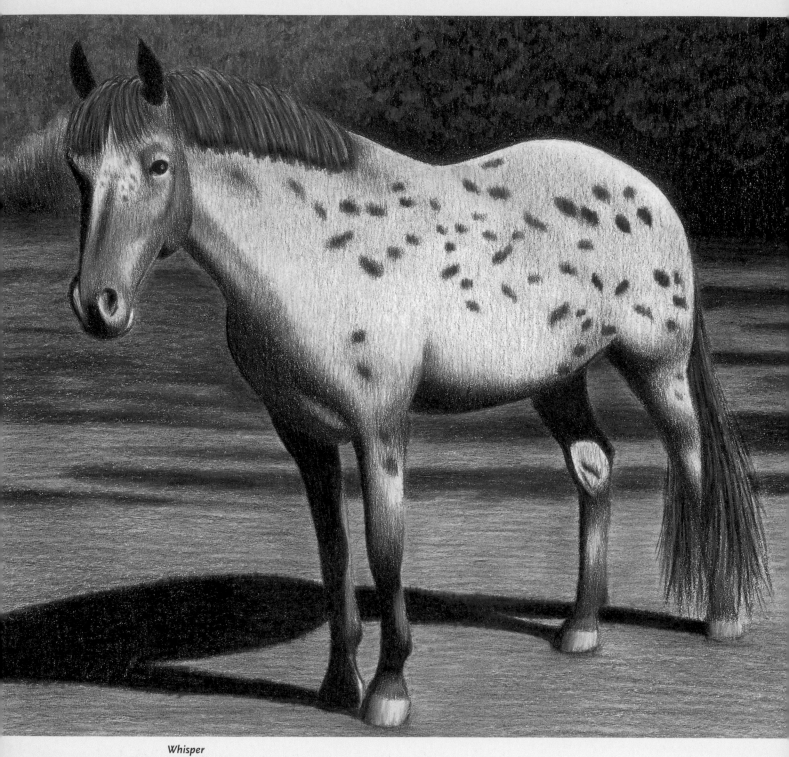

Whisper
8" × 10" (20cm × 25cm) • Private Collection

Horses

Horses are a wonderful subject for colored pencil. They possess a wide range of color and pattern while remaining remarkably alike in many other ways. Thankfully, the facial features, manes and tails can be similarly rendered so you often just need to concentrate on color and pattern.

Horses are large animals and not as commonly owned as cats, dogs and birds, but they are a very popular subject and there is a large demand for artists who can do commissioned work. Not being terribly familiar with horses myself, my first horse commission was a combination of fear of being stepped on and ignorance about the importance of which way the ears pointed. When the owner and I chose the reference photo, she exclaimed how fearful her horse looked in some of the pictures just because of the ears! I soon learned to pay careful attention to such important aspects of a horse's expression. I had no idea!

Keep in mind that you can apply the same basic techniques to many different horses, whether the portrait you wish to do is of an animal that you know very well or one commissioned by a complete stranger. Just personalize the portrait with color and markings. Oh, and don't forget to ask about those ears!

Black Horse

The beauty of this black horse lies in the wonderful sheen created by the sunlight falling on the glossy fur. I like the shine because it accentuates the dramatic bone structure of the face and body, but it challenges me to figure out some interesting color combinations that replicate the shine while toning it down to an acceptable level. Too much shine can be overpowering. So,

let's learn how to create rich, dark fur that has shine and luster without overwhelming the subject. This demonstration utilizes the technique of starting with a grisaille to establish the value pattern and then layering colors that develop the pattern. The final step of burnishing completes the effect and gives this black horse its radiance.

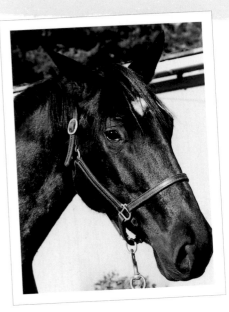

MATERIALS

General Materials
Graphite pencil • Kneaded eraser
One piece Rising Stonehenge paper

Prismacolor Pencils
Deco Aqua • Black • Lilac
Black Grape • Goldenrod
Aquamarine • Indigo Blue
Burnt Ochre • Violet • Terra Cotta
Pink • Peacock Green • Limepeel
Mediterranean Blue • Dark Umber
Sunburst Yellow • Parrot Green
Peacock Blue • True Blue
White • Chartreuse

Black Horse Reference Photo
The final step will differ from this photo in that the background has been softened and muted. The shine in the fur is toned down, creating a rich, black horse.

Black Horse Line Drawing
Before you begin applying color, enlarge the line drawing to the size you would like your finished piece to be. Then transfer the line drawing by gently tracing the image onto the Stonehenge paper with a no. 2 pencil. Blot the graphite lines with a kneaded eraser and sweep the paper with the drafting brush to ensure a clean working surface.

Step 1: Establish a Good Foundation

	Point	Pressure	Stroke
Deco Aqua	S	3	X

Wash the entire background.

	Point	Pressure	Stroke
Black	S	4	C

Fill in the eyeball and rim, leaving the highlights free of color.

	Point	Pressure	Stroke
Black	S	2-4	LS & L

Establish an accurate value pattern in the fur and mane; adjust your pressure in the dark and light areas. Make sure to apply Black, full value, to define the darkest areas of the horse (a). Notice how quickly you create the appearance of shine when your values are correct.

	Point	Pressure	Stroke
Black	S	4	L

Fill in the cast shadows and details on the bridle.

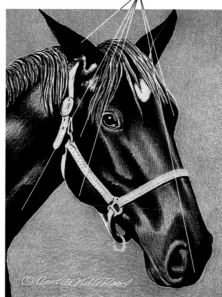

Point		Pressure			Stroke				
D–Dull	**SD**–Semi-dull	**1**–Very Light	**2**–Light		**V**–Vertical Line	**C**–Circular		**X**–Crosshatch	**B**–Burnish
S–Sharp	**VS**–Very Sharp	**3**–Medium	**4**–Full Value		**ST**–Stipple	**L**–Linear		**LS**–Loose Scribble	

You have seen that I have chosen two more colors in addition to Black to build the fur color. This is because Black is not as dramatic or interesting on its own. As stated previously, I always apply at least three layers to give depth to my work.

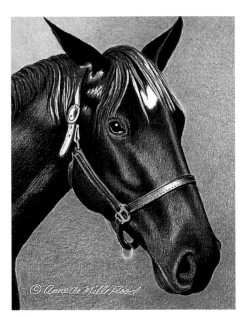

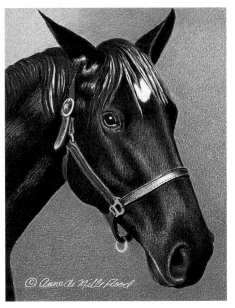

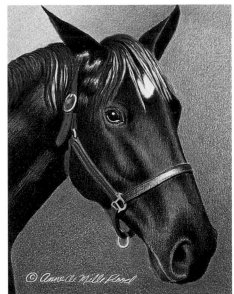

Step 2: Build on Your Foundation

Lilac S 3 X
Work on the background from the lower-right corner and shade gradually upward, leaving the upper-left corner untouched.

Black Grape S 4 C
Apply another full-value layer to the eyeball.

Goldenrod S 4 C
Detail the corner of the eye.

Black Grape S 2-4 LS & L
Continue building value patterns in the fur and mane by layering over the Black and adjusting pressure where necessary. Keep the value pattern in mind!

Goldenrod S 2-4 L
Create the stitches in the bridle and fill in the buckles.

Black Grape S 2-4 L
Reinforce the cast shadows and begin shading the bridle.

Step 3: Layer to Build Color

Aquamarine S 3 X
Continue shading the background starting in the lower-right corner, gradually moving upward. Leave the upper-left corner free of this color.

Indigo Blue S 2-4 LS & L
Build rich darks by layering over the Black Grape areas in the fur. Continue to follow the value pattern established in the previous steps.

Burnt Ochre S 3-4 L
Keep building the bridle colors with Burnt Ochre.

Step 4: Make the Shiny Areas Shimmer

Violet S 3 X
Shade upward, starting in the lower-right corner of background. Leave the upper-left corner alone.

Terra Cotta S 3 L
Add a touch to the corner of the eye.

Terra Cotta, Pink S 3 LS
Apply touches of Terra Cotta and Pink to the shiny areas of the fur and mane. These colors will be burnished later with White, so if you'd like, make them even more dramatic than you see here.

Terra Cotta S 3-4 L
Continue building the bridle colors.

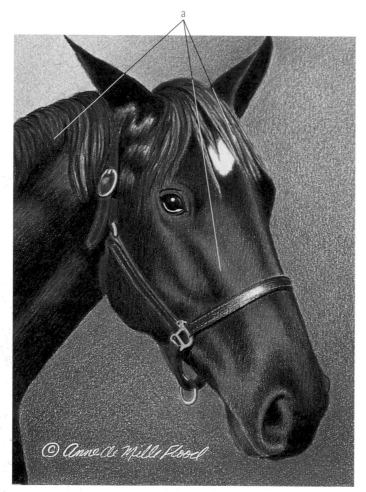

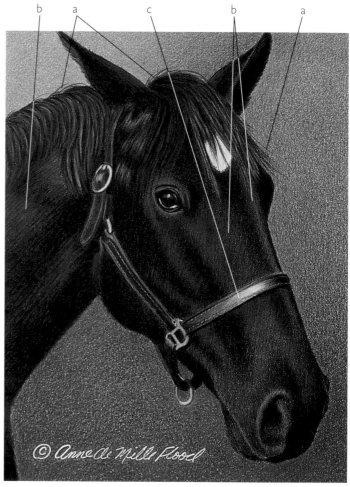

Step 5: Enhance the Picture

Peacock Green S 3 X
Continue to shade the background moving upward from the lower right, leaving the upper-left corner free of color.

Black S 3 L
Reinforce the eyeball and details around the eye.

Limepeel, Mediterranean Blue S 3 LS
Scatter bits of Limepeel and Mediterranean Blue on the shiny areas in the fur and mane (a).

Dark Umber S 3-4 L
Add details to the bridle.

Sunburst Yellow S 3-4 L
Add details to the buckles.

Step 6: Bring it All Together

Parrot Green S 3 X
Layer into the upper-left corner.

Peacock Blue S 3 X
Layer in the lower-right corner of the background. Blend both background colors where they merge.

True Blue S 4 B
Burnish along the edges of the highlight and bottom edge of the eye.

Black S 3-4 LS
Reinforce the dark areas of the fur. Also create wisps of delicate hairs where the mane overlaps the background (a).

Indigo Blue S 3-4 LS
Add to the shiny areas of the mane and fur (b). This color will tone down the shine before burnishing.

Black S 4 L
Add details to the bridle.

White S 4 B
Burnish the shiny areas of the bridle (c).

Check the Background

Check the background to see if it frames the subject effectively. Are the edges of the background and horse united, or is there a halo effect around the horse? If there is a halo effect, blend the edges where the background and horse come together with a colorless blender. If you are pleased with the end result, congratulate yourself on a job well done! If not, then proceed to step 7 for some added finishing touches.

Evaluate Your Finished Piece

Check your picture from a distance to be sure you are pleased with the result. If the fur doesn't look glossy, see if you have established a good value pattern. Are the dark areas deep enough? If not, go back and reinforce those areas with Indigo Blue and Black Grape. Have you pressed hard enough with the White pencil to make the shiny areas of the fur stand out? A good value pattern is essential to create the effect of shine. Does the eye look shiny and round? If not, lift a bit of color from the eyeball to enhance the highlight. Be sure you have burnished around the highlights to create a reflection.

Step 7: Finishing Touches

Chartreuse, Peacock Green S 3 X

Complete the background with a layer of Chartreuse in the upper-left corner and Peacock Green in the lower-right corner. Blend these two colors where they merge.

White S 4 B

Press hard with the White pencil, burnishing sufficiently to enhance the areas of shine on the fur and mane.

Midnight

10" × 8" (25cm × 20cm)
Collection of the Artist

Chestnut

I love how the shy, intelligent eye of this chestnut-colored horse gazes out at me and how the sunshine and fur color just say, warm. In this demonstration you will learn how to capture the effect of this sun-drenched horse by layering warm, golden colors and burnishing shiny areas. This demonstration differs from that of the black horse in the preceding pages in that you will still be creating shiny fur, but without the use of a grisaille. A few very deep value areas are first defined, then you will layer gradually from light to dark. You will see the fur pat-tern and shadows develop as you build color, defining the animal's shape.

I chose to surround this horse with a background that is a subtle combination of cool blues and green that I feel complement its warmth. Notice how the background is darkest at the top of the picture, contrasting with the parts that are bathed in sunlight, and gradually lightens up against the darkest areas of the neck and face—one of my favorite methods of enhancing light patterns.

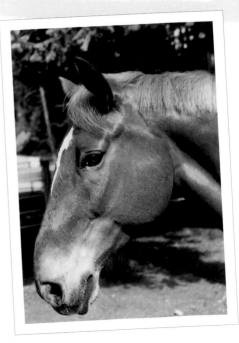

Chestnut Horse Reference Photo

MATERIALS

General Materials
Graphite pencil • Kneaded eraser
One piece of Rising Stonehenge paper
Stylus or embossing tool

Prismacolor Pencils
Indigo Blue • Dark Umber
Cream • Tuscan Red
Jasmine • French Grey 10%
Apple Green • Goldenrod
Parrot Green • Pumkin Orange
Warm Grey 90%
Chartreuse • True Blue
Terra Cotta • Peacock Blue
Black • Burnt Ochre • White

© Anne de Mille Flood

Chestnut Horse Line Drawing
Enlarge the line drawing to the size you would like your finished piece to be. Transfer the line drawing by gently tracing the image onto the paper with a no. 2 pencil. Blot the graphite lines with a kneaded eraser and sweep the paper with the drafting brush to ensure a clean working surface. Emboss a few hairs that overlap the background at the top of the head. Also, emboss a few hairs inside the right ear.

Point		Pressure		Stroke			
D–Dull	**SD**–Semi-dull	**1**–Very Light	**2**–Light	**V**–Vertical Line	**C**–Circular	**X**–Crosshatch	**B**–Burnish
S–Sharp	**VS**–Very Sharp	**3**–Medium	**4**–Full Value	**ST**–Stipple	**L**–Linear	**LS**–Loose Scribble	

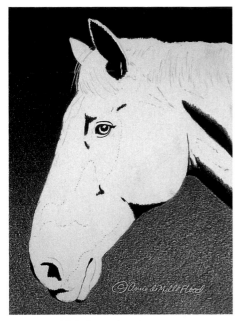

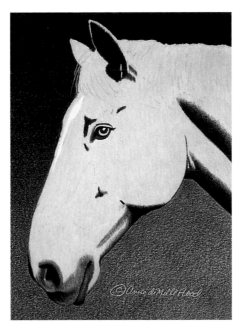

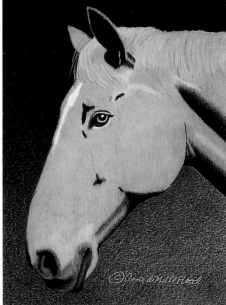

Step 1: Establish the Darkest Areas

	Point	Pressure	Stroke
Indigo Blue	S	3-4	X

Shade the background with Indigo Blue full value at the top and gradually lighten near the bottom.

Dark Umber	VS	4	L

Fill in the darkest shapes of the eye including the pupil. Leave a highlight.

Dark Umber	S	4	L

Fill in the darkest shadow areas of the fur including inside the ear.

Dark Umber	S	4	L

Fill in the darkest shapes in the nostrils and mouth.

Step 2: Establish the Fur-Begin Nose and Mouth

Indigo Blue	VS	4	L

Layer the eyeball and build the shape of the lids around the eye.

Cream, Tuscan Red	S	3	LS

Establish a basecoat of fur with Cream except for the blaze and dark areas. Layer the darkest areas with Tuscan Red.

Indigo Blue	S	3-4	L

Build the shape of the mouth and nostrils.

Step 3: Building Color

Peacock Green, Tuscan Red	S	4	X

Darken the upper background with full-value Tuscan Red and Peacock Green.

Jasmine	S	3	C

Wash the iris with an even layer.

Jasmine	S	3	LS

Layer the fur of the entire horse using a directional stroke. Do not cover the areas of highlights.

French Grey 10%	S	3	L

Layer the light areas of skin around the nose and mouth. This is the transition area between the fur and the skin.

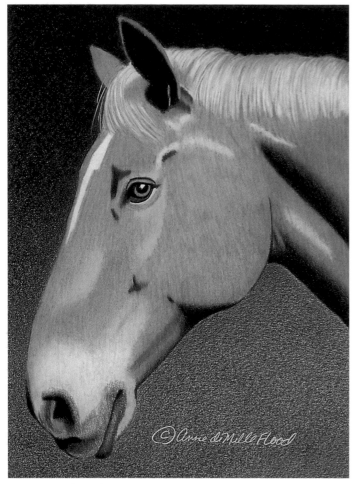

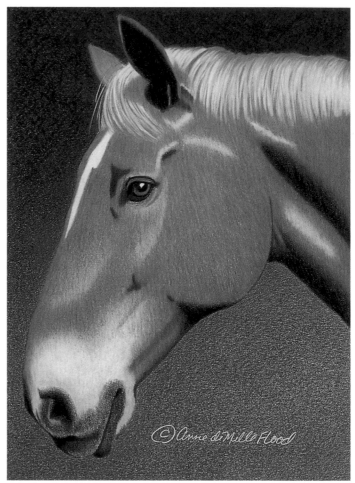

Step 4: Layer the Background and Fur

Apple Green	S	3	X

Wash the lower background with Apple Green.

Goldenrod	VS	3	C

Layer the iris with Goldenrod.

Goldenrod	S	3	LS

Layer the fur with Goldenrod, leaving the highlights free of color.

Step 5: Build the Fur, Model the Nose and Mouth

Parrot Green	S	3	X

Layer on the lower portion of the background.

Pumpkin Orange	VS	3	C

Layer the eye.

Pumpkin Orange	S	3	LS

Layer the fur.

Warm Grey 90%	S	3	L

Continue to create the shape of the nose and mouth by modeling them with Warm Grey 90%.

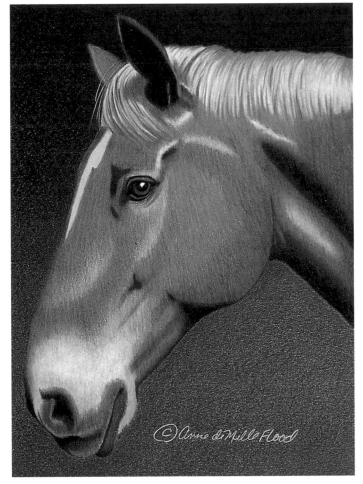

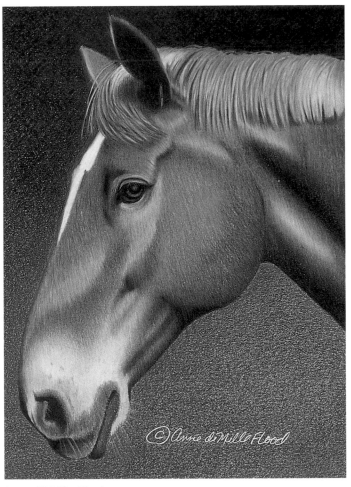

Step 6: Add the Details

Chartreuse, True Blue	S	3	X

Layer the lower portion of the background with Chartreuse and True Blue.

Terra Cotta	VS	3	C

Layer the iris.

French Grey 10%	S	4	B

Burnish the lower edge of the eye.

Terra Cotta	S	3	LS

Continue to model the fur.

French Grey 10%	S	4	B

Burnish the nose and mouth. This layer should soften and blend those areas.

Evaluate Your Finished Piece

The shine of this horse is achieved through the layering process and also by burnishing areas that have been left free of color. If your horse does not look glossy, ask yourself if you left enough highlight to give it a glow. Rich, dark shadows will also contribute to the effect of shine. Blending the fur colors as they are layered will achieve an overall look of glossy, glowing fur.

Step 7: Finishing Touches

Peacock Blue	S	3	X

Wash the background for the last time.

Black, Peacock Blue	VS	3	L

Reinforce the dark shapes in the eye with Black. Add Peacock Blue to the high-light and rim.

Dark Umber, Black	S	4	L

Reinforce the dark shadows in the fur with Dark Umber and Black.

Burnt Ochre, Tuscan Red	S	3	LS

Blend Tuscan Red and Burnt Ochre into the midtone areas.

White	S	4	B

Burnish highlights into the fur with White.

Black	S	4	L

Reinforce the dark shapes in the nose and mouth with Black.

White, Warm Grey 90%	S	4	B

Add fine hairs with White. Add freckles with Warm Grey 90% then burnish them with White.

Appaloosa

When I saw this charming horse standing in a field, I was struck by the dappled markings that give this breed their unique appearance. The spotted pattern and coloring of the Appaloosa varies widely, so each horse's look is uniquely its own. The spots on this horse stand out nicely against the soft gray of the fur.

It is easy to end up with a "pasted-on" effect when creating spotted fur, so it's important to incorporate the pattern with each layer. This sample shows you how the simultaneous build-up of the spots while layering the colors of the fur, gives this pattern an integrated appearance. Be sure to work on merging the edges of the spots and the lighter areas so they seem to be joined.

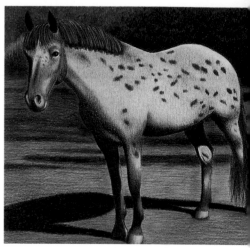

Whisper
8" × 10" (20cm × 25cm)
Private Collection

EYE

Black	S	4	C	Fill the pupil and rim.
Indigo Blue	S	4	C	Cover the Black.
White	S	4	B	Burnish the highlight.

MANE AND TAIL

Black	S	4	L	Establish dark shapes.
Indigo Blue	S	3	L	Layer midtones.
Warm Grey 90%	S	3	L	Layer over Indigo Blue.
White	S	4	B	Burnish strands.

FUR AND SPOTS

Black	S	3	LS	Establish spots and define darkest shadows.
French Grey 10%	S	3	LS	Wash entire horse.
Warm Grey 90%	S	3	LS	Layer spots and shadows.
Light Umber	S	3	L	Apply to nose and legs
Warm Grey 20%	S	3	LS	Wash entire horse again.
White	S	4	B	Burnish and blend all of gray fur. Do not cover spots. Work along edges of spots to join the edges.
Black	S	4	LS	Layer over spots one more time and work along edges to make them join with light areas.

HOOVES

French Grey 10%	S	3	L	Wash hooves.
Black	S	4	L	Establish dark shadows.
Warm Grey 20%	S	3	L	Create shape by modeling the hooves.
Light Umber	S	3	L	Continue modeling the midtones of the hooves.

GRASS

Limepeel	SD	4	LS	Wash entire grass.
Indigo Blue	SD	4	LS	Establish shadow areas.
Black	SD	4	B	Darken shadow cast by horse.
Burnt Ochre	SD	4	LS	Add some color to light areas of grass.
Dark Green	SD	4	LS	Darken shadow areas and add to light areas also.

BACKGROUND

Tuscan Red	SD	4	V	Establish patches of color.
Indigo Blue	SD	4	V	Continue to create patches of color, overlapping Tuscan Red.
Dark Green	SD	4	V	Wash over Indigo Blue and Tuscan Red. Lift random patches with electric eraser or reusable putty.
Peacock Blue	SD	4	V	Wash entire background again.

Bay

The rich black mane, clean white blaze and lustrous red fur give this bay a distinctive appearance. The cocked ears signal attentiveness as she gazes intelligently from her dark eyes.

The fur colors are layered gradually from lightest to darkest, leaving the white blaze free of color. The mane is built with the darkest shapes first and finished by burnishing the midtones with white streaks.

The green tones of the grass and background perfectly complement the warm, red tones of the fur.

This sample also shows that when rendering a background behind a subject, you don't need to be completely realistic. You can suggest greenery by quickly layering blotches of many colors, then randomly lifting shapes with your electric eraser. A wash over this mixture of color and shapes will unite the illusion and the viewer's eye will see the forms that suggest a tree or bush. This allows you to work more quickly than if you tried to draw each leaf.

Clementine
14" × 11" (36cm × 28cm)
Collection of Kim Pratt

EYE

Black	S	4	C	Wash entire iris, except highlight.
Indigo Blue	S	4	C	Wash iris again.
Pink	S	3	C	Layer in corner of eye.
Deco Blue	S	4	B	Burnish around highlight

MANE

Black	S	4	L	Layer darkest shapes in mane.
French Grey 90%	S	3	L	Layer midtones.
Indigo Blue	S	3	L	Layer midtones again.
White	S	4	B	Burnish strands of mane.

FUR

Goldenrod	SD	3	L	Wash entire horse with directional strokes.
Pumpkin Orange	SD	3	L	Wash entire horse again.
Terra Cotta	S	3	L	Begin building contours and the shadows.
Tuscan Red	S	3	L	Continue building contours and shadows.
Dark Umber	S	4	L	Darken contours and shadows again.
Black	S	4	L	Enhance just the darkest shadows.
Dark Brown	S	3	LS	Work all over the horse, blending areas together.
White	S	4	B	Burnish some shine on the fur.

BRIDLE

Black	S	4	L	Establish all the darkest shadows and areas of the bridle.
Sepia	S	4	L	Layer midtones.
Indigo Blue	S	4	L	Create reflections on bridle.
White	S	4	B	Burnish some shine on bridle.

BUCKLES AND RING

Deco Yellow	S	4	L	Outline edges of all.
Pumpkin Orange	S	4	L	Add some detail.
Dark Umber	S	4	L	Darken shadow areas.
Slate Grey	S	4	L	Add reflections.

BACKGROUND AND GRASS

Limepeel	SD	3-4	V	Wash entire background and grass.
Indigo Blue	SD	3-4	V	Darken shadow areas in grass. Add dark shapes to background.
Grass Green	SD	3-4	V	Cover shadow areas in grass and add some random pattern.
Tuscan Red	SD	3-4	V	Create random, blotchy shapes in background.
Dark Green	SD	3-4	V	Cover Tuscan Red areas and add more random shapes.
Pumpkin Orange	SD	3-4	V	Add more random shapes.

Lift some random shapes with an electric eraser. Wash the entire background with Grass Green and Peacock Green.

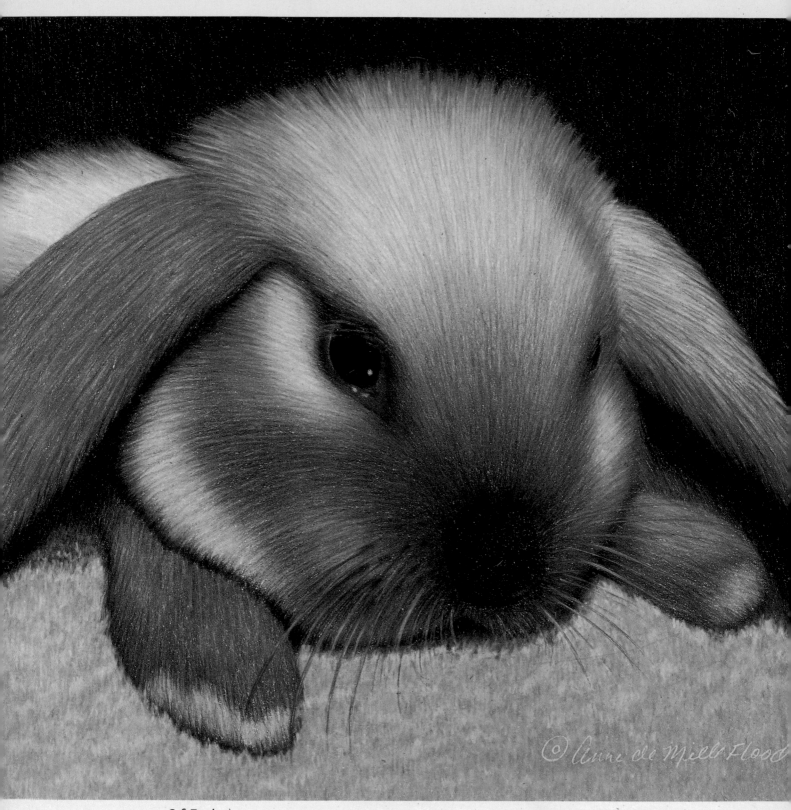

Soft Touch
11" × 14" (28cm × 36cm) • Collection of the Artist

Cuddly Friends

Cuddly is the only word that perfectly describes these adorable creatures that often fit into the palm of a hand and whose most endearing feature is that they are just so darn cute!

Whether it is a fluffy bunny, a silky guinea pig or a downy hamster, we just love to hold it and feel its softness.

This chapter will give you some tips on working with very small animals and how to give your portrait a tangible appearance that is so inviting that the viewer will just want to reach out and touch it!

Bunny

You have learned a lot about fur throughout this book, but this demonstration adds one more aspect to that knowledge. Everyone who looks at this bunny comments that they just want to touch it, and that feeling is exactly what you should achieve by doing this exercise. You will use the colorless blender pencil several times throughout this demonstration to blend layers and create the illusion that this bunny is irresistibly cuddly.

You will create a dark, simple background to surround the light-colored bunny. You will also develop the foreground with texture and color to contrast with the softness of the bunny's fur (a nice strategy to employ when you want to enhance your focal point).

The stars of this portrait are the bunny as well as the exceptional softness of the fur.

Bunny Reference Photo

MATERIALS

General Materials
Graphite pencil • Kneaded eraser
One piece Rising Stonehenge paper
Colorless blender • White Stabilo pencil

Prismacolor Pencils
Dark Umber • Indigo Blue
French Grey 10% • Light Peach
Cream • Black • Light Umber • Jasmine
Sepia • Yellow Ochre • Dark Purple
French Grey 20% • French Grey 50%
Blush Pink • Rosy Beige • Dark Green
Cloud Blue • Deco Blue

Bunny Line Drawing
Before you begin applying color, enlarge the line drawing to the size you would like your finished piece to be. Then transfer the line drawing by gently tracing the image onto the Stonehenge paper with a no. 2 pencil. Blot the graphite lines with a kneaded eraser and sweep the paper with the drafting brush to ensure a clean working surface.

Point		Pressure		Stroke			
D–Dull	**SD**–Semi-dull	**1**–Very Light	**2**–Light	**V**–Vertical Line	**C**–Circular	**X**–Crosshatch	**B**–Burnish
S–Sharp	**VS**–Very Sharp	**3**–Medium	**4**–Full Value	**ST**–Stipple	**L**–Linear	**LS**–Loose Scribble	

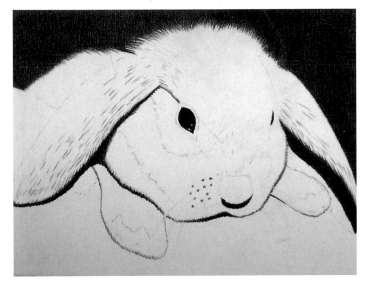

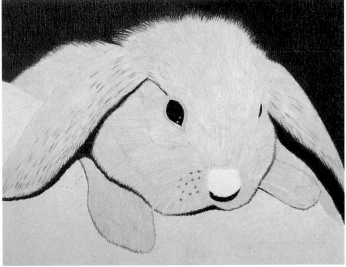

Step 1: Begin With the Darks

	Point	Pressure	Stroke
Dark Umber	SD	4	C

Fill in the eyeball and leave the highlight free of color. Notice how I rounded the eye to make it look more open than it appears in the reference photo. I also added a small crescent on the right to indicate the other eye.

Dark Umber	SD	4	LS

Establish the darkest shadows under the ears, nose and paws.

Indigo Blue	SD	4	V

Wash the entire background but be sure to work carefully around edges of the bunny.

Step 2: Begin the Washes

French Grey 10%	SD	3-4	LS

Begin establishing the fur pattern with this first wash.

Light Peach	S	3	L

Outline the rim of the eye.

Cream	SD	3	C

Begin establishing the texture of the blanket.

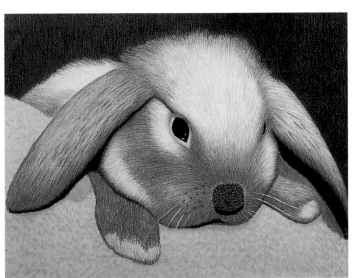

Step 3: Darken the Shadows, Begin the Fur Pattern

Black	SD	4	LS

Layer over the Dark Umber in the shadows.

Black	S	3	C

Add to the eyes but do not cover the highlight.

Light Umber	S	3-4	LS

Begin to establish the fur pattern on the ears, face and paws. Make your strokes follow the shape of the bunny.

Jasmine	SD	3-4	LS

Continue to create texture in the blanket with stroke and pressure.

Jasmine	S	3	L

Layer over the Light Peach along the rim of the eye.

Dark Umber	S	3	C

Apply the first layer to the nose.

 Tip

Remember that your eye can fool you when it comes to fur direction. Turn both your reference photo and your drawing upside down when working on the edges where the fur and background come together. Since the first layer of the background color is dark, it is important to get this edge applied accurately right from the beginning.

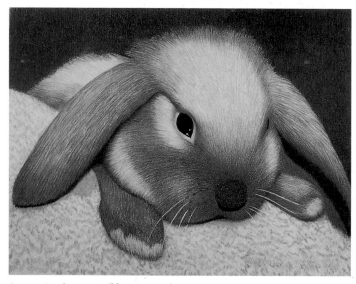

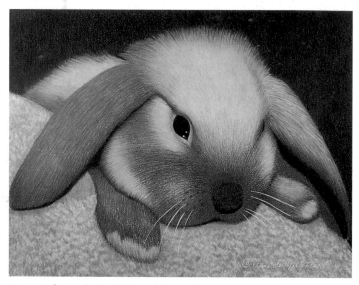

Step 4: Continue to Build Pattern and Texture

Sepia S 4 C
Layer over the Dark Umber on the nose, using a tight circular stroke to create a soft texture.

Sepia S 3-4 LS
Layer over the areas of Light Umber on the ears, face and paws. Use heavier pressure to darken where necessary.

Yellow Ochre S 3-4 LS
Layer over the entire blanket and continue to build texture. Begin the shadows around the bunny.

Dark Purple S 4 V
Continue to layer the background with another wash.

Colorless blender S 4 L
Follow the shape of the bunny and press hard to blend the layers of the fur.

Step 5: Soften and Blend With a Colorless Blender Pencil

French Grey 20% S 3 LS
Layer over the gray areas of the fur. Loosen your stroke to show the fur pattern clearly.

French Grey 50% S 3 LS
Layer over the left ear only.

Blush Pink S 3 L
Layer over the Jasmine along the rim of the eye.

Blush Pink, Rosy Beige D 3 LS
Scribble over the entire blanket.

Dark Green SD 4 V
Complete the background with this layer.

Colorless blender S 4 V
Blend the background so it is smooth and dark.

Colorless blender S 4 L
Follow the shape of the bunny, and press hard to blend the layers of fur.

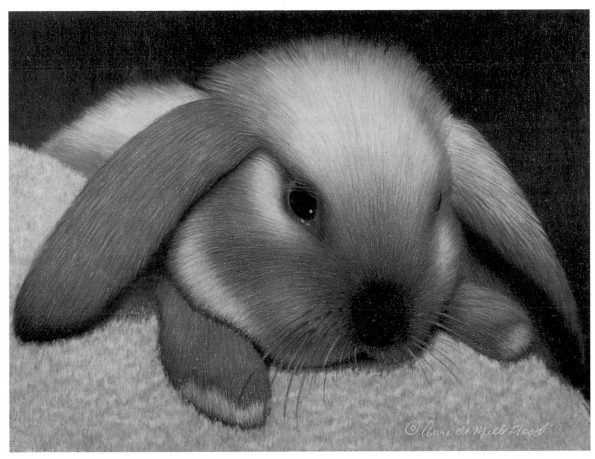

Step 6: Finishing Up

Sepia S 3 LS
Darken the shadows cast by the bunny onto the blanket.

Black S 4 LS
Add to the darkest shadows around the edges of the bunny.

Black S 3 C
Use a very small, circular stroke to finish the nose and give it a velvety effect.

Dark Umber S 3-4 LS
Continue to build the fur pattern in only the darkest areas.

Light Umber S 3 LS
Blend along the edges where the fur and background meet. Add some whiskers.

Colorless blender S 4 L
Press hard and blend all areas of the fur. Be sure to work carefully along the edges where the fur and background meet.

White Stabilo pencil S 4 L
Add some whiskers and eyelashes. Touch up the highlight on the eye.

Cloud Blue, Deco Blue SD 4 LS
Scribble both colors over the entire blanket.

Soft Touch
11" × 14" (28cm × 36cm)
Collection of the Artist

Guinea Pig

Whenever I choose a reference photo, I always take into account how I can make the animal look its best. In the case of this guinea pig, I decided to get in very close and focus on the face and the interesting fur pattern. Guinea pigs tend to look boxy in a body shot, so it can be difficult to create a good composition. You can see from this picture that I filled the frame with the subject and did not include much background or foreground. Don't be afraid to get in close and get a really clear shot. Remember, the animal is the heart of the portrait, and sometimes all we really need to see is an intimate glimpse of its expression. You know your pet best, so choosing a photo should be easy. You have the best opportunity to capture it when it is the most adorable.

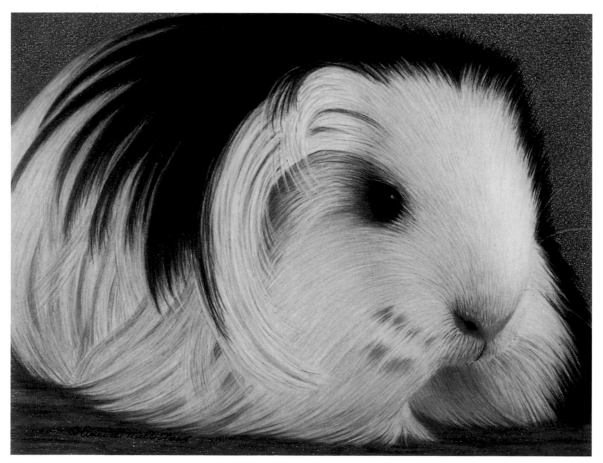

Mavis
11" × 14" (28cm × 36cm)
Collection of Laura Shane

Eye

Color				Description
Black	S	4	C	Wash the eyeball, except highlight.
Indigo Blue	S	4	C	Layer over Black; don't cover the highlight.
Light Peach	S	3	L	Apply first layer to eyelid line.
Jasmine	S	3	L	Layer over entire eyelid line.
True Blue	VS	3	L	Add to highlight.
Yellow Ochre, Pink	S	3	L	Layer over the entire eyelid line with both colors.
Clay Rose	S	3	L	Apply final layer to eyelid line.
White	SD	4	B	Burnish the highlight in the eye and burnish along the eyelid line.
Light Umber	S	3	L	Apply to eyelid line and fur around the eye to create shadow.

Fur

Color				Description
Black	SD	4	L	Begin the dark fur with a full-value layer and elongated strokes to denote the long fur.
French Grey 10%	SD	3	L	Apply the first layer of the light fur following the contours of the body and using elongated strokes as with the dark fur. Leave the right side of the nose free of color.
Indigo Blue	SD	4	L	Continue to layer the long dark fur, use heavy pressure for dark, rich color.
French Grey 30%	S	3	LS	Continue to layer the light fur with an open, loose stroke to define fur pattern.
Yellow Ochre	S	3-4	L	Continue to build the pattern in the light fur, adjusting pressure to create areas of shadow.
Slate Grey	S	3	L	Blend along edges where light and dark fur meet. Add some streaks to areas of light fur.
Black	S	3-4	L	Layer over the dark fur again, adding wisps of fur along edges where light and dark fur meet.
Celadon Green, Rosy Beige	S	3	L	Add streaks of both colors to light fur to continue to build shadows and contours.
Light Umber	S	3	L	Layer in darkest shadow areas including around the eye, under the nose and throughout the light fur.
White	S	4	B	Burnish the final details along edges where light and dark fur meet. Use the White pencil to burnish wisps of detail through the light fur. Burnish a few whiskers.

Nose

Color				Description
Light Peach	S	3	V	Wash the nose.
Jasmine	S	3	V	Apply a second wash.
Light Umber	S	3	L	Darken inside nostrils.
Yellow Ochre, Pink	S	3	V	Apply another layer of each color to nose and inside nostril.
Clay Rose	S	3	V	Apply final wash to nose.
Dark Umber	S	4	L	Darken inside nostrils.

Background

Color				Description
Yellow Ochre, Mulberry, Aquamarine, True Blue	S	3	X	Apply successive washes of the colors using a crosshatch stroke—continue to apply color until you are satisfied with the smoothness and combination. With this method you can adjust the shade by whichever color you decide on for the last layer.

Foreground

Color				Description
Slate Grey, Warm Grey 90%	SD	4	L	Wash back-and-forth with Slate Grey and Warm Grey 90%.
White	S	4	B	Burnish with some White.

Hamster

So diminutive that they fit into the palms of
our hands, hamsters are one of the smallest
and most fragile pets to own. Every feature
is tiny, so a large reference photo will help
you clearly see all the details and will make
the process go more smoothly.

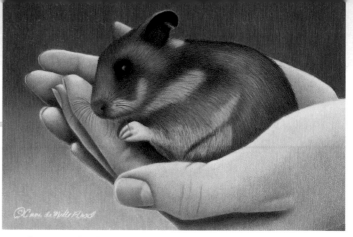

Hands Down Adorable
11" × 14" (28cm × 36cm)
Collection of the Artist

FUR

French Grey 10%	S	3	LS	Apply the first layer of the gray fur.
Jasmine	S	3	LS	Apply the first layer of the brown fur.
Goldenrod	S	3	LS	Continue to layer the brown fur.
French Grey 30%	S	3	LS	Layer over areas of French Grey 10% on fur, but make the stroke more loose and open.
Mineral Orange	S	3	LS	Layer over Goldenrod on fur.
Light Umber	S	3	LS	Layer over areas of gray fur to create fur pattern.
Colorless blender	S	4	V	Work over all of fur with blender pencil.
Terra Cotta	S	3	LS	Continue to layer the brown fur but adjust pressure and stroke accordingly.
Yellow Ochre	S	'3	LS	Layer over areas of gray fur, loosely to create pattern and shadow.
Dark Brown	S	3	LS	Continue to create pattern in both brown and gray fur.
Colorless blender	S	4	V&L	Work over all of fur with blender pencil.
Dark Umber	S	4	LS	Add pattern to the fur and darken the shadows.

PAWS

French Grey 10%	S	3	LS	Wash the paws.
Jasmine	S	3	LS	Begin to shape the paws.
Deco Pink	S	3	L	Continue to model the paws.
Mineral Orange	S	3	LS	Model the shape of the paws.
Blush Pink	VS	3	V	Finish the paws.

NOSE

Jasmine	S	3	L	Wash the nose.
Deco Pink	S	3	L	Add a layer to the nose.
Mineral Orange	S	3	LS	Wash the nose.
Blush Pink	VS	3	V	Wash the nose.

Pink	S	3	V	Add a layer to the nose.
Tuscan Red	S	3	V	Finish with a touch of Tuscan Red, then Dark Umber inside the nostril.

EYE

Black	VS	3	C	Wash the eye.
Indigo Blue	VS	3	C	Wash eye, leave highlight free of color, and outline rim of eye.
Deco Blue	S	3	V	Add to highlight in eye.
Black	S	3	C	Darken the eye and eye rim.
Indigo Blue	S	3-4	V	Add to edges of highlight in eye.

EAR

Black	VS	3	C	Wash the inside of ear.
Indigo Blue	VS	3	C	Layer over the Black.
Black	S	3	C	Darken inside the ear.

HANDS

Cream, Light Peach	VS	1	V	Wash both hands.
Deco Pink	S	3	L	Begin to model the hands.
Peach	VS	3	V	Continue to model the hands.
Mineral Orange	VS	3	V	Continue to model the hands.
Blush Pink	VS	3	V	Continue to model the hands.
Pumpkin Orange	S	3	V	Continue to model the hands.
Tuscan Red	S	3	V	Layer over the darkest shadows only on the hands.
Dark Umber	S	4	LS	Layer over the Tuscan Red on hands.

WHISKERS

Light Umber	VS	2	L	Add some delicate whiskers.

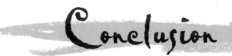

Conclusion

Congratulations! If you are reading this, I hope you have successfully completed a colored pencil portrait of your pet. Don't worry if your first attempt wasn't what you hoped for, and don't give up! I went through a lengthy process of try and try again until I found techniques, color combinations and methods that worked for me. If you reflect on each portrait that you attempt, you will soon realize that you learned quite a lot from every one. You will see improvement with each portrait, I promise!

I have tried in this book to make the process as simple as possible to follow, but I cannot stress enough the importance of simply persevering. As I tell my students frequently, the desire to succeed is just as important as the fabled "talent" that we all hope we possess. Improve your skills through practice, and that knowledge will enhance your talent enormously. So keep at it! This book has shown you a lot about technique, color and materials, so now you must put your heart into your pet portrait to make all those elements come together.

As your confidence grows and you build a portfolio of successful pictures, you can then decide what to do with your art. Is this pastime simply recreation and relaxation for you, or would you like to take it seriously enough to turn it into a money-making venture? That's strictly up to you; but in either case, remember that you are the one who is responsible for your success or failure. How well you deal with criticism and your ability to focus on the positive feedback that you receive will greatly influence your success. Turn to your family and friends for support, but be willing to look for objective opinions from other artists to help you improve your craft. In other words, find the balance between praise and critique that will help you grow as an artist.

In conclusion, I would like to share with you how amazing this journey as an artist has been for me. It has been exhilarating and frustrating, discouraging and exciting, up and down. In short, it's heaven and hell, occasionally at the same time. But it's so very worth it, especially when I create a portrait that captures the essence of a being.

Thank you from the bottom of my heart for buying this book. Continue your learning beyond what I have offered here, let your own creativity be your guide, and don't forget—never give up!

Double Delight

These two adorable Clouded Leopard cubs were another occasion for me to try my hand at wildlife art. They were born to parents Raja and Josie at the Point Defiance Zoo and Aquarium in April 2003, and I was allowed access to them for a photography session. What a rare opportunity! They are important additions to the population of this endangered species, and I was delighted to be able to capture their engaging and endearing image in this colored pencil portrait.

Double Delight
15" × 13" (38cm × 33cm)
Collection of the Artist

index

A-B

Appaloosa horse, 114
Avians, 92-103
 beaks, 63-65
 budgies, 103
 canary, 102
 cockatiel, 94-97
 eyes, 42, 50-51
 Macaw, 98-101
Bay horse, 115
Beaks, 63-65
Birds. *see Avians*
Black horse, 106-109
Budgies, 103
Bunny, 118-121
Burnishing, 13

C

Canary, 102
Canines, 80-91
 eyes, 42, 48-49
 Golden Retriever, 86-89
 noses, 57-58
 St. Bernard, 90
 West Highland Terrier, 82-85
 Yellow Lab, 91
Cats. *see Felines*
Chestnut horse, 110-113
Circular stroke, 12
Cockatiel, 94-97
Color, 10
Color wheel, 21
Conclusion, 125
Crosshatch stroke, 12
Curly fur, 31

D-E

Dogs. *see Canines*
Drafting brush, 18
Electric eraser, 21
Enlarging photographs, 22

Equines, 104-115
 Appaloosa, 114
 bay horse, 115
 black horse, 106-109
 chestnut horse, 110-113
 eyes, 42, 46-47
 mouths, 55-56
 noses, 55-56
Erasers, 19
Eyes, 40-51
 avian, 42, 50-51
 canine, 42, 48-49
 equine, 42, 46-47
 feline, 42-45

F

Feathers, 35-39
 patterns, 37
Felines, 66-79
 eyes, 42-45
 noses, 54
 Siamese cats, 72-75
 striped cats, 78-79
 tabby cats, 68-71
 white cats, 76-77
Fur, 24-39
 curly fur, 31
 long fur, 28
 shiny fur, 30
 short fur, 29
 stroke pattern, 26
 value pattern, 26

G-L

Glue, 20
Golden Retriever, 86-89
Gouache, 21
Graphite pencils, 18
Graphite transfer paper, 20
Grisaille, 27
Guinea pig, 122-123
Hamster, 124

Highlight, 14
Horses. *see Equines*
Introduction, 8-9
Layering, 14
Lifting compounds, 19
Line drawings, 22
Linear stroke, 12
Long fur, 28
Loose scribble stroke, 12

M-N

Macaw, 98-101
Materials, 16-23. *see also Supplies*
 color-mixing guide, 21
 color wheel, 21
 drafting brush, 18
 electric eraser, 21
 erasers, 19
 glue, 20
 gouache, 21
 graphite pencils, 18
 graphite transfer paper, 20
 lifting compounds, 19
 paper, 18
 pencil extender, 19
 pencil sharpener, 18
 pencils, 18
 photographs, 16-17
 studio, 16
 stylus, 19
 super glue, 20
 tape, 19
 tracing paper, 20
 workable fixative, 20
Modeling, 14
Noses
 canines, 57-58
 equine, 55
 feline, 54

P

Paper, 18
Pencil extender, 19
Pencil sharpener, 18
Pencils, 18
Photographs, 16-17
 enlarging, 22
Point, 10-11
Portraits
 Annie, 61
 Anticipation, 8
 Apollo, 102
 Blue and Gold Macaw, 92, 101
 Bonnie and Clyde, 33
 Calvin, 32
 Champion HMS Pure Joy, 55
 Charlie, 102
 Clementine, 115
 Double Delight, 125
 Freckles, 34
 Gabby, 34
 Hands Down Adorable, 124
 Harleigh, 90
 Hunter, 89
 Kimba, 32
 Kimbaroo, 64
 Louie, 35
 Mavis, 122
 Midnight, 109
 Miki, 64
 Misty, 62
 Molucca, 65
 Mustafa, 24, 27
 Nikki, 71
 Oscar, 65
 Paisan, 80, 91
 Peter, 85
 Poquita, 52, 64
 Pumpkin, 62
 Raja, 5
 Sassy, 97
 Shadow, 33
 Shelty, 34
 Siamese, If You Please!, 66, 75
 Snowflake, 76
 Soft Touch, 116, 121
 Spinner, 27
 Tango, 65
 Tiger, 78
 Watching and Waiting, 15
 Whisper, 104, 114
Pressure, 10-11

S

Shading, 10-11
Sharpness of pencil, 11
Shiny fur, 30
Short fur, 29
Siamese cats, 72-75
St. Bernard, 90
Stipple stroke, 12
Striped cats, 78-79
Stroke, 12
 circular, 12
 crosshatch, 12
 linear, 12
 loose scribble, 12
 stipple, 12
 vertical line, 12
Studio, 16
Stylus, 19
Super glue, 20

T

Tabby cats, 68-71
Tape, 19
Techniques, 10-15
 burnishing, 13
 color, 10
 enlarging photographs, 22
 feathers. *see Feathers, generally*
 fur. *see Fur, generally*
 grisaille, 27
 highlight, 14
 layering, 14
 line drawings, 22
 modeling, 14
 point, 10-11
 pressure, 10-11
 shading, 10-11
 sharpness of pencil, 11
 tonal foundation, 27
 transferring, 22-23
 wash, 13
Teeth, 59-60
Tonal foundation, 27
Tongues, 59-60
Tracing paper, 20
Transferring, 22-23

V-Y

Vertical line stroke, 12
Wash, 13
Wax bloom, 20
West Highland Terrier, 82-85
Whiskers, 61-62
White cats, 76-77
Workable fixative, 20
Yellow Lab, 91

Get Creative with Your Pencil Art!

COLORED PENCIL EXPLORATIONS

Discover the limitless possibilities of colored pencil blended with mixed media! Inside *Colored Pencil Explorations*, you'll find the work of today's most innovative colored pencil artists, highlighting a range of new and exciting effects in step-by-step detail. With demonstrations and plenty of information on materials, tools and each medium's basic characteristics, you'll achieve amazing results you never knew were possible.

ISBN 1-58180-186-6, hardcover, 144 pages, #31956-K

These books and other fine North Light titles are available from your local art & craft retailer, bookstore, online supplier or by calling 1-800-448-0915.

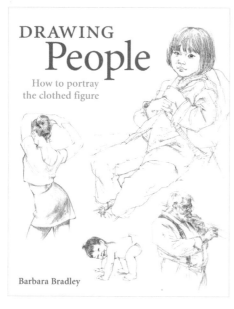

DRAWING PEOPLE

A complete course in drawing, *Drawing People* focuses on the clothed person as opposed to the nude figure. Author Barbara Bradley takes a friendly approach to teaching the fundamentals of drawing people - proportion, perspective and value. You'll also learn how to draw different clothing, how you can use folds in your drawings, and how to draw clothing on people. Included are tips for drawing heads and hands accurately and special instructions for drawing children.

ISBN 1-58180-359-1, hardcover, 176 pages, #32327-K

DRAWING IN COLOR: FLOWERS & NATURE

Lee Hammond makes the art of drawing flowers and nature in colored pencil easy and fun--even if you're a beginner! She provides guidelines for creating depth and realism, along with step-by-step techniques for rendering the fine details of brilliant and realistic fruits, flowers, bees and butterflies. You'll find all the instruction you need to draw gorgeous flowers and natural elements.

ISBN 1-58180-037-1, paperback, 80 pages, #31674-K

COLORED PENCIL SOLUTION BOOK

Janie Gildow and Barbara Newton, successful teachers and artists of this exciting, versatile medium, provide you with answers to the most commonly asked questions about colored pencil, from basic techniques and proper tool selection to using techniques to create realistic colors, light and textures. You'll also find solutions to fixing the most common mistakes!

ISBN 1-58180-026-6, hardcover, 128 pages, #31672 K